Art of Our Time

The Saatchi Collection

Lund Humphries London

in association with

Rizzoli
NEW YORK

Art of Our Time

Published in 1984
(except in the United States of America) by
Lund Humphries Publishers Ltd
26 Litchfield Street London WC2H 9NJ

ISBN 0 85331 479 9 paperback
ISBN 0 85331 483 7 casebound in boxed set of 4
 volumes

Published in 1985 in the United States of America by
Rizzoli International Publications Inc
712 Fifth Avenue New York NY 10019

ISBN 0–8478–0577–8 paperback

LC 84–61639

Designed by Herbert & Mafalda Spencer
Made and printed in Great Britain by
Lund Humphries Printers, London and Bradford

Published in four volumes:

Book 1

**ANDRE BAER BELL FLAVIN HESSE JUDD LEWITT MANGOLD MARDEN MARTIN McCRACKEN
MORRIS NAUMAN RYMAN SANDBACK SERRA TUTTLE**

By Peter Schjeldahl

Book 2

ARTSCHWAGER CHAMBERLAIN SAMARAS STELLA TWOMBLY WARHOL

By Jean-Christophe Ammann Michael Auping Robert Rosenblum Peter Schjeldahl

Book 3

BASELITZ GUSTON KIEFER MORLEY POLKE SCHNABEL

By Rudi Fuchs Hilton Kramer Peter Schjeldahl

Book 4

**BARTLETT BOROFSKY BURTON CLOSE FISCHL GOLUB JENNEY JENSEN LONGO MURRAY
NUTT ROTHENBERG SALLE SHAPIRO SHERMAN WINTERS**

By Prudence Carlson Lynne Cooke Hilton Kramer Kim Levin Mark Rosenthal Phyllis Tuchman

CLEMENTE

By Michael Auping

DEACON HODGKIN KOSSOFF SCULLY WILLING

By Lynne Cooke

Art of Our Time

4

List of Illustrations

Dimensions are given first in inches, then in centimetres.
Height precedes width precedes depth, unless otherwise indicated.

JENNIFER BARTLETT

1
17 White Street
1977
Enamel, silkscreen grid, baked enamel on 12 in.
(30·5 cm) square steel plates
Overall: 116×116 (294·6×294·6)

2
22 East 10 Street
1977
Enamel, silkscreen grid, baked enamel on 12 in.
(30·5 cm) square steel plates
Overall: 38×129 (96·5×327·7)

3
At the Lake
1978
Enamel, silkscreen grid, baked enamel on 12 in.
(30·5 cm) square steel plates, oil on canvas
Overall: 77×188 (195·6×477·5)

4
The Garden
1981
Installation in 9 parts:
Charcoal on paper
Frame: 73¼×81¼ (186×206·4)
Plaka on plaster wall
96×171¾ (244×436·3)
Ceramic tiles on plaster wall
96×60 (244×152·4)
Enamel, silkscreen grid, baked enamel on 12 in.
square steel plates
88¾×101 (225·4×256·5)
Oil on canvas 90×78 (228·6×198)
Enamel on glass 93×48 (236·2×122)
Glass (above window)
10×81 (25·4×205·7)
Mirror (below window)
31×81 (78·7×205·7)
Oil on mirror 93×49 (236·2×124·5)
Plaka on paper collage mounted on canvas
Plaka on wood frame
84¾×88¼ (215·3×224·3)
Lacquer and enamel on 6 wood panels
Screen: 72×126 (183×320)

JONATHAN BOROFSKY

5
Tilted Painting No. 7
1975
Charcoal on canvas
49×56 (124·5×142·2)

6
Canoe Painting at 2,491,537
1978
Acrylic on masonite
2 panels: 92½×59 (235×150)

7
Running Man at 2,550,116
1978/79
Acrylic on plywood
89½×110¼ (227·3×280)

8
Motor Mind at 2,559,701
1978/79
Dayglo paint on masonite, sheet aluminium, motor
70×37 (178×94)

9
Portrait of Descartes (after Frans Hals) on 4 Surfaces at 2,673,049
1980
Acrylic on shaped canvas
70×52×30 (178×132×76)

10
2,841,780 Painting with Hand Shadow
1981/83
Acrylic on canvas, light mounted on wall behind canvas
109×83 (277×211)

SCOTT BURTON

11
Black Lacquered Table
1975/77
Lacquered wood
30×36×36 (76·2×91·4×91·4)

12
Child's Table and Chair
1978
Lacquered wood, fabric, foam rubber, steel and brass
Chair: 27×12×12 (68·6×30·5×30·5)
Table: 21×22×17 (53·3×55·9×43·2)

13
Rock Chair
1982
Orange-red lava stone
42×45×54 (107×114·3×137·2)

14
Rock Chair
1982
White lava stone
48×40×36 (122×101·6×91·4)

15
Onyx Table
1978/81
Onyx, steel armature, fluorescent light
29×60×60 (73·6×152·4×152·4)

16
Chaise Longue
1983/84
Rosa Baveno granite
3 parts, Overall: 41½×24×67 (105·4×61×170·2)

CHUCK CLOSE

17
Joe
1969
Acrylic on canvas
108×84 (274×213)

ERIC FISCHL

18
Bad Boy
1981
Oil on canvas
66×96 (168×244)

19
The Old Man's Boat and the Old Man's Dog
1982
Oil on canvas
84×84 (213·4×213·4)

LEON GOLUB

20
Francisco Franco (1975)
1976
Acrylic on unprimed linen
20×17 (51×43)

21
Mercenaries IV
1980
Acrylic on canvas
120×230 (305×584)

22
Mercenaries I
1979
Acrylic on canvas
120×164 (305×416·6)

23
White Squad (El Salvador) IV
1983
Acrylic on canvas
120×152 (305×386)

24
Mercenaries V
1984
Acrylic on linen
120×172 (305×437)

NEIL JENNEY

25
Forest and Lumber
1969
Acrylic on canvas
58¼×70¼ (148×178·4)

26
Loaded and Unloaded
1969
Acrylic on canvas
58¼×70¼ (148×178·4)

27
Man and Machine
1969
Acrylic on canvas
58×70 (147×178)

28
Window No. 6
1971/76
Oil on panel
39¾×57½ (101×146)

29
Atmosphere
1976
Oil on panel
36½×67 (92·7×170·2)

BILL JENSEN

30
Claude
1979
Oil on linen
23×16 (58×41)

31
Guy in the Dunes
1979
Oil on linen
36×24 (92×61)

ROBERT LONGO

32
American Soldier and Quiet Schoolboy
1977
Enamel on cast aluminium
28×16×5 (71×40·6×13)

33
Men in the Cities
1981
Charcoal and graphite on paper
96×60 (244×152·4)

34
Men Trapped in Ice (triptych)
1979
Charcoal and graphite on board
Each panel: 60×40 (152·4×101·6)

35
Corporate Wars: Walls of Influence
1982
Cast aluminium bonding, lacquer on wood
Each side panel: 108×60 (274×152·4)
Central panel: 108×84 (274×213·4)
Overall: 108×312×48 (274×792·5×122)

36
Tongue to the Heart
1984
Acrylic and oil on wood, cast plaster, hammered
lead on wood, durotran, acrylic on canvas
136×216×25 (345·4×548·6×63·5)

ELIZABETH MURRAY

37
Beginner
1976
Oil on canvas
113×114 (287×289·5)

38
New York Dawn
1977
Oil on canvas
88½×65 (225×165)

39
Small Town
1980
Oil on canvas
6 parts, Overall: 132×130 (335×330)

40
Sleep
1983/84
Oil on canvas
129×129 (327·7×327·7)

JIM NUTT

41
Running Wild
1970
Acrylic on metal
46×43½ (117×110·5)

42
Pink Encounter
1970/71
Acrylic on metal
23¾×18¼ (60·3×46·4)

43
Tight Lips and Dreams
1972
Oil on board
16×16 (40·6×40·6)

44
You're Giving Me Trouble
1974
Acrylic on canvas
86½×73½ (220×187)

SUSAN ROTHENBERG

45
United States
1975
Acrylic and tempera on canvas
114×189 (289·6×480·1)

46
Cabin Fever
1976
Acrylic and tempera on canvas
66¾×84½ (170×214·6)

47
Untitled (Head)
1978
Acrylic on canvas
68×77½ (173×197)

48
Squeeze
1978/79
Acrylic and flashe on canvas
92×87 (233·7×221)

49
Somebody Else's Hand
1979
Acrylic and flashe on canvas
21×36 (53×91)

50
Patches
1982
Oil on canvas
87×117 (221×197)

51
Skating an Eight
1983
Oil on canvas
63×41 (160×104)

DAVID SALLE

52
He Aspires to the Conditions of the . . .
1979
Acrylic on canvas
48×70 (122×178)

53
Rob Him of Pleasure
1979
Acrylic on canvas
48×70 (122×178)

54
Perhaps or Probably Really is Lost
1980
Acrylic on canvas
58×88 (147×223·5)

55
The Fourth Since I Came Up
1980
Acrylic on canvas
2 panels: 48×72 (122×183)

56
The Power that Distributes and Divides
1981
Acrylic on canvas
2 panels: 86×100 (218·4×254)

57
From Planets to Favored Men
1981
Acrylic on canvas
2 panels: 84×120 (213·4×305)

58
A Couple of Centuries
1982
Acrylic and oil on canvas
2 panels: 110×160 (280×406·5)

59
Zeitgeist Painting No. 4
1982
Acrylic and oil on canvas
2 panels: 156×117 (396×297)

60
Poverty is No Disgrace
1982
Acrylic and oil on canvas with chair attached
3 panels: 98×205 (249×520·7)

61
Midday
1984
Acrylic and oil on canvas and wood
2 panels: 114×150 (289·6×381)

62
The Trucks Bring Things
1984
Acrylic, oil and fabric on canvas with light fixture
2 panels: 102×173¼ (259×440)

63
My Head
1984
Acrylic and oil on canvas, wood
7 panels: 120×210½ (304·8×534·7)

JOEL SHAPIRO

64
Untitled
1975
Cast iron
3½×7⅛×7¾ (9×18×19·7)

65
Untitled
1978
Cast bronze
2¾×23⁷⁄₁₆×17⅛ (7×59·7×43·3)

66
Untitled
1978
Cast bronze
2¾×7½×4½ (7×19×11·4)

67
Untitled
1980
Cast bronze
6×7¾×16 (15·2×19·7×40·6)

68
Untitled
1980/82
Cast bronze
23¾×13×8⅛ (60·3×33×20·6)

69
Untitled
1980/81
Cast bronze
52⅞×64×45½ (134·3×162·6×115·6)

70
Untitled
1980/82
Cast bronze
11⅛×17×10¾ (28·3×43×27·3)

CINDY SHERMAN

71
Untitled Film Still No. 3
1977
Black and white photograph
16×20 (40·6×50·8)

72
Untitled Film Still No. 5
1978
Black and white photograph
16×20 (40·6×50·8)

73
Untitled Film Still No. 18
1978
Black and white photograph
16×20 (40·6×50·8)

74
Untitled Film Still No. 21
1978
Black and white photograph
16×20 (40·6×50·8)

75
Untitled Film Still No. 25
1978
Black and white photograph
16×20 (40·6×50·8)

76
Untitled Film Still No. 32
1979
Black and white photograph
16×20 (40·6×50·8)

77
Untitled Film Still No. 45
1979
Black and white photograph
16×20 (40·6×50·8)

78
Untitled Film Still No. 48
1979
Black and white photograph
16×20 (40·6×50·8)

79
Untitled No. 66
1980
Colour photograph
20×24 (50·8×61)

80
Untitled No. 70
1980
Colour photograph
20×24 (50·8×61)

81
Untitled No. 74
1980
Colour photograph
20×24 (50·8×61)

82
Untitled No. 87
1981
Colour photograph
24×48 (61×122)

83
Untitled No. 88
1981
Colour photograph
24×48 (61×122)

84
Untitled No. 92
1981
Colour photograph
24×48 (61×122)

85
Untitled No. 97
1982
Colour photograph
45×30 (114·3×76)

86
Untitled No. 98
1982
Colour photograph
45×30 (114·3×76)

87
Untitled No. 99
1982
Colour photograph
45×30 (114·3×76)

88
Untitled No. 100
1982
Colour photograph
45×30 (114·3×76)

89
Untitled No. 96
1981
Colour photograph
24×48 (61×122)

90
Untitled No. 122
1983
Colour photograph
Frame: 86¾×57¾ (220×146·7)

TERRY WINTERS

91
Fungus
1982
Oil on linen
60×78 (152·4×198)

92
Caps, Stems, Gills
1982
Oil on linen
60×84 (152·4×213·4)

93
Botanical Subject 2
1982
Oil on linen
48×36 (122×91·4)

94
Botanical Subject 4
1982
Oil on linen
48×36 (122×91·4)

95
Botanical Subject 5
1982
Oil on linen
48×36 (122×91·4)

96
Botanical Subject 6
1982
Oil on linen
48×36 (122×91·4)

97
Stamina 1
1982
Oil on linen
60×84 (152·4×213·4)

98
Stamina 2
1982
Oil on linen
60×84 (152·4×213·4)

99
Theophrastus' Garden I
1982
Oil on linen
87×70 (221×178)

100
Theophrastus' Garden II
1982
Oil on linen
87×70 (221×178)

101
Colony
1983
Oil on linen
78½×103½ (199·4×263)

102
Untitled
1983
Oil on linen
42×26 (106·7×66)

FRANCESCO CLEMENTE

103
Autoritratto
1980
Oil on canvas
12×8 (30·5×20·5)

104
I Quattro Punti Cardinali: Nord
1981
Pastel on paper
Sheet: 24×18 (61×45·5)

105
I Quattro Punti Cardinali: Est
1981
Pastel on paper
Sheet: 24×18 (61×45·5)

106
I Quattro Punti Cardinali: Sud
1981
Pastel on paper
Sheet: 24×18 (61×45·5)

107
I Quattro Punti Cardinali: Ouest
1981
Pastel on paper
Sheet: 24×18 (61×45·5)

108
Non Morte di Eraclito
1980
Charcoal and pastel on paper mounted on canvas
79×335 (201×850)

109
Weight
1980
Pastel on paper
Sheet: 24×18 (61×45·5)

110
Interior Landscape
1980
Pastel on paper
Sheet: 24×18 (61×45·5)

111
Untitled
1981
Oil on canvas
Tondo: 20×16 (51×41)

112
One, Two, Three
1981
Oil on canvas and fabric
96×288 (244×732)

113
The Magi
1981
Fresco
78¾×118 (200×300)

114
Smoke in the Room
1981
Fresco
78¾×118 (200×300)

115
The Fourteen Stations, No. I
1981/82
Oil and encaustic on canvas
78×88 (198×223·5)

116
The Fourteen Stations, No. II
1981/82
Oil on canvas
78×88 (198×223·5)

117
The Fourteen Stations, No. III
1981/82
Encaustic on canvas
78×93 (198×236)

118
The Fourteen Stations, No. IV
1981/82
Oil and encaustic on canvas
78×88½ (198×225)

119
The Fourteen Stations, No. V
1981/82
Oil on canvas
78×92 (198×233·5)

120
The Fourteen Stations, No. VI
1981/82
Encaustic on canvas
78×88 (198×223·5)

121
The Fourteen Stations, No. VII
1981/82
Oil on canvas
78×90 (198×228·5)

122
The Fourteen Stations, No. VIII
1981/82
Oil and encaustic on canvas
78×93 (198×236)

123
The Fourteen Stations, No. IX
1981/82
Encaustic on canvas
78×93 (198×236)

124
The Fourteen Stations, No. X
1981/82
Oil and encaustic on canvas
78×93 (198×236)

125
The Fourteen Stations, No. XI
1981/82
Oil on canvas
78×93 (198×236)

126
The Fourteen Stations, No. XII
1981/82
Oil and encaustic on canvas
78×93 (198×236)

RICHARD DEACON

127
Untitled
1980
Laminated wood with rivets
118×114×114 (300×290×290)

128
Untitled
1981
Laminated wood
84⅝×120×55 (215×305×140)

129
Art for Other People No. 2
1982
Marble, wood, vinyl plastic with rivets
17×62¼×13 (43×158×33)

130
If the Shoe Fits
1981
Galvanised and corrugated sheet steel with rivets
60×130⅜×60 (152·5×331×152·5)

131
Art for Other People No. 5
1982
Laminated wood
42×42×72 (106·7×106·7×183)

132
For Those Who Have Ears No. 1
1982/83
Laminated wood and galvanised steel with rivets
84×144×60 (213·4×365·8×152·5)

133
Out of the House
1983
Galvanised steel and linoleum with rivets
48×24×60 (122×61×152·5)

134
The Heart's in the Right Place
1983
Galvanised steel with rivets
79×130×92 (200·7×330·2×233·7)

135
Two Can Play
1983
Galvanised steel
72×144×72 (183×365·8×183)

136
For those Who Have Eyes
1983
Stainless steel with rivets
60×60×90 (152·4×152·4×228·6)

137
Art for Other People No. 9
1983
Galvanised steel with rivets
21×13⅜×4⅓ (53×34×11)

138
Tall Tree in the Ear
1983/84
Galvanised steel, laminated wood and blue canvas
147⅝×98½×59 (375×250×150)

HOWARD HODGKIN

139
Family Group
1973/78
Oil on panel
36×42 (91·4×106·7)

140
Paul Levy
1976/80
Oil on panel
20⅞×24 (53×61)

LEON KOSSOFF

141
Children's Swimming Pool, 11 o'clock Saturday morning, August 1969
1969
Oil on board
60×81 (152×205)

142
School Building, Willesden, Spring 1981
1981
Oil on board
53½×65½ (136×166·4)

143
Family Party, January 1983
1983
Oil on board
66×98¼ (167·6×249·5)

144
Inside Kilburn Underground, Summer 1983
1983
Oil on board
54¼×66¼ (137·8×168·3)

SEAN SCULLY

145
The Bather
1983
Oil on canvas
96×120 (243·8×304·8)

146
By Day and By Night
1983
Oil on canvas
97½×142 (247·7×360·7)

VICTOR WILLING

147
Navigation
1977
Oil on canvas
78¾×94½ (200×240)

148
Griffin
1982
Oil on canvas
98½×78¾ (250×200)

149
Knot
1984
Oil on canvas
78¾×86½ (200×220)

150
Callot Harridan
1984
Oil on canvas
78¾×86½ (200×220)

Biographical Notes

JENNIFER BARTLETT

Born in Long Beach, California, 1941
Education:
Mills College, Oakland, California, 1963 (BA)
Yale University School of Art and Architecture, New Haven, Connecticut, 1964 (BFA)
Yale University School of Art and Architecture, New Haven, Connecticut, 1965 (MFA)
Recipient of Creative Artists Public Service Grant, 1974
Recipient of Harris Prize, School of the Art Institute of Chicago, Chicago, Illinois, 1976
Instructor at:
School of Visual Arts, New York, 1972–7
Recipient of Lucas Visiting Lecture Award, Carlton College, Northfield, Minnesota, 1979
Recipient of Brandeis University Creative Award, Waltham, Massachusetts, 1983
Lives and works in New York City and Paris

JONATHAN BOROFSKY

Born in Boston, Massachusetts, 1942
Education:
Carnegie Mellon University, Pittsburgh, Pennsylvania, 1964 (BFA)
Ecole de Fontainebleau, France, Summer 1964
Yale University School of Art and Architecture, New Haven, Connecticut, 1966 (MFA)
Instructor at:
School of Visual Arts, New York, 1969–77
California Institute of the Arts, Valencia, California, 1977–80
Lives and works in Venice, California

SCOTT BURTON

Born in Greensboro, Alabama, 1939
Education:
Studied painting with Leon Berkowitz, Washington, DC, and with Hans Hofmann, Provincetown, Massachusetts, 1957–9
Columbia University, New York (studied literature), 1962 (BA)
New York University, New York (studied literature), 1963 (MA)
Lives and works in New York City

CHUCK CLOSE

Born in Monroe, Washington, 1940
Education:
Everett Community College, Washington, 1958–60
University of Washington, Seattle, 1960–2 (BA)
Yale-Norfolk Summer School of Music and Art, Norfolk, Connecticut, 1961
Yale University School of Art and Architecture, New Haven, Connecticut, 1963 (BFA) and 1964 (MFA)
Recipient of Fulbright Scholarship, 1964
Akademie der bildenden Künste, Vienna, 1964–5
Instructor at:
University of Massachusetts, Amherst, Massachusetts, 1965–7
School of Visual Arts, New York, 1967–71
New York University, New York, 1970–3
Recipient of National Endowment for the Arts Award, 1973
Lives and works in New York City

ERIC FISCHL

Born in New York City, 1948
Education:
California Institute of the Arts, Valencia, California, 1972 (BFA)
Lives and works in New York City

LEON GOLUB

Born in Chicago, Illinois, 1922
Education:
University of Chicago, (studied art history), 1940–2 (BA)
School of the Art Institute of Chicago, 1946–50 (MFA)
Instructor at:
Wright Junior College, Chicago, 1950–5
University College, Northwestern University, Chicago, 1953–6
Indiana University, Bloomington, Indiana, 1957–9
Tyler School of Art, Temple University, Philadelphia, Pennsylvania, 1965
School of Visual Arts, New York, 1966–9
Rutgers University, New Brunswick, New Jersey, 1970–present
Lives and works in New York City

NEIL JENNEY

Born in Torrington, Connecticut, 1945
Education:
University of Massachusetts College of Art, Boston, Massachusetts, 1964–6
Lives and works in New York City

BILL JENSEN

Born in Minneapolis, Minnesota, 1945
Education:
University of Minnesota, Minneapolis, 1968 (BFA) and 1970 (MFA)
Lives and works in New York City

ROBERT LONGO

Born in Brooklyn, New York, 1953
Education:
North Texas State University, Denton, Texas
Nassau Community College, New York
College of Art, State College University of New York, Buffalo, New York, 1975 (BFA)
Lives and works in New York City

ELIZABETH MURRAY

Born in Chicago, Illinois, 1940
Education:
School of the Art Institute of Chicago, Chicago, Illinois, 1962 (BFA)
Mills College, Oakland, California, 1964 (MFA)
Instructor at:
Bard College, Annandale-on-Hudson, New York, 1974–5
Wayne State University, Detroit, Michigan, 1975
California Institute of the Arts, Valencia, California, 1975–6
School of the Art Institute of Chicago, Chicago, Illinois, 1975–6
Bard College, Annandale-on-Hudson, New York, 1976–7
Princeton University, Princeton, New Jersey, 1977
Yale University, New Haven, Connecticut, 1978–9
Recipent of Walter M. Campana Award, The Art Institute of Chicago, Chicago, Illinois, 1982
Lives and works in New York City

JIM NUTT

Born in Pittsfield, Massachusetts, 1938
Education:
School of the Art Institute of Chicago, Chicago, Illinois, 1965
Lives and works in Wilmette, Illinois

SUSAN ROTHENBERG

Born in Buffalo, New York, 1945
Education:
Cornell University, Ithaca, New York, 1967 (BFA)
George Washington University and Corcoran School of Art, Washington, DC
Lives and works in New York City and Long Island

DAVID SALLE

Born in Norman, Oklahoma, 1952
Education:
California Institute of the Arts, Valencia, California,
1973 (BFA) and 1975 (MFA)
Lives and works in New York City

JOEL SHAPIRO

Born in New York City, 1941
Education:
New York University, New York, 1964 (BA) and 1969
(MA)
Recipient of National Endowment of the Arts
Award, 1975
Instructor at:
Princeton University, Princeton, New Jersey,
1974–6
School of Visual Arts, New York, 1977–present
Lives and works in New York City

CINDY SHERMAN

Born in Glen Ridge, New Jersey, 1954
Education:
College of Art, State College University of New
York, Buffalo, New York, 1972–6 (BA)
Lives and works in New York City

TERRY WINTERS

Born in New York City, 1949
Education:
Pratt Institute, Brooklyn, New York, 1971
Lives and works in New York City

FRANCESCO CLEMENTE

Born in Naples, Italy, 1952
Lives and works in New York City, Rome and
Madras, India

RICHARD DEACON

Born in Wales, Great Britain, 1949
Education:
Somerset College of Art, Taunton, England, 1968–9
St Martin's School of Art, London, 1969–72
Royal College of Art, London, 1974–7
Chelsea School of Art, London, 1977–8
Lives and works in London

HOWARD HODGKIN

Born in London, 1932
Lived in the United States, 1940–3
Education:
Camberwell School of Art, London, 1949–50
Bath Academy of Art, Corsham, 1950–4
Instructor at:
Charterhouse School, Surrey, 1954–6
Bath Academy of Art, Corsham, 1956–66
Chelsea School of Art, London, 1966–72
Trustee of the Tate Gallery, London, 1970–6
Artist in Residence, Brasenose College, Oxford,
1976–7
Trustee of the National Gallery, London,
1978–present
Lives and works in London and Wiltshire, England

LEON KOSSOFF

Born in London, 1926
Served in the Army in France, Belgium, The
Netherlands and Germany, 1945–8
Education:
St Martin's School of Art, London, 1949–53
Borough Polytechnic, 1950–2
Royal College of Art, London, 1953–6
Lives and works in London

SEAN SCULLY

Born in Dublin, Ireland, 1945
Education:
Croydon College of Art, London
Newcastle University, England
Moved to the United States, 1975
Harvard University, Cambridge, Massachusetts
Recipient of Harkness Fellowship
Instructor at:
Princeton University, Princeton, New Jersey, 1982
Recipient of Guggenheim Foundation Fellowship,
1983
Becomes American citizen, 1983
Lives and works in New York City

VICTOR WILLING

Born in Alexandria, Egypt, 1928
Education:
Slade School of Fine Art, London, 1949–54
Lived mainly in Portugal, 1957–75
Recipient of Thorne Scholarship, 1980
Artist in Residence, Corpus Christi College and
Kettle's Yard Gallery, Cambridge, 1982
Lives and works in London

Contents

Mark Rosenthal **Jennifer Bartlett, Jonathan Borofsky, Neil Jenney, Robert Longo, Elizabeth Murray, Susan Rothenberg, David Salle, Cindy Sherman**

The Saatchi Collection of recent American art is both dizzying and invigorating, for it offers a provocative relief map of significant figures on the American scene. With conviction and daring, it presents a roll-call and full portrayal of those few artists believed to have made an important achievement. The effect of this outline is stark, yet in it one can perceive a critical development in recent art in general.

Jennifer Bartlett Elizabeth Murray

For Jennifer Bartlett and Elizabeth Murray a subject is a motif, to be melded or subsumed in a pictorial composition. However arbitrary this structure may be, it dictates in a large part how the motif will be presented. Like Cézanne and then the Cubists, Bartlett and Murray never quite relinquish the subject; its content is usually expunged by the artistic process. The viewer is placed at an emotional distance, and the centre of interest becomes the hand of the artist.

Process is the all-important characteristic of the art of Bartlett and Murray. The artists adapt a variety of media and support possibilities in an ever-expanding elaboration of the modernist aesthetic that it is not what one paints that is particularly important, but the sheer variety and joy of creation that is the goal. Always aware of the work of art as a physical entity, these two artists have, nonetheless, chosen to turn away from the ascetic literalness of Minimalism. Rather, like the Cubists, they 'struggle' towards representation; their art is about an activity in which a *thing* is synthesised with the properties of art. Representation as it becomes abstraction or vice-versa, the potential of abstract structure or concrete means to render the presence of a subject, become the most sublime of the operations to contemplate in their work.

Jennifer Bartlett frequently employs the modernist convention of the grid, thereby stressing the degree to which her art is based on an arbitrary structure. She creates wondrous rhythmic arrangements of the square units with an outcome that is at times musical in character. Themes are stated, varied, contradicted and restated in these fluid compositions. Besides accumulating perceptions by apprehending the units one by one, the spectator also views the highly elaborated surface as a whole image of interrelated aspects.

Bartlett's oft-seen motif of the house is the subject of *17 White Street* and *22 East 10 Street* (plates 1 and 2) produced in 1977. In the first, she suggests differing fields on which the house might appear, but in the second, this rather diagrammatic approach yields to a more dramatic rendering. Still, the theme is captive of the æsthetic means that created it. Bartlett wrote of the house: '[It] is . . . just a given image that I work with . . . a throwaway . . . My interest is in how it can be done rather than what the imagery is.' Similarly, in *At the Lake,* 1978 (plate 3), the suggestion of waterlilies is minimised by their depiction as clear, geometricised ovals.

The Garden, 1981 (plate 4), was perhaps the most elaborate work Bartlett had made to that date. It is a virtuoso demonstration of how an artist, trained in the lessons of Modernism, thinks about rendering a subject. A variety of possibilities are present, including oil paint, plaka, acrylic, collage, tempera, silkscreen,

15

enamel, charcoal, graphite and lacquer, variously found on a plaster wall, paper, canvas, glass and panel. Abstraction and *tromp l'oeil* illusionism are balanced and countered by an actual view into a garden. The inclusion of the mirror turning the viewer back on himself is yet the final touch in this *l'art pour l'art* demonstration.

The Garden is replete with references to the history of art, including obvious quotes from Impressionism and Neo-Impressionism. But these are only part of the tale. Bartlett has integrated the work of art and its surroundings to form a continuous æsthetic field, echoing contemporary, site-specific experiments, and, perhaps more to the point, Renaissance frescoes. If *The Garden* is filled to the point of overflowing with such referential material, it is only in keeping with the ebullient and extravagant spirit that characterises Bartlett's art.

Elizabeth Murray has a more poetic, if no less modernist, approach to subject matter. Using the mode of biomorphic forms and allusive titles, *Beginner,* 1976 (plate 37) may refer to an infant and its umbilical cord located in the womb. Similarly evocative is *New York Dawn,* 1978 (plate 38). The small white circle appears to be an emerging force among the large shapes of colour, an effect which is reinforced and made specific by the title. In these early pictures, Murray's art recalls the abstraction of Georgia O'Keeffe, Arthur Dove or Jean Arp, for example, in whose work abstract forms are invested with meaning and titles often have considerable import.

A dramatic change in Murray's painting occurred between 1978 and 1980 and is magnificently represented in *Small Town,* 1980 (plate 39). She broke an image apart into separate canvases which were then loosely gathered together. The rather awkward forms already present were greatly exaggerated by the assemblage. Since beginning to dissolve her images, Murray has increased the pictorial complexity of her art rather dramatically. For instance, in *Small Town* the openings between the canvas sections uncover the wall behind and indicate a contrast between pictorial and actual space, while performing a compositional function that is similar to the white spot in *New York Dawn.* Thus, Murray's hand, manipulating a composition of allusive shapes and the physical properties of art, is now the subject of her work.

Jonathan Borofsky
Neil Jenney
Susan Rothenberg

A major source for the shared attitude of Jonathan Borofsky, Neil Jenney and Susan Rothenberg is indicated by Jenney's statement that 'Pop is the father of us all'. In Pop Art, the motif was no longer an excuse to make a painting but its *raison d'être*. However, Borofsky, Jenney and Rothenberg reject the irony and psychological distance often found in Pop, and display a decisive engagement with subject matter. They stress attention, contemplation, even exaltation and reverence toward the theme. By contrast, the modernist has the notion that the subject of a work of art is itself; all meaning is manifested by inherent qualities. Borofsky, Jenney and Rothenberg replace the transcendent object with the elevated subject. Their next task is to make their works as emotionally charged, intensely felt, and direct as possible.

Borofsky, Jenney and Rothenberg typify an attitude that may have its roots in part in the 1960s spirit of rebellion, an era when the obsessions in America included the world political situation, preservation of nature, various eternal verities, and psychological awareness. These artists rebelled, specifically, against the cool, polished styles of the most recent manifestations of modern art. Indeed, the concept of style, so sacred to modernist pioneers who valued this as a hard-won achievement, was denigrated by Borofsky and Jenney. Aggressively nonchalant, Jenney, at one time, called his style 'unconcerned', a pronouncement that would have been unthinkable at an earlier period.

Neil Jenney's use of words to join a linguistic message to a visual image is an exaggerated and emphatic gesture in the revolt toward subject matter. In *Forest and Lumber,* 1969 (plate 25) and *Man and Machine* (plate 27) the anecdotal themes gain an absolute, iconic tone by the boldly stated words beneath the images. Jenney's method is to seek complete comprehension of an immediately

understandable theme by juxtapositions based on cause and effect relationships or formal-cum-thematic parallels between the elements.

Notwithstanding the directness of Jenney's imagery, he is still quite preoccupied by issues of formalism. The frame, title, image and brushstroke are distinct aspects of a complex whole. It is as if he wants to deal with the function of the frame as a boundary between the real world and art, the presence of language vis-à-vis an image, and the development of the brushstroke from the Abstract Expressionists to Jasper Johns.

In 1970, Jenney began to paint in a more naturalistic, 'concerned' style, in the hope of achieving a greater, visual impact. Paintings done in recent years, such as *Window No.6*, 1971/76, and *Atmosphere*, 1976 (plates 28 and 29) are contained within highly elaborated, often irregular frames. So effective is the distancing function, the frame establishes a kind of altar on which the image assumes an almost sacred quality. In this period, the theme of life-threatening technology contrasted with the purity of nature has been implicit in all of Jenney's paintings.

When Susan Rothenberg first came to prominence, her sole subject was the horse. Its repetition could be compared to the role of a mantra for a religious individual, or the signature compositions of Piet Mondrian, Mark Rothko and Barnett Newman, or the upside-down motifs of Georg Baselitz. In effect, the expressiveness of one composition is so great for its creator that the image can be endlessly repeated. With each variation, its inherent, profound meaning is stated, amplified, elaborated and characterised anew.

The horse is a theme that is archetypal in character, and Rothenberg elicits associations of a psychological, mythical and cultural kind. In *Cabin Fever*, 1976 (plate 46), it is the pure, unbridled animal, evincing the energy and life of nature. A contrast to the full-limbed grace and speed of this creature is *United States*, 1975 (plate 45), in which the animal is completely static, its weighty, stolid character suggesting a plough horse. The artist's provocative title is, in fact, based on a formal description, that the two differing halves of the horse, the two 'states', have been 'united' in one view. In this sense, Rothenberg suggests a resonance between the formal structure of the painting and the image therein, much as Elizabeth Murray had done. Yet, by the title, Rothenberg has enticed the viewer to interpret the image in political terms, as a symbol of the United States of America, which has domesticated nature to the extent that a much-admired animal has lost its vitality and become an emblem of the force that has tamed it.

The paradoxical character of the horse is duplicated by the artist who paints this subject. On the one hand, the umber colour, unspecified locale, and relatively primitivistic style are reminders of cave painting. Indeed, Rothenberg has said, 'I identify the content of my work strongly with spirituality, with a universal religious impulse'. And so, she assumes the persona of the cave painter, observer and admirer of nature. On the other hand, the image of the horse in both *Cabin Fever* and *United States* has been divided by vertical lines, which are intended to establish the surface of the picture and define the location of the animal in relation to the overall format. Thus, Rothenberg's intentions, like those of Jenney, are somewhat divided, although not necessarily divergent. She wants to create an immediately comprehensible, meaningful subject, and, at the same time, deal with it in a visually exciting manner. The latter urge, however, never submerges the inherent richness of the subject or the degree to which the artist might, herself, identify with it.

When Rothenberg turned from the theme of the horse in 1978, she became preoccupied with the head. Works such as *Untitled (Head)*, 1978 (plate 47), and *Squeeze*, 1978/79 (plate 48), maintain the characteristically energetic, earlier linear style. But whereas there was a certain clarity of subject matter in the horses, from this time forward Rothenberg's imagery often exhibits an ambiguity, even while retaining its primeval, confrontational quality. The apparently vomiting head is typical. She once described it as having derived from her attempts to quit smoking. Beyond that specific origin, it suggests the discharge of any

nausea-inducing substance or experience. Furthermore, the image of a head cradled by limbs suggests a birth; in this interpretation, the line from the mouth is an umbilical cord of sorts. However, because it is disembodied and fairly gaunt and pasty in colour, the head has qualities not unlike a skull. Someone grabs the formerly protected head in *Somebody Else's Hand,* 1979 (plate 49) as if away from between the legs of its parent. The size of the hand vis-à-vis the head suggests an adult poking his/her fingers through the openings of a child's skull, an action similar to handling a bowling ball. Recent works, such as *Patches,* 1982 (plate 50) and *Skating an Eight,* 1983 (plate 51), continue to demonstrate the provocative and ambiguous character of Rothenberg's art. It is as if we witness the raw, determined signs of some primitive, whose language will forever remain beyond us.

The potentially divergent directions of subject and structure in a work of art are nowhere more exaggerated, at least among the artists under discussion, than in the output of Jonathan Borofsky. In almost every object he makes, a powerfully-felt theme is balanced by an emphasis on the physical character of the object. *Tilted Painting No. 7,* 1975 (plate 5), seems to reveal the ages of man, as shown on a stage-set with parted curtains. At first, humanity is found in a womb-like cloud in the sky. Then, the journey of life is indicated by the sailboat, in the middle right; above, within a mountain, is a pair of heads, perhaps signifying the fates blowing on the boat and determining its course. Finally, humanity reaches an isolated aura of light in the centre of the painting. A sail is no longer necessary, and free-floating is possible. Borofsky's universal/personal subject is located on a canvas that immediately draws attention to itself for an obvious, literal reason. It is tilted. Borofsky turns askew tradition, wherein a painting is meant to invite the viewer to enter its world, without distraction. Instead of an illusion we are confronted by an object on which an image is painted.

The balancing of subject with structure occurs, again, in *Canoe Painting,* 1978 (plate 6). Here, it is as if the figure in *Tilted Painting No. 7* has left the boat and started to ascend toward another stage of existence. The theme is painted on an emphatically eccentric form that is reminiscent of the shaped canvases of formalist painters as well as the decorated canoes of tribal cultures. Thus, Borofsky, like Rothenberg, aligns himself with both early and advanced civilisations. Adding to the strategy of an image on a shaped canvas, Borofsky introduces movement in *Motor Mind,* 1978/79 (plate 8). Thematically, the revolving, aluminium object suggests the energetic flow of thoughts in the mind of the figure: formally, it provides the static image with dynamism. *Portrait of Descartes (after Frans Hals) on 4 Surfaces,* 1980 (plate 9) exaggerates the form-versus-content dichotomy yet further. A profound thinker, as painted by an artist of considerable skill, is forced on to this odd structure. Sitting rather ingloriously on the floor, the work forces us to contemplate a *thing* that happens to have an image of a philosopher painted upon it.

Notwithstanding Borofsky's compulsive need to make certain his images are always recognised as being located on physical objects, he, nonetheless, paints subject-matter of the most personally significant kind. *Motor Mind* refers to the general state of his ever-racing subconscious; *Painting with Hand Shadow,* 1981/83 (plate 10) defines some of those thoughts specifically; and *Running Man,* 1978/79 (plate 7) derives from his experience as a jogger. However, Borofsky hopes that his images will be meaningful to a broad public, indeed become objects of genuine empathy. In this regard, *Running Man,* along with certain other of his images such as *Hammering Man,* have come to have a totemic quality. To the extent that jogging is ubiquitous in Western culture, Borofsky, the runner, is Everyman. But the figure has a frightened, desperate expression which suggests his action is based on more than an aspiration for physical well-being – a need for escape.

The alienated, twentieth-century anti-hero has a principal role in Borofsky's art. By contrast, the deadpan copy of a painting of a famous man by an equally well-known painter is a method of recalling, and perhaps yearning for, another era, when the individual was worthy of being called a hero. Borofsky's art is a balancing of the dichotomy between the frightened individual and the fully

confident, superior being, an opposition of subject and structure, and a dramatic variation in style and execution between works: at its core is a determined uncertainty.



Robert Longo

David Salle

Cindy Sherman



The communicative nature of Borofsky, Jenney and Rothenberg may have helped free the next generation of artists to be even more insistent about placing subject matter at the centre of their concerns. Indeed the real world seems to gush forth in the work of Robert Longo (b.1953), David Salle (b.1952), and Cindy Sherman (b.1954). Not having roots in the minimal-process era, the conventions of Modernism do not represent a divergent interest or a burden for these artists. Instead, if a sign of objecthood or the hand of the artist is present, it serves the stated theme.

Acting as if Modernism is dead, Longo, Salle and Sherman often utilise such representational traditions as narrative, illustration, symbolism, or allegory. They are students, too, of the popular imagery found in advertising, television and movies, and are truly the inheritors of that tradition of accessible imagery. Longo, Salle and Sherman seem to be particularly fond of the period of the 1940s to 1950s, when the media was beginning to have a very significant effect on society, as the dominant purveyors of popular culture. Ironically, their interest in the media of these years is at once a rejection of the then current mode of Abstract Expressionism; Longo, Salle and Sherman reconnect art with everyday life at a point when their American, artistic forebears denied that world in painting.

Robert Longo might also be called a mantra painter in that he is preoccupied with a single theme: the anonymous Everyman subsumed in a nightmare vision of America. By its title, *American Soldier and Quiet Schoolboy,* 1977 (plate 32) describes the protagonist of almost all of Longo's works, a man who has had a 'quiet', that is to say, passive childhood, after which he has assumed the uniform of a 'soldier' in the business-oriented life of America. Wearing a hat, the figure can be traced to an earlier period in history, when current American life was being shaped. The pose is especially typical of Longo's cast of characters. Everyman seems to be dancing and writhing in pain, as if stabbed or shot in the back. Thus, the minion of the business world suffers as a military man might.

In *Men in the Cities,* 1981 (plate 33) the pose again suggests a conflation of abandonment and agony, as urban life is made a scene of masochism. Seen together, *Men in the Cities* and *Men Trapped in Ice,* 1979 (plate 34) have the same locale; being trapped on an ice floe becomes a metaphor for life in the metropolis. That baby seals are likewise trapped on ice and clubbed to death in the contemporary world is a troublesome parallel to the situation of these men. All creatures are doomed, regardless of their habitat.

The sense in Longo's art of claustrophobia or 'no exit' is emphatic in *Corporate Wars: Walls of Influence,* 1982 (plate 35) in which the outer wings of a triptych served as prison-like enclosures. By the title, Longo characterises these ominous forms as the profoundly effective, ethically corrupt forces of society. Their outward appearance is described with the hard, black, geometrical shapes of early twentieth-century skyscrapers. Within the walls occur the wars of corporate enterprise. Although Longo's world is predominantly male, the inclusion of women here is not for the purpose of showing contrasting behaviour. Longo indicates no sympathy or compassion for the figures; they are neither heroes nor victims.

Longo employs the triptych format to compartmentalise themes and to structure meaning. In *Tongue to the Heart,* 1984 (plate 36), the suffering figures, who try not to see or hear evil, are now subsidiary to the central image of a corporate hall of power. The predella section of the triptych shows a view of ocean waves, but instead of offering a balm or route for escape, the water is seen from a vantage point resembling that of an individual on the raft of the Medusa. The desperation of the situation is mocked by the title of the work.




The brute, impersonal force of the world as Longo imagines it is equalled by the bellicose style of his art. And yet, one must surmise an implicit idealism and belief in the possibility of a better life, for his favoured triptych composition is a pointed reference. It recalls representations of the death of Christ, a subject concerned with suffering and inhumanity, and a future transfiguration. For Longo, art may serve this moral and religious function.

While Longo is preoccupied with an Everyman who is victim of the economic conditions of society, David Salle is interested in more psychological portrayals. The atmosphere of a Salle painting can be likened to pulp novels and 1950s *film noir,* in which a quiet desperation fills the air. Salle conveys this disturbed milieu with facial expressions that are distracted, if visible at all, and physical gestures that are almost always conventional in character. We are thus persuaded to examine appearances very carefully for a deeper layer of meaning.

Although Salle's hand is much in evidence as he assembles images, his play with motifs has a poetic rather than formalist goal. He implies meaning through a process of layering and juxtaposing, with a result similar to Surrealist works, or the multivalent creations of Robert Rauschenberg, particularly during the early 1960s. A work by Salle usually consists of distinct parts, each adding implication to the other. A non-objective form gains content vis-à-vis a particular image; a stylistic juxtaposition suggests a thematic contrast; an apparitional figure overlays several others, thereby creating connections; or, colouristically dissociated sections are meaningfully joined. Not unlike the complexities of a 'synthetic' Cubist work, Salle entwines formal rhythms with thematic ones. The title adds the final layer, for it often has little to do with the imagery. Salle forces the viewer to invent a relationship, adding yet another veil to the whole complex. Juxtaposed dissociated images result in a kind of surrealist creation.

A major theme of Salle's art appears to be the existence of women, yet they rarely have a uniqueness about them. For instance, the dreamy, smoking poses suggest soap-opera stills, or tobacco advertisements as was the case in earlier paintings by Willem de Kooning and Tom Wesselmann; the more active nudes also echo females depicted in the media. In effect, women are the province of the male imagination in Salle's art; indeed, the nude woman is virtually always present to imply a sexual object. The nudity along with an expectant air in a number of paintings suggest that the arrival of a male will complete the picture. Or, turning from *He Aspires to the Conditions of the . . .* (plate 52) and *Rob Him of Pleasure* (plate 53) to *Perhaps or Probably Really is Lost* (plate 54), one senses that the absence of the telephone in the latter implies a guest may no longer be expected. The viewer might even presume that Salle depicts the male fantasy of female oral gratification symbolised by the smoking of a cigarette. In Salle's art the life of women is, in fact, life as Salle and certain of the media project it to be.

Whereas Salle is involved with a process of manipulation and juxtaposition, Cindy Sherman creates single, clearly understandable images. There is virtually no sign of the process by which the work was created. The emphasis is on a lone female figure, often in a tense, dramatic situation. There may be vulnerability, fear or anxiety in her eyes; at times, she seems to be searching for someone or something. On occasion, she is like one of Salle's women; self-absorbed, dreamy or staring.

Formally, Sherman's photographs have more to do with the history of painting than that of photography. She often employs mannerist or baroque lighting effects and compositions, and her love of textural play and detail reflects an attention to surface and detail such as might be found in a work by Velazquez or Matisse. Even her concentration on the subject of women is in keeping with the history of painting.

As with Baroque art, there is great theatricality in Sherman's work. Each photograph has the appearance of a single still image, isolated from an anecdote or narrative. The viewer might surmise the suggested story, so conventional-seeming are the images, but the drama of each is self-sufficient.

Melodrama, claustrophobia and desperation fill the air, and the photographs possess the spirit of the 1940s and 1950s. Yet, although each appears familiar, as if taken directly from a well-known movie, television drama or advertisement, it is a product of Sherman's subtle absorption and adaptation of these sources.

Sherman herself is the model for each photograph. With the skill of an accomplished actress, she *becomes* these various women. The artist displays virtually the entire range of stereotypes that is already fixed in popular media and culture, from Virgin to vixen. As opposed to Salle's distant, male outlook, Sherman can know all of these images. Never denying the authentic substance of a conventional persona, she enhances these obvious stereotypes. The major question Sherman poses to viewers is whether the stereotype is, in fact, accurate; do we – women or men – identify with standardised pictures of ourselves? While our reaction might be negative, Sherman's position does not coincide. Her work and its process show the ease with which she finds the commonplace within herself. In effect, she is humanising these guises in order to explore them. Finally, she may understand herself as an accumulation of these learned, stereotypical images.

Although the human presence has returned, with determination, to art, its character is as problematic as it has been throughout the modernist adventure. Instead of possessing a pre-ordained dignity, the individual is, variously, shadowy, tortured, degraded, mindless, frightened or stereotyped. Contemporary art duplicates the degree to which a human life seems to have relatively little value in society. The use of primitivistic styles of depiction and an undercurrent of spiritual values demonstrate a suspicion that unseen forces are controlling human destiny.

Phyllis Tuchman **Scott Burton**

Scott Burton has noted that Gerrit Rietveld, the Dutch architect-designer, 'defies category'. No less can be said of Burton himself. For a decade, the 45-year-old New Yorker has been exhibiting bronze tables, aluminium chairs, granite *chaises longues*, and copper pedestal tables which are indisputably works of art. His furniture confounds notions of what constitutes a sculpture. Since Burton's works are functional, they also question the role of three-dimensional art. You don't just view his things, you use them.

Consider the series of chairs made from natural boulders – gneiss, lava stone, flint, marble, and granite – which Burton began making in 1980. The attributes of sculpture establish their authoritative presence and rustic character. You respond to material, to its texture and colour, to how it was shaped and proportioned. Raw, rough sides contrast with smooth-cut seats and backs. From some angles, the beauty of the boulders the artist selected at quarries on the East and West Coasts is a matter for admiration. But facing the chairs, you're propelled to sit down.

Context plays a significant role in our appreciation of Burton's work. In situations where his objects are placed beside manufactured furniture, their identity as art is clear. You have only to compare his stone chairs in the garden of The Museum of Modern Art in New York with their classic wire chair neighbours to grasp how the Burtons are sculptural and the others merely well-designed. In some other settings, besides installing his own work, the artist has supervised the laying of paths as well as the siting of trees and lights. In the grounds of a government agency in Seattle where Burton mixed together boulders and chairs cut from them, you notice natural history and fine arts complementing one another. Currently Burton is involved with urban design projects for plazas and city parks which reveal how he is helping to redefine the way artists can work with architects and landscape architects in the planning stages rather than in post-production.

Burton has obviously not limited himself to exhibiting in galleries and museums. One reason can be found in his prediction of 1978 that 'the true potential importance of a new movement of artists' decoration would be on a broader, economic scale, on a public scale'. Thus, borrowing his own words, Burton shares with Rietveld a 'sensibility [which] combines the most abstruse modernist researches with the most social-minded intentions'.

When Burton designs his furniture with a lexicon of styles, he endows his art with yet more meaning. Confronted by a black-lacquered table incorporating aspects of Chinese, Arts and Crafts, and De Stijl work, or a steel table stacking the circle, square, and triangle associated with Constructivism and Suprematism, or a group of storage cubes which adapt features of a hard-edge painting, you reflect upon the sculptor's original source material. There is both the pleasure of recognition as well as respect for invention.

By creating objects for spaces in which we live, work and relax, Burton has realised something he recognised in Rietveld's career: 'art can be critical and reformist, and at the same time capable of public dissemination, though it may have to take
new forms to be so'. Our environment is richer for his efforts.

Kim Levin **Chuck Close, Eric Fischl, Leon Golub**

Chuck Close 'Sometimes I laugh because to make a painting is such a long and involved process. I'll spend three weeks gessoing a canvas – ten coats – getting it all sanded and getting it perfect and it reminds me of those motel signs, 'if you lived here you'd be home now' – if I were Ryman I'd be done. And then I spend another two weeks getting a fine pencil grid and if I were Agnes Martin I'd be done. And then I've got ten more months of work to do.'
Chuck Close, 1978

The mammoth frontal heads that Chuck Close paints are images as static and iconic as any minimalist work. But when they first appeared, it was their realism that was most striking. Photographic verity, deadpan reproduction, and imitation of nature (by way of the illusionistic but literal surface of a black and white snapshot) were startlingly new. By now photo-realism has come and gone, and the extreme scale, the underlying concern with identity, and the ambivalent involvement with Minimalist principles have become increasingly apparent. Like that of many post-minimalist artists who emerged in the late 1960s, his work is reductive, formal, and literal in a way that turns the reductive approach against itself.

Joe (plate 17) is one of only eight or nine black and white paintings that Close made between 1967 and 1970. In these early paintings, evidence of the artist's hand was reduced to a minimum, colour was eliminated, and as for economy of materials, a tablespoon of black paint sufficed to cover a nine by seven foot canvas. And the human countenance, greatly enlarged, was reduced to physical facts of physiognomy. Reduction, however, is not the same as subtraction. These Brobdignagian mug shots – with their tight focus, their magnified pores, their myopic clarity – can be almost hypnotic. Among Close's paintings, the image of *Joe* is uniquely artificial. 'Joe [fellow artist Joe Zucker] involved himself in the making of that particular painting unlike any other sitter. He collaborated by altering the way he looked before I painted him', explains Close. 'He anticipated the problem of having to deal with a nine foot high image of himself. He got a haircut, greased down his hair, borrowed a shirt and tie, and for a hundredth of a second he looked like a car salesman. I didn't recognise him.'

Subsequent work by Close has elaborated on his conceptual premises. After 1970, when he began painting in colour, the process was equally literal and even more artificial: using only the three colours of the colour separation printing process, building up the image one colour at a time, he mimicked a dye transfer print. He also began making the grid visible, creating the heads out of hundreds of dots of colour within grid squares, and, more recently, using his inky fingerprint – the mark of his own identity – as the module that adds up to the image of a head. He uses information as content, substitutes technique and process for style, and exposes the artificiality of his realism, which is always the result of a code, a system of predetermined, programmed marks. It is the artificialities of his work – and the almost surreal anti-expressionism – that speak to us today.

Eric Fischl Eric Fischl is usually grouped with the new breed of so-called Neo-Expressionist artists. Rejecting abstract modernist ideas and ideals, and the objectivity of minimalism and photo-realism, these painters are reacting as well against attempts to make a fresh start during the 1970s by escaping into non-traditional modes of art. 'You were to invent a new world, but you weren't given any skills to do it', Fischl has said. His painting style – subjective, flawed, naturalistic, old-style figuration – hovers precariously between clichéd, illustrative, painterly skills and desultory awkwardness. But the conservative casual style, the appearance of ordinariness, the relaxed brushstrokes, and the slippery space are deceptive: the content of his imagery is radical.

What makes Fischl's work extraordinary is the way his ambiguous scenes of contemporary hedonism and suburban life convey highly-charged tension and psychosexual innuendo. The banal scenes he depicts are loaded with threatening narrative implications, conjuring up feelings of anxiety and nameless dread. Everything in his paintings is on the edge of slipping out of control. In the midst of the banalities of everyday life, something traumatic is always going on, and we are never quite sure what it is. *Bad Boy* (plate 18) with its exposed secrets, social taboos, Oedipal conflicts, Freudian symbols, and forbidden fruits, is a neat illustration of messy psychological complexities. Its peekaboo stripes of sun and shadow tinge everything they touch with an aura of complicity and duplicity. When Fischl's paintings coalesce, as this one does, they are memorable.

The figures he paints are often inexplicably nude. He presents them as exhibitionists and makes us into voyeurs, implicating them and us in surreptitious exploits and exploitations. He also exposes unacknowledged primal impulses beneath the social veneer. And he lays bare not only adolescent fantasies but late twentieth-century insecurities. 'One, truly, does not know how to act! Each new event is a crisis, and each crisis is a confrontation that fills us with much the same anxiety that we feel when, in a dream, we discover ourselves naked in public.'

Leon Golub In 1956, when he was one of the Chicago 'monster masters' whose painting style of grotesquely expressive figuration countered the Abstract Expressionism coming out of New York, Leon Golub wrote: 'We are beset by and conditioned through mass media whose oversimplified stereotypes remain oblivious to problems . . .'. In 1967, while mainstream artists were abandoning art objects in their attempt to close the art/life gap – and Golub was painting *Gigantomachies* that referred to the Hellenistic friezes of Pergamon – he spoke up for a distanced art: 'Field, environment, Happenings – these are all events and situations that involve you (the viewer). You have to complete our work for us. Well, it isn't that I don't love you as much as anyone else, but I like the concept of distance.'

For years Golub's work went against the current, and was considered peripheral. It wasn't until recently, when we began to realise that progress had nasty side-effects and the twentieth century wasn't delivering the utopias promised by early Modernists – and a new generation of young artists began to express the widespread disillusion and dissolution of abstract ideals – that Golub's work has become central. It can now be seen as a statement of the other side of Modernism: generic images of a century which has seen the rise of mass man and mass media, totalitarian regimes, officially-sanctioned atrocities, and the capability for monstrous destruction, all in the name of progress. The consistency of his vision of power and violence is impressive. His early work showed an interest in the savagery of tribal art. His battles between gods and giants were depictions of monstrous power struggles. In his *Napalm* and *Vietnam* paintings of the late 1960s and early 1970s, the raw eroded images and brutality became specific. His portraits of world leaders explored individual faces of power, and his *Mercenaries, Interrogations,* and *White Squads* are images of power at its lowest common denominator: brute force.

An inherent characteristic of the toughest American art since Abstract Expressionist days has been a voracious appetite for power. Golub has shifted this stylistic quality to the arena of subject matter – illustrating not just the old adage that power corrupts but the covert content of his colleagues' forms – and made it

not only political but psychological. By catching the all-too-human smirks and sneers on the faces of the torturers and depersonalising the victims, his paintings insist on the artist's and the viewer's complicity. But Golub's tough style refuses to wallow in the sensuality of expressionism. Its uninflected flatness simply gets the job done, with intimidating scale and 'a paroxysmic fixity'. His technique is as vicious and visceral as his subject matter: paint scraped down to the thinnest skin with a meat cleaver, canvas rubbed raw, surface as dry as a bone. Sliding between ideology and formalism – and between politics and the psyche – his work is full of ambivalences and contradictions. His paintings confront the 1980s on his own uningratiating terms.

Hilton Kramer **Bill Jensen**

The paintings of Bill Jensen are an anomaly on the contemporary art scene. Whereas the ambitions of painting in his artistic generation have tended, as they have for many painters since the emergence of the New York School in the 1940s, to make outsize scale a fundamental coefficient of pictorial expression, Jensen has moved in the opposite direction by creating an art of extreme compression. By so doing, he has somewhat altered our relation to painting itself, and made of it something unexpectedly inward. By discarding the new favoured public scale for painting, he has re-established the art as an intensely private experience.

We are not obliged, in viewing Jensen's paintings, to stand back from them in the customary way in order to encompass a vast expanse filling our entire field of vision. Because of their reduced size, we are instead compelled to draw close to them – to place ourselves in a position of physical intimacy in relation to them – if we are to see them, and see into them, with the requisite degree of penetration. The pictorial surface is indeed conceived of not as a 'field', as that term is now understood, but as a kind of palimpsest requiring of the viewer an intensity of concentration comparable to that of the painter in the process of creating it. With Jensen's art, we are inexorably drawn inward – to shadows, to mystery, to an interior experience unlike any that we know in the art of his time. Literally and otherwise, his paintings require us – no less than the painter – to adopt a new aesthetic posture if we are to experience them at all.

It is disorienting, of course, to encounter new paintings – paintings seen for the first time – that break so decisively with our expectations of what a painting is, what kind of space it occupies on the wall and in our minds, and what our relationship to it is likely to entail. We naturally look for precedents, and in Jensen's case they are largely to be found among the first generation of American modernists – Marsden Hartley, Arthur Dove, and Georgia O'Keeffe, and, a generation earlier, Albert Pinkham Ryder, with whose swirling, visionary images Jensen's appear to have a keen affinity. In Jensen's painting there is a similar tendency to organic form, to a repertory of shapes and structures derived from nature, and to modes of illumination that favour twilight and half-light, a kind of dream-light in which the memory of objects is not easily distinguished from the shadows enclosing them. The forms themselves tend to be coiled or clenched, to be glimpsed in moments of metamorphosis or tension, and give the impression of something emergent, as if derived from some aesthetic equivalent of biosynthesis. They leave us with the sense of having observed and somehow participated in a cycle of birth and rebirth – an analogue, perhaps, of the process by which the painter has created them.

Paintings of this intensely inward character, paintings that are at once symbolic in meaning and yet elusive in their references, do not readily disclose their mysteries. They draw us into a world of private associations and obscure memories – a nocturnal mindscape as familiar as our own dreams but as resistant to easy interpretation as the profoundest dreams tend to be. In this mindscape, everything is vivid, everything brilliantly realised in purely visual terms, yet haunted by an aura that seems to lie just beyond the boundary of the visible. In this respect, Jensen's paintings have a kinship with certain modes of lyric poetry, and require in the 'reader' the kind of concentration one brings to poetry of that order. They are certainly an anomaly in the art of Jensen's generation, and an original one.

Lynne Cooke **Jim Nutt**

The frontispiece to a recent catalogue of the artist's work showed the Chicagoan dapperly dressed in loose tweeds casually toying with a golf club as he glanced towards the camera. Not the sort of image that immediately springs to mind for the maker of an art lauded for its ability to penetrate the inhibitions of the ego and realise images that convey the netherworld of the erotic, the violent and the aggressive. Facile though it may be to expect the physiognomy or demeanour of an artist to betray some sign that registers the peculiar nature of his other obsessions, in Nutt's case it is particularly inappropriate. While his art deals with libidinal fantasies of a kind that are normally repressed – and, when not repressed, unutterable and concealed in 'polite' society – it is neither autobiographical, nor private nor expressionist.

Multiple and heterogeneous sources have been proposed for his art; they range from all manner of vernacular imagery (ads, tattooing, comics, penny arcades, game boards) to fine art from many cultures and eras (Javanese puppets, medieval manuscript marginalia, Japanese wood block prints, Greek frescoes) to the art of 'the outsiders', the insane and the naïve. But it is less a question of influence than of affinity. Nutt's art may be formally synthetic but the progenitors are, tellingly, often anonymous artisans such as graphic artists, Greek vase painters or tribal carvers who are not easily identified by 'hand', let alone artistic persona and 'vision'. Painstaking if neutral crafting characterises Nutt's work; a calligraphic virtuosity is wedded to an impeccable surface finish, one which fastidiously eliminates all traces of the individual mark. The mode of presentation – the boxed frames, quasi-stages, simple backdrops, inset predellas and medallions – also reinforces this sense of an objective statement.

Emerging in the late 1960s in group shows with cheeky if apt titles like *The Hairy Who,* Nutt's work raucously, often bawdily but undeniably comically, rummaged in areas long eschewed by the fine arts. *Running Wild* (plate 41), in which an ogrish modern harridan bestrides a landscape strewn with the dismembered remains of puny foes triumphantly bearing aloft her latest trophy, a giant penis, no doubt rudely prised from its owner, is at once fearsome, grotesque and hilarious. Since the aggressive crudity, subversive humour, slangy tone, scatalogical motifs, tawdry milieus and downbeat protagonists were very much part of an era, one that also witnessed The Freak Brothers and Frank Zappa, Nutt's concerns do not, as is often claimed, belong to a peculiarly Chicagoan matrix.

A tempering of the more extreme violence and of the blaring harsh colour is noticeable in Nutt's more recent work, accompanied by a deepening of insight, so that at times poignancy replaces the former boisterous and mordant crudity. *Tight Lips and Dreams* (plate 43) shows the protagonist surrounded by cameo images of his erotic fantasies so beguiling that they seem to have addled his mind: as the images hectically circulate, his face rapidly changes colour and his eyes swim. An additional comic level is introduced by means of the format which recalls that of icons with their centralised saints surrounded by the principal incidents or agents who contributed to their attaining grace. Whilst still uncensorious and never moralistic, the subject matter too has changed somewhat, to focus more on scenarios from ordinary life. Though more elliptical than narrative in character, these works nonetheless constitute a droll kind of comedy of manners.

27

In works such as *You're Giving Me Trouble* (plate 44) it is therefore unnecessary to look for psychoanalytical explanations. This combination of the erotic and humorous has a distinguished lineage, for as Aristophanes so well understood, the comic makes possible the pronouncement of the otherwise prohibited. Invoking this Greek author is not entirely fortuitous for there have been few painters in Western art (a notable exception being Miró) who have approached the louche grotesquerie of this kind of subject-matter in so uninhibited and so ebulliently irreverent a fashion, with such decorative finesse in design and elegance and virtuosity in form, since the black-figure painters of erotic satyr cups.

Phyllis Tuchman **Joel Shapiro**

Joel Shapiro's sculptures will be featured prominently in the histories of the 1970s and 1980s. His pint-sized houses and animated figures sparked renewed interest in representation. After initially abiding by many of Minimalism's tenets, Shapiro, a native of New York City born in 1941, deflected this legacy of the 1960s. His imagery is referential and personal. His sculpture evokes feelings rather than arcane theories. Moreover, Shapiro played an important role in the bronze revival, having been one of the first artists to cast his work in a material that had long been scorned.

Roberta Smith has correctly characterised the sculptor's career as varied and loquacious, but his reputation is primarily based on two bodies of work. In 1972, Shapiro initiated a score of tiny houses which look as if a child had designed them. Many rest directly on the floor, surrounded by caverns of space, or sit on eye-level shelves which equally draw attention to their minute aspects. A few are mounted on expansive, table-top bases. The earliest were executed in iron; later examples were cast in bronze. In 1980, Shapiro introduced a corps of scrawny, stick-like figures made from wood beams. (Knot holes and grain remain visible in those cast in bronze.) They have an acrobatic, gravity-defying manner.

While Shapiro's images are recognisable, they adhere to non-representational principles. Says the artist, 'These works are figurative, but they function abstractly'. Even though Shapiro's works embody such Minimalist features as crisp edges and sleek planes, his relationship to that movement is comparable to the one David Smith had with Constructivism. However, whereas the older sculptor emphasised the abstract nature of his personages (cf. *Construction on a Fulcrum*), the younger man addresses realistic constituents more forcefully.

Shapiro's flat-roofed sheds and gable-topped houses are familiar, yet disconcerting. Only a few inches high, they appear to be as impenetrable as massive fortresses. The artist's cold walls and minuscule openings hardly induce nostalgic memories of suburban home life. The human-like, stiff-limbed, deadpan figures, especially those with extra appendages, are eerier than an horrifically-dressed scarecrow. At first, Shapiro's world calls to mind the lands Gulliver visited, but his uninhabitable buildings and tumbling creatures are even more frighteningly expressive of our own times. While you recognise formal ideas he inherited from, say, Carl Andre and Donald Judd, you sense a mood of alienation and discomfort shared with the Surrealism of Alberto Giacometti.

'I'm more interested in how one thinks about something than in what something looks like', Shapiro said in 1982. 'I am interested in what a house or a figure might mean, or what it means to me. I am interested in my capacity to refer to it in terms of sculpture, but not to illustrate it or describe it.'

Prudence Carlson **Terry Winters**

In a sense, Terry Winters' work is involved in an empirical – a relentlessly interrogatory – stripping away of the skins of sheer appearance in order to come at some essential structure or some irreducible element of form. Most of his newest paintings both posit and lay bare one simple primary device: a circle suggestive of a cellular or celestial body, the honeycomb's basic hexagonal 'box', a regularly branching plant stalk, a spiral generated by a swift cursive line, a round pod synonymous with a single lick of paint. These devices are themselves again and again broken down to the raw fact of pigment, to instances of skirmish or sudden felicity on Winters' part with his materials. As such, they become building blocks – at once figurative, formal and physical units – from which the entire, wildly mutable and almost always mesmerising universe of his paintings is made. Winters' choice of naturalist imagery is thus in no way haphazard or coy, but profoundly bound up with the way all his works, new and old, are meditations upon the very act of painting. The object, however, of these meditations or explorations locates itself not in process – that endpoint fixed for art by Formalist canon – but in the problematic nature of painted images and of image-making. Frequently pushed to extremes of visual ambiguity and caused to wobble between material chaos, abstract pattern (or structure) and identifiable form, Winters' images address the same concerns as does the art of Guston, Twombly or Johns.

What's at first most blatant and seductive about Winters' works is their adept paint-handling. Winters' versatility in the possible ways of laying down pigment looks back to the formal licences of Abstract-Expressionist art and, like these licences, calls attention to his paintings as tangible, 'real-world' objects. Yet Winters' works take care to sidestep mere objecthood; and, touched by a certain ironic reserve, they also put little credence in subjective expression. The curiously mingled sensuousness, inexpressivity and philosophic thrust of these paintings hinge largely upon Winters' palette and choice of imagery.

In all the earlier and perhaps half of the newest works, Winters' images – rootless plant forms, parts of dismembered flowers, crowds of mushrooms or mollusc shells, schematic crystals – are derived from small, mostly hand-sized, and common-place natural things. Lifted from their native settings, enlarged manyfold, and subjected to an abstracting process superficially imitative of anatomical study, these forms have been rendered vacant, inert, emphatically impersonal. In other 1983/84 paintings (like *Colony* (plate 101)), the abstracting process or activity of 'dissection' has been carried a step further to produce forms so rudimentary that they seem to lie at the origin or, equally, at the anatomised end of material being. Here are blastula-like clusters of tightly packed globes, reticulated membranes made of myriad circles, rude cube shapes, slippery triangles, filamentous lines. Hovering between the organic and the geometric, between raw matter and the simplest of forms, these newer images are anonymous, archetypal. They, too, like Winters' earlier plant forms, have been pared of their contextual husk, emptied of all allusion – including even reference to themselves as natural phenomena – and returned to some ideal, primordial state of perfect potentiality and blankness. If the images' potentiality is drawn out, it is done so guardedly and only at the artist's whim; if their cut-up, repetitive,

desiccated forms are once again quickened, this vitality is expressly an effect of Winters' sinuous paint-handling. Winters' pose of scientific objectivity, reinforced by his use of subdued 'natural' colours (earthen browns, slate blues, a calcium white, an algal green), inhibits his images from escaping into independent pictorial or symbolic life.

As if in proof, though, of these images' capacity alone to generate and sustain a 'world', they are run through many changes. Suspended in paint work that has grown increasingly more mobile, Winters' forms are swivelled, hugely magnified or diminished, continuously superimposed and woven in and out of 'sight', or definition, across the field of canvas. Treated to varying degrees of pictorial completeness (or incompleteness), his images more or less blend into passages of unarticulated brushwork: they may appear inchoate or half-effaced and spectral, as well as full-blown. Winters' works disclose, finally, the presence of a kind of vital figurative substratum to even the most muddy, helter-skelter and incoherent painting. They exhibit the way pigment or 'undifferentiated matter' can both fluidly and tenuously give way to endless chains of mutually complicating, mutually obliterating images. Here, the artist's medium, much like protoplasm or the chaos of myth, is felt to contain any number of past *and* future figures, forms, even systems.

The time evoked by Winters' paintings is thus more than simply the measure of process; it is evolutionary and open-ended. The space, too, of his works is strangely equivocal: at once airlessly close and suggestively boundless, this space warps back from the skin of surface paint through untold strata of revisionary markings and 'imagings'. Winters' paintings emerge, in fact, through a dual process of simultaneous evocation and cancellation – a process that duplicates not only the life history of natural things, but also the restless and incessant flux of thought itself. A meaning does adhere to the artist's simple plant forms and – more clearly still – to his newfound 'cells', spirals, lobe shapes and other structural units. The symbolic import of these anatomised, but always just legible, images lies in that they are tracings of the invisible and most fundamental, self-defining movements of a mind.

Michael Auping **Francesco Clemente**

Francesco Clemente has said he is attracted to painters who claim the position of dilettantes, 'in order to maintain the integrity of their inquiry'. One of the things that most readily distinguishes Clemente from his more systematically-oriented elders, as well as many of his Neo-Expressionist colleagues, is the kaleidoscopic character and scale of his art, both physically and conceptually. Clemente said recently, 'I'm interested in an art that has no scale'. It is, though, difficult to explain exactly why Clemente's eccentric meandering through subjects, styles, medias, formats and sizes maintains an odd but graceful balance.

One should not be surprised if it takes time to 'understand' Clemente's pivoting spray of images. The connections and cross-references between his autobiographical analysis, mutating self-portraits, erotic fantasies and fears and odd anatomical expressions, combined with his fascination for metaphysical systems (Christianity, alchemy, astrology, mythology, the Tarot), all overlayed with his re-interpretation of various artistic sources (ancient, renaissance, surrealist, Hindu, expressionist), creates a labyrinthine field that is not easily deciphered by normal codes of logic. Understanding Clemente's perspective is more a function of appreciating the rhythm and subtle management of these images rather than a step-by-step translation.

Movement and dislocation are the fundamental creative and managerial forces for Clemente. Accompanied by his wife and two children, he has established an essentially nomadic existence by deliberately changing geographic and cultural perspective with an almost disciplined regularity. He maintains 'home bases' on three continents: an apartment in Rome, a house in Madras, India and a studio in New York. This itinerant existence undoubtedly feeds the continuous mutation of Clemente's imagery and techniques. He has created frescoes in Italy (and America), woodcuts in Japan, and handmade paper for Muslim hangings as well as painted miniatures in India. In addition to the numerous drawings and pastels, his output includes paintings, sculpture, mosaics, etchings and photographs. As Edit de Ak has put it, Clemente is 'a chameleon in a state of grace'.

The artist's part-time move to New York elicited the dramatic series *The Fourteen Stations* (plates 115–126). Clemente's interpretation of the subject is as much a human drama of the present as it is an elegy to the past. Instead of the traditional Fourteen Stations, illustrating Christ's experiences on his way to the cross, Clemente has created 12 large canvases that constitute a complex network of autobiographical experience, cultural history and Christian symbolism. Religious imagery mingles with intensely psychological subject matter. He approaches religion as he does art; less as a monolithic set of beliefs and more as a living organism effected by our anxious responses to the everyday realities of life.

The *Stations* could be more specifically interpreted as an expression of his new environment. Each of the works in the series was painted in oil, a new technique for the artist. Created in the winter of 1981/82, he worked on all twelve canvases simultaneously, painting mostly at night. The sombre colours – grey, green, blue, black and white – and turbulent configurations could logically be a function of this process as well as a natural apprehension of the ersatz and often contradictory environment of Lower Manhattan, where his studio is located.

Clemente's art is more symbolic than narrative in character. It is a fluctuating symbolism, however, undergoing constant re-invention: at times reminiscent of the private, witty world of Klee; at other times the more ominous visions of Blake. Clemente's symbols often have an inverted or double-sided quality, figuratively and literally. Certain images (Nos.II and VII) in the *Stations* series are painted so that they can be turned upside down to work with equal effect. Similarly, in the *Stations* catalogue (Whitechapel Art Gallery, London) Clemente created a series of symbolic drawings on transparent paper, some of which are meant to be viewed from either side of the page. Such 'inversions' are common in Clemente's work.

Clemente sees his work in terms of the concept of the ideogram, a slip-stream between language and image. This semi-private language is used in a highly self-conscious analysis of experience. As Carter Ratcliff has pointed out, in Clemente's art 'style blends with iconography, iconography turns into an attribute of a personal style, all gives itself over to the artist's project of devising a self'. Clemente's self-portrait is a central aspect in his art, a ghost-like protagonist staring out at the viewer with glaring almond eyes, wide mouth and short-cropped hair as he moves through a series of arcane dramas with history, art, religion, death, birth and, most intensely, his own psyche.

This self-searching is as fearless as it is wide-ranging. Clemente's imagery reels between global observations and meditations on his bodily functions and desires. Clemente not only openly addresses narcissicm, at times he pushes it to new limits, publicly analysing his fascination with the skin and body orifices. In Clemente's pantheon, however, the sexual and the erotic are simply parts of a larger puzzle and balance the more ominous, seemingly monolithic references in his life: art and religion. There is often a comic side to Clemente's sexual meandering, a feeling for the hilarity and profound uniqueness of the human body.

Clemente's strategy is driven by the permission he gives himself to paint every imaginable image. Ideologically, his work establishes a context in which a search for absolutes would appear pretentious, if not naïve. Clearly, there is a sense of transition and reconstruction in Clemente's art; he approaches the concept of an avant-garde with scepticism. Clemente prefers to think of himself as a 'minor artist'. Indeed a dilettante of sorts, whose itinerant behaviour is protection against the danger of a prescribed logic or expectation.

Lynne Cooke **Richard Deacon, Howard Hodgkin,
Leon Kossoff, Sean Scully, Victor Willing**

Richard Deacon Encountering any of Deacon's sculptures is akin to the rare experience of being
introduced to a stranger, someone whom one could not possibly have met before,
yet feeling convinced, nonetheless, that one has known them. Various aspects of
his work contribute to this impression; first, the intimacy of the relationship
between viewer and object, for however massive they become, the sculptures do
not dominate. It is we who, like Alice, adjust by expanding and contracting to meet
the situation; then, the strong sense each has of a specific persona, such that they
cannot be viewed strictly formally. The kinds of allusion that coalesce and
interweave reinforce this duality of familiarity and strangeness. In *Tall Tree in the
Ear* (plate 138) for example, a large blue silhouette of a bean bisects a silver pear.
The reference to 'ear' in the title seems to pertain both to the shape of the one and
to the volume of the other – yet it describes neither. Simultaneously, the mental
image conjured up by the title seems somehow, though obviously not literally,
realised: as when a sound heard is so striking – makes such an impact – that it
takes on the palpability, the form, of actuality. One imagines one could hold it in
one's hand. This evoking of the absent from the present, of the conceptual from
the concrete, is a recurrent feature of Deacon's work.

References to organs and orifices recur frequently in Deacon's sculpture, the
allusions reverberate in multiple ways. *Two Can Play* (plate 135) is replete with
analogies not only to the sensual and the sexual organs, but to the vegetal as well
as the animal, the man-made and the natural (it could as readily be a trap as a place
of refuge). This tapestry-like condensation of imagery and metaphor is not
dependent purely on the spectator's collusion in a game of imaginative
speculation. The ties are deeper; more determined than contingent. By means of a
lexicon of 'core' forms, including cones, spheres, tubes and pots, Deacon searches
like Rilke, a poet he greatly admires, for (in Rilke's words) 'an innermost language,
without terminations . . . a language of word-kernels, a language that's not
gathered, up above, on stalks but grasped in the speech-seed'. If this underlying
commonality amongst forms accounts in part for the eloquence which is so
striking a feature of Deacon's art, too much emphasis should not be given to the
metaphorical at the expense of the physical.

Deacon admires the manner in which 'the objects that appear in Rilke's poetry,
whilst taking on connotations retain the quality of actuality'. His own practice is
similar for he is above all an object-maker, as distinct from an image-maker or a
craftsman. Such a distinction is, of course, artificial but it does point to the
importance for him of the sculptural object as not just the source but the very locus
of meaning. Galvanised steel is employed in both *Out of the House* (plate 133) and
Art for Other People No.9 (plate 137). In the former it provides the armature onto
which a skin of worn linoleum has been stretched. The techniques employed are
relatively straightforward and unspecialised; the elements are rivetted together
with small brackets, which act like membranes afixing malleable matter to the
skeleton. In *Art for Other People No.9* the sheet metal is skeleton, structure and
tissue: yet it now seems at once organic and man-made, for from one angle the
object recalls an ear, from another a mould. Again, the procedures are
matter-of-fact. Deacon styles himself a 'fabricator' and the materials he chooses,
significantly, are neither rare or precious, nor are they larded with specific

historical and aesthetic references. Their character depends on the specific circumstances in which they have been utilised. Thus, form informs the subject and the allusions are determined as much by the physical matter, the materials and processes, as by the imagery. The versatility with which sheet metal has been employed in these two instances attests to Deacon's engagement with the making and the substance, the raw matter, of each work. Each piece evolves as a consequence of a dialogue between the initial idea and the actual execution of that idea; there is no place for blueprints, preliminary models and maquettes. In his student years, Deacon undertook a number of structured performances in which the materials largely dictated the final nature of the piece. Whilst this is no longer his method, such experiences were to some degree formative. For he creates objects whose very mystery and potency derives from their insistent physicality, their formal presence.

Howard Hodgkin

'One's apprehensions of people are totally indirect . . . I can't think of anything less like visual or physical reality than the traditional portrait.

I want to get the sort of evasiveness of reality into my pictures. I mean, looking at you now, I don't see Ingres' portrait of M. Bertin, for example, because I'm always seeing something else and something more, I might be looking past you or looking at the light falling on parts of you or thinking of you. So it's my idea of you as well as what I see that's in my mind. But this kind of realism which depends also a lot on illusionism is, of course, evanescent, frail and difficult to establish.'
Howard Hodgkin

'A remembered moment', whether of an incident or an individual, constitutes the subject matter of each of Howard Hodgkin's paintings. From the specifics of a situation he makes a pictorial equivalent, one that communicates to the spectator via feelings rather than description. Mimetic illusionism is thus eschewed not merely because it fails to correspond to actual experience as lived, and even less to memory which, typically, is elusive, mutable, fragmented, partial, and varied in focus and in intensity, but because it cannot contain enough, it cannot become that coefficient of experience, perception, memory and emotion which Hodgkin seeks. ' . . . *alla prima* painting doesn't in fact contain enough . . . It only contains as much as you have had time to put down . . . the glancing immaterial quality (I want) has got to refer to a great deal. You need to take in an awful lot for it to have meaning. What takes a long time is to give it meaning, to enclose within it emotions, feelings and obviously a quantity of impressions rather than the single one that one might have been able to include in an *alla prima* beginning.' Thus a painting may take several years to gestate as Hodgkin rephrases, extemporises, ponders, and conjures the seed into a metaphorical blossom.

Since 1970 he has worked on wood, preferring its resilient surface to the more pliant canvas, preferring too its possibilities for repeated working, and the absence of a virgin surface; for with a wooden support the first marks are laid onto something that already has character – just as new experiences, however striking, are always mediated and modulated by previous ones.

The collaged, assembled appearance of Hodgkin's paintings, in which a plane slips to reveal a portion or detail of something otherwise obscured, is the outcome of a protracted series of forays. It corresponds not just to the slipping, glancing nature of viewing interiors in close-up but also becomes an analogue for memory, for its cumulative overlays, its imperviousness to literal time and to separate occurrence as it refracts images and blends, melds and blurs individual episodes. The voyeuristic aspect of earlier works such as *Family Group* (plate 139), where the intimacy is assertive yet the subject matter nonetheless rebuffs interpretation, where the riddling allusiveness teases as it flaunts its privateness, has been tempered in more recent works, such as *Paul Levy* (plate 140), by a greater metaphorical and emotional richness. Because of this heightened intimacy and feeling, the work has become less defensively opaque: it now acts, as one critic has termed it, as a 'transporting reverie'. This poetic image which, as Bachelard says, 'places us at the edge of articulate being', is achieved through an increased

structural complexity, through the deepening tension between pockets of illusionistic space and the flat patterned surface, through the sonorous even luscious harmonies of saturated, refulgent colour, and through the more explicit, more invasive if still succulent marks.

Autobiographical in genesis and sentient in character, Hodgkin's work is nevertheless neither subjective nor expressionist, for he studiously avoids personal marks, a signature touch, in an attempt to ground the work in an objective idiom, recognising that although the painting is to him a correlative for experience, for the viewer the quality of the pictorial resolution is the crucial consideration. Indian miniatures, Matisse and Vuillard have contributed variously to the formation of his pictorial idiom, and he has special affinities with Delacroix, but it is above all to Jane Austen that reference should be made (though Hodgkin's is in no sense a literary art). Both address a world essentially domestic in character, one in which a too great intimacy, an intricate over-familiarity is relieved and made tolerable through the distance provided by studied appearance, artifice and decorum. The glittering sheen of a svelte style clothes the rapier frankness of vision with impeccable manners. The distilled yet latent meaning percolates through this only as innuendo, aside and inflection.

Leon Kossoff

'. . . there is a total absence of idealising in the classic sense . . . The idealising is in the direction of moral qualities, above all of endurance . . . Kossoff has painted his own people, giving them something approaching mythological status.'
Helen Lessore

Coagulated encrustations of paint form not the skin but a viscous matrix, a primal substance out of which life is generated, spawned and extruded by gouging, clawing, delving and incising. This tissue of matter is not the outcome of extensive painting and repainting but of a brief if embattled skirmish: 'Although I have drawn and painted from landscape and people constantly I have never finished a picture without first experiencing a huge emptying out of all factual and topographical knowledge. And always, the moment before finishing, the painting disappears, sometimes into greyness forever, or sometimes into a huge heap on the floor to be reclaimed, redrawn and committed to an image which makes itself.' Within this textured continuum certain images are accorded focal attention, generally by means of illustration and anecdote – and in such a way that both Daumier and Dubuffet are called to mind: Dubuffet in the *faux-naïf* drawing of, say, the little round car in *School Building, Willesden, Spring 1981* (plate 142); and Daumier in the sense of isolated loneliness expressed in physical terms in his images of fleeing figures and of Don Quixote.

But Kossoff's work should be distinguished on two counts. The first stems from the way in which he mixes visual languages: at times illusionistic details cohabit alongside their antitheses: *naïf* and mimetic drawing, flattened surface planes and receding space are juxtaposed: the scale also shifts abruptly and irrationally in places. This unorthodox approach breeds tensions and awkwardnesses. In part they are welcomed as an index to an authentic vision, one which has neither been refined nor tempered by the niceties of stylistic uniformity. By contrast, it suggests that the image has been wrested from intractable matter in a desperate outburst. At times Kossoff seeks to reinforce this humanistic vision by a very calculated composition; the placing of the male profile, more lucid and legible than anything else, in the exact centre mid-distance of *Inside Kilburn Underground, Summer 1983* (plate 144) is one instance of this, another is the couple on the left of *School Building, Willesden, Spring 1981* who, too prominent and too particularised in expression to act merely as staffage, resemble donor figures in an altarpiece who introduce and mediate between the spectator and the scene.

The second way in which Kossoff must be distinguished from Daumier and Dubuffet depends on the fact that he grounds his art in the *genius loci* of a familiar milieu. Speaking of London, the source of all his subjects, the artist surmised: 'The strange everchanging light, the endless streets and the shuddering feel of the sprawling city lingers in my mind like a faintly glimmering memory of a long

forgotten, perhaps never experienced childhood, which if rediscovered and illuminated, would ameliorate the pain of the present.' Kossoff has always painted identifiable sites, unlike the other two for whom the anomie of man's condition was better expressed by placing him in a neutral, void and unspecific environment. If *Inside Kilburn Underground, Summer 1983* alludes to man's isolation in an urban context, in a manner not wholly unrelated to the scenes of similar subjects painted in New York in the 1930s by artists such as Raphael Soyer and Mark Rothko, the intent is altogether different. For Kossoff is not interested in social observation *per se* but attempts in his art to make restitution, to repair, not merely to acknowledge a state of being. And this is revealed as much in the process of painting as in the surface effects.

Before commencing a painting Kossoff is already deeply familiar with his subjects, both through daily contact and his numerous preliminary drawings. The subjects are evoked on the canvas and then, in a set of actions which may be repeated many times, they are dissolved, dismembered, obliterated and returned to inchoate matter, to chaos and incoherence, in a process in which he risks destroying them forever. If dramatically restored, reborn, they are all the more valued for the very fact of having undergone this process of loss and renewal. If this act of redemption conveys religious allusions it is not inappropriate, for it recalls the ritual by which an adult initiate is accepted into certain fundamentalist sects. Having been fully immersed in the cleansing water the figure emerges, dramatically new-born into an ecstatic emotive union with his brethren. On another and more telling level this process of adjustment and recovery might be compared to the activity of the child (described by Freud in *Beyond The Pleasure Principle*) who tirelessly repeated games in which he threw away his toys (a gesture that was only sometimes followed by the equally pleasing experience of having them restored) in an endeavour to master that sense of loss and isolation which is an inevitability of human experience. Though similar in implication, Kossoff's discussion of his practice is couched in more strictly aesthetic terms: 'Drawing is not a mysterious activity. Drawing is making an image which expresses commitment and involvement. This only comes about after seemingly endless activity before the model or subject, rejecting time and time again ideas which are possible to preconceive. And whether by scraping off or by rubbing down, it is always beginning again, making new images, destroying images that lie, discarding images that are dead. The only true guide in this search is the special relationship the artist has with the person or landscape from which he is working. Finally, in spite of all this activity of absorption and internationalisation the images emerge in an atmosphere of freedom.'

Thus Kossoff cannot be considered an expressionist in any orthodox sense: he is not so much involved with realising his emotions in response to a particular scene or situation as with showing us the world as it is – that is, as he knows it – and, simultaneously, showing it to us remade, and remade in such a way that its essential fragmentation and isolation are, however temporarily, counteracted – overcome if not negated – in the enmeshing, enfolding, embalming viscous material that literally and metaphorically generates the subject matter, our world.

Sean Scully

'It's romantic to make art, and the more extreme or idealistic it becomes, the more romantic. Some people think paintings have to be very gestural before they're romantic. I think they have to be very extreme . . . I'm using a method that is visually conclusive, which at the same time releases feelings, without giving up classical structure.'
Sean Scully

In mid-1978, at the time of this statement, Sean Scully had just exhibited a series of duo-tonal greyish-black thinly striped paintings which only imperceptibly differed from one another. Aligned with Minimalism on account of the reductivist appearance, Scully was probing its potential for a more transcendent content – albeit in the wake of Brice Marden. If Barnett Newman's painting had been a major force behind burgeoning Minimalism, it was Ad Reinhardt's aesthetic that more nearly presaged its theoretical stance. Scully's work of the late 1970s might be said

to have inverted this relationship. With its muted, regular, repetitive composition, its extreme optical complexity arising from nuanced relationships between unnameable close-valued colours, its holistic structure which eschewed internal sub-divisions, and its assertive objectness, it recalled Reinhardt's art, whereas in its refusal to expunge all intimations of something beyond sheer facticity it affirmed its lineage from Newman. But the content remained stochastic rather than revealed, just as Scully's aims had not fully crystallised: '. . . most art that calls itself abstract is abstract only because it doesn't have people in it, but that isn't abstract at all. Abstract art is to do with dialogue that addresses itself to the internal universe; it transports you and informs you.'

By 1982 his work had changed significantly, through the introduction of a high-keyed palette, wider stretchers, inset panels which modified not only the unitary all-over structure but the strictly rectangular format, bolder thicker stripes and, appropriately, a more expressive finish. Where previously he had permitted only minor irregularities and imperfections that arose during the making to inflect the precisionist surface, the handling now became looser and more emotive. The content, too, was less vague; more dramatically focused and more emotionally charged. In certain respects these paintings are reminiscent both of Stella's coloured stripes as in *Seward Park* of 1958 and of those paintings such as *Hyena Stomp* (1962) notched and shaped by the dictates of a repeated internal configuration. But the implacably secular character of Stella's art is far removed from the spiritual tone that now permeates these paintings in an authoritative manner. It imparts a distinctively individual timbre, one that over-rides any formal borrowings, as seen for example in *The Bather* (plate 145) which seems to be at once both an abstract paraphrase of, and a homage to, Matisse's *Bathers By A River. The Bather* demonstrates the way in which Scully's maturity has been won from synthesising diverse even discordant aspects of his earlier work. The baroque dynamism and grandeur draws on the hectic activism of the space lattices of the mid-1970s as well as the imposing rigour of the later near-monochromes. A new understanding of the potential of light to generate metaphysical meaning replaces the former concern with an iconic, hieratic presence, generated by the symmetrical, impassive unitary formats. On account of the optical activity, the 1970s paintings were perceptually demanding: if the tonal and colour relationships were understated, the light was subdued; if vividly active, it was dazzling. In the recent works the lighting is increasingly eloquent. More subtle in type and in intensity, it draws attention from the formal aspects to questions of subject matter.

The notion that God takes on concrete form in the guise of light is an ancient one, and one which has often leant itself more satisfactorily to abstract than to representational embodiment: compare, for example, the rose windows at Chartres with Holman Hunt's *Light of the World* in Keble College Chapel. In the twentieth century it is possibly Barnett Newman who has most tellingly explored this idea. In Newman's work luminosity usually derives from the affective nature of large expanses of a single hue, from the tonal relationships and from colour symbolism. By contrast, in Scully's paintings light has a visceral immediacy because it arises direct from the colour relationships (as in Matisse). It has also become less disembodied, in keeping with the resolutely physical character of these multi-panel structures, the palpable material quality of the paint itself and the assertive monumentality. By means of this resonant luminosity *By Day and By Night* (plate 146) indicates an opening out of ways to convey significant spiritual meaning. As Scully said recently of abstract art: 'Nobody challenges its religious power, but they challenge its narrowness. I don't think it will always be that way; it should become broader and broader . . . And that's what I intend to try and do.'

Victor Willing

'Once we accept the artist as a hero we also look in his work for a lead outside art, an indication of some course of audacious action or commitment. Finding himself called upon to give a sign which will, he knows, be interpreted in moral or political terms, the artist may accept this respect as his due and replan the world to his taste, or, in his panic, simply point ahead in the direction that he happens to be running, or, aware that there is a mistake and the situation is getting out of hand, retire and leave his telephone unhooked. Once alone, he will invent a game to pass the time.'
Victor Willing, 1956

Of the three alternatives facing the artist as he saw it, Victor Willing seems to have opted for the third. Portentous if enigmatic structures, monuments in disquietude, feeble gestures against the baleful passage of time comprise the imagery of much of Willing's art since his return to London in 1975. The Egypt where he spent his first five years was an idyllic ambience of lush vegetation and dazzling light, a world that was virtually restored to him in the halcyon environment outside Lisbon where he lived for almost twenty years from 1956. But in contrast to the natural paradise, in Egypt he would also, however unconsciously, have been made aware of the ravages of time on civilisations; for few cultures have made a more concerted and heroic stand against both erosion and destruction than the ancient kingdoms of the Nile. However indirectly, these experiences seem to have had an impact on his work of the past decade.

Although on moving to Lisbon he had begun painting regularly, circumstances gradually pushed painting to the fringes of his daily life, so his resumption after his return to Britain can, as he says, be seen as a second birth. What is remarkable about this resurrection is the way in which he has emerged fully formed, without the usual preparatory period of finding a subject and an idiom, and in virtual isolation from the contemporary context. One factor which contributed significantly both to his maturity and his independence was the process by which he arrived at his subjects. Protracted periods of insomnia produced a hitherto inexperienced ability to dream whilst awake – but 'dream' is hardly the right term for an experience which was more akin to reverie, a deep yet conscious imagining. Willing discovered that the images conjured up during these bouts had a forcefulness and pertinancy that made him want to retain them. He began to draw them, to note them down in an endeavour to capture some relic, some witness to their existence. But drawing did not really suffice. It was only when they were painted that they regained that palpability and scale, the flavour of the original experience. While the earliest of his paintings evolved in this manner, the more recent ones have been deliberatively constructed, a change in procedure that has, however, produced no marked shift in his work.

Although these images correspond to specific inner states or feelings, they in no way mirror or describe them. Rather, they are poetic images like those which for Bachelard, a writer whom Willing much admires, generate reverie. The format they take, the philosopher argues, is that of a tableau – they are not extracted from narrative or dramatic episodes. These silent, static images reverberate in the spectator's mind arousing memories at the same time as they initiate further musing. In *Navigation* (plate 147), as in many of the paintings from the late 1970s, this tableau aspect is particularly marked. The scenario is imbued with a prescient expectancy, as if the protagonists are but momentarily off-stage. The scale is at once cosmic and domestic, the grandeur of the theme subtly tempered: against the timeless images of the suspended ball and the mysterious pool of light cutting the circle, the coffee mug strikes a mundane note. Characteristically, the images hover tantalisingly on the fringes of myth and ritual, but being neither straightforward nor explicit the allusions become all the more resonant.

By demonstrating that the fantastic creature of *Griffin* (plate 148) is not in fact supernatural but must be artificially fabricated, Willing alludes to those procedures whereby we first construct our idols and gods, or borrow them from elsewhere, and then try to suspend disbelief in order that they fulfill their desired function. But the coherence and cohesiveness which appertain in a world actually shaped by a unified system of belief cannot be won in this way. It is the

39

unassuagable wish for such wholeness which accounts for the insistent note of yearning that informs all Willing's work. It contributes also to the nostalgia, a sentiment which he defines as a 'longing for an impossible continuity', that suffuses his vision.

Though an image like the serpentine *Knot* (plate 149) might be monumental, the mood never becomes rhetorical. As in so many of Willing's works the meditative rather than tragic aura derives from the combined effect of the sensuous loose brushwork, the abbreviated but fluent line and the resonant colour harmonies which bathe the scenes in a tranquil if mysterious light. His finest works, like *Callot Harridan* (plate 150), bring to mind those melancholy isolated shots that occur in certain Fellini films like *Amarcord* (in which the grotesque has given way to pathos), where the itinerant players have wandered with a languorous fatalism out of the camera's range, leaving the world (perhaps) temporarily uninhabited, waiting, silent. But in Willing's work the fugitive is, paradoxically, robust; it has a palpable, sensate presence far removed from the evanescent intangible light that in fact constitutes the screen image. Writing about another painter over twenty-five years ago, Willing described the type of artist he himself has now become: 'If the baroque flourish is bravura, the courage of the man who does not care, in the rococo it is the flourish of the man who is beyond caring. He is the introverted exhibitionist, a sophisticated clown, a giggling courtier, the dandy on a battlefield . . . The rococo artist will hint at sinister acts while using all the grace and decoration suitable in a lover's pavilion. He arouses our suspicion but declines to tell us how to react to the things he hints at. His evocations are free of moral injunction, he is concerned only with trapping rumours of disaster hanging like smoke in a garden.'

Plates

Dimensions are given first in inches, then in
centimetres.
Height precedes width precedes depth, unless
otherwise indicated.

JENNIFER BARTLETT

1
17 White Street
1977
Enamel, silkscreen grid, baked enamel on 12 in.
(30·5 cm) square steel plates
Overall: 116×116 (294·6×294·6)

JENNIFER BARTLETT

2
22 East 10 Street
1977
Enamel, silkscreen grid, baked enamel on 12 in.
(30·5 cm) square steel plates
Overall: 38×129 (96·5×327·7)

JENNIFER BARTLETT

3
At the Lake
1978
Enamel, silkscreen grid, baked enamel on 12 in.
(30·5 cm) square steel plates, oil on canvas
Overall: 77 × 188 (195·6 × 477·5)

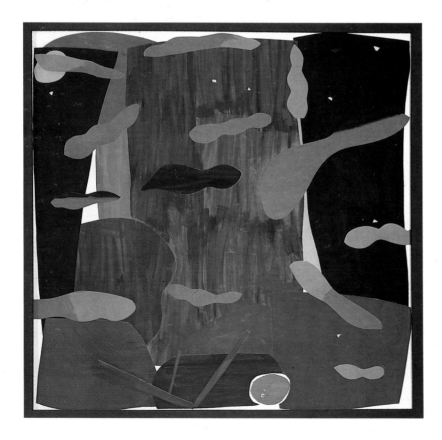

Detail

JENNIFER BARTLETT

4
The Garden (three views)
1981
Installation in 9 parts:
Charcoal on paper
Frame: 73¼×81¼ (186×206·4)
Plaka on plaster wall
96×171¾ (244×436·3)
Ceramic tiles on plaster wall
96×60 (244×152·4)
Enamel, silkscreen grid, baked enamel on 12in
square steel plates
88¾×101 (225·4×256·5)
Oil on canvas
90×78 (228·6×198)
Enamel on glass
93×48 (236·2×122)
Glass (above window)
10×81 (25·4×205·7)
Mirror (below window)
31×81 (78·7×205·7)
Oil on mirror
93×49 (236·2×124·5)
Plaka on paper collage mounted on canvas
Plaka on wood frame
84¾×88¼ (215·3×224·3)
Lacquer and enamel on 6 wood panels
Screen: 72×126 (183×320)

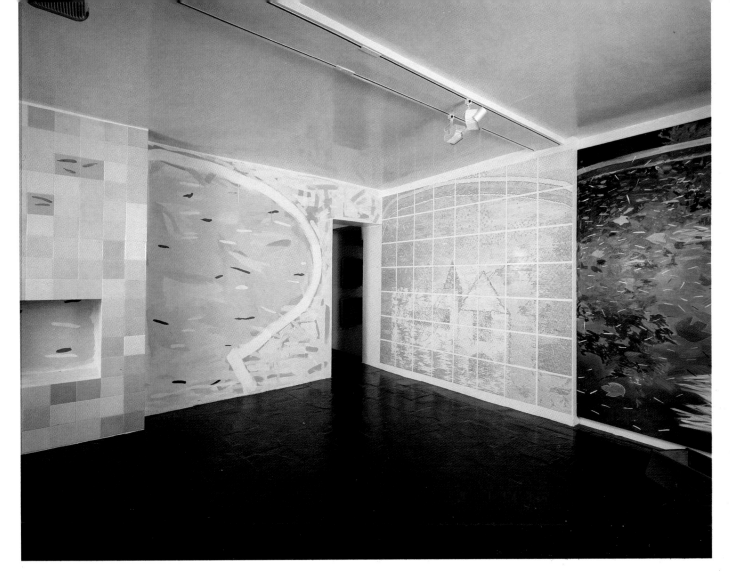

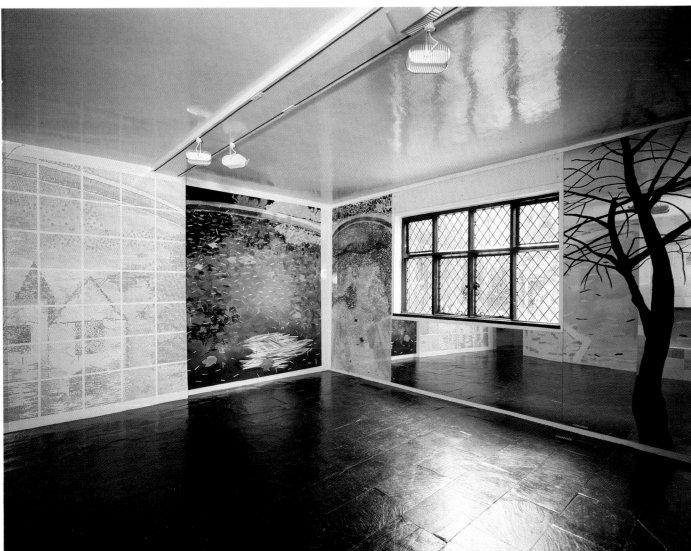

JONATHAN BOROFSKY

5
Tilted Painting No. 7
1975
Charcoal on canvas
49×56 (124·5×142·2)

JONATHAN BOROFSKY

6
Canoe Painting at 2,491,537
1978
Acrylic on masonite
2 panels: 92½×59 (235×150)

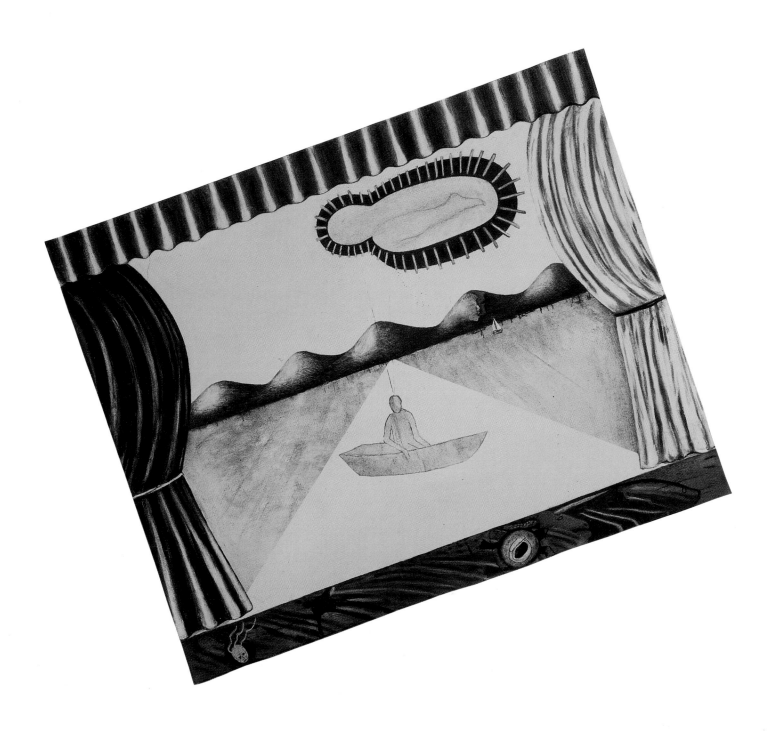

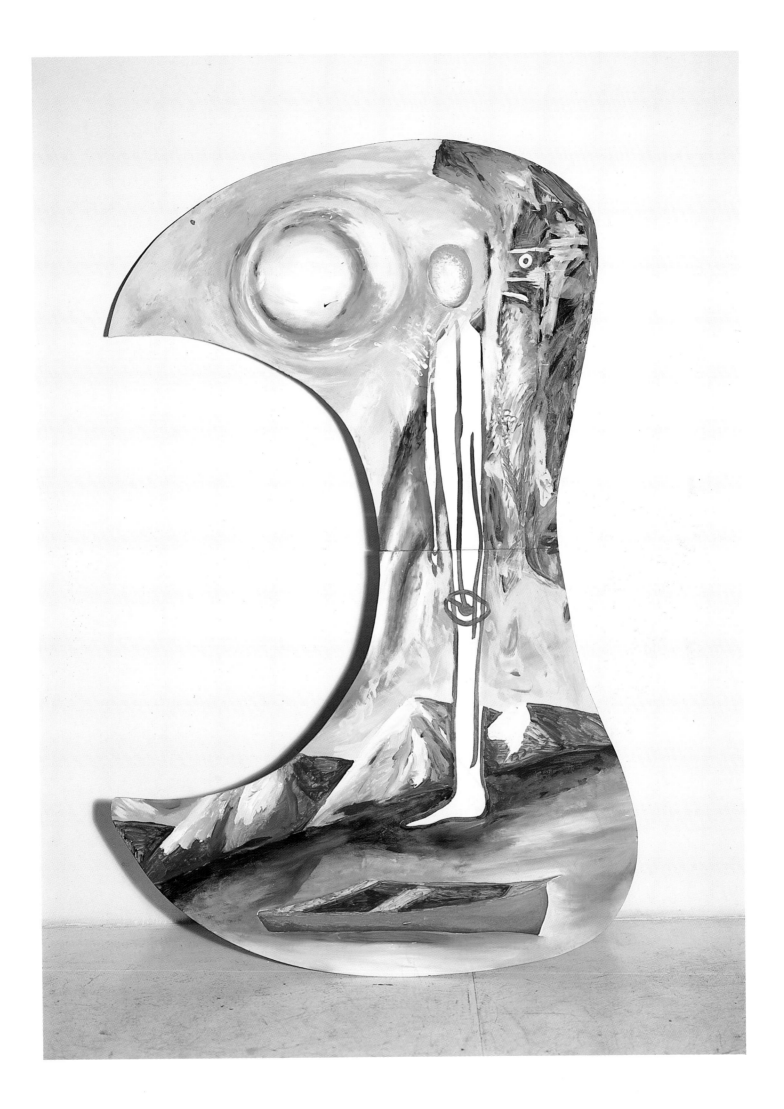

JONATHAN BOROFSKY

7
Running Man at 2,550,116
1978/79
Acrylic on plywood
89¹/₂ × 110¹/₄ (227·3 × 280)

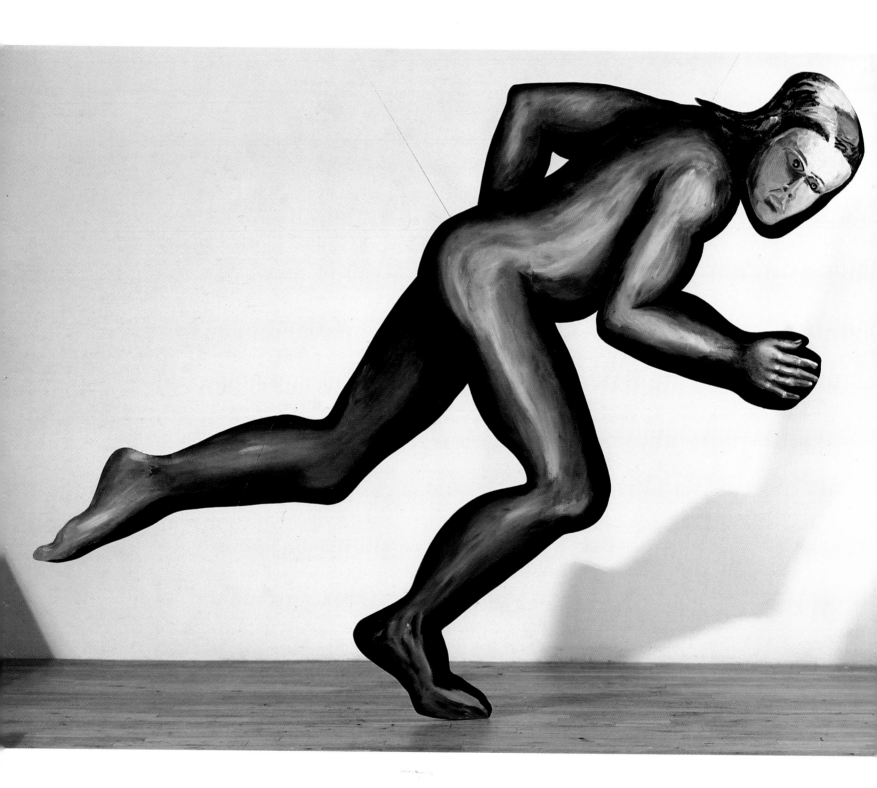

JONATHAN BOROFSKY

8
Motor Mind at 2,559,701
1978/79
Dayglo paint on masonite, sheet aluminium, motor
70×37 (178×94)

JONATHAN BOROFSKY

9
**Portrait of Descartes (after Frans Hals) on 4
Surfaces at 2,673,049** (two views)
1980
Acrylic on shaped canvas
70×52×30 (178×132×76)

JONATHAN BOROFSKY

10
2,841,780 Painting with Hand Shadow
1981/83
Acrylic on canvas, light mounted on wall behind canvas
109×83 (277×211)

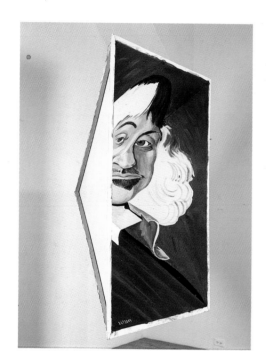

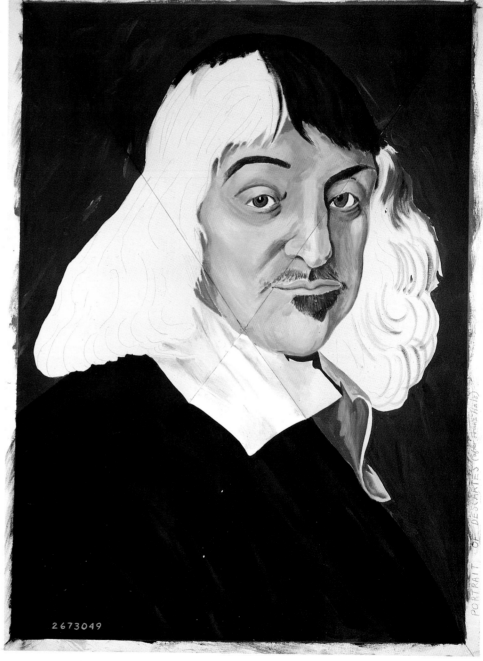

SCOTT BURTON

11
Black Lacquered Table
1975/77
Lacquered wood
30×36×36 (76·2×91·4×91·4)

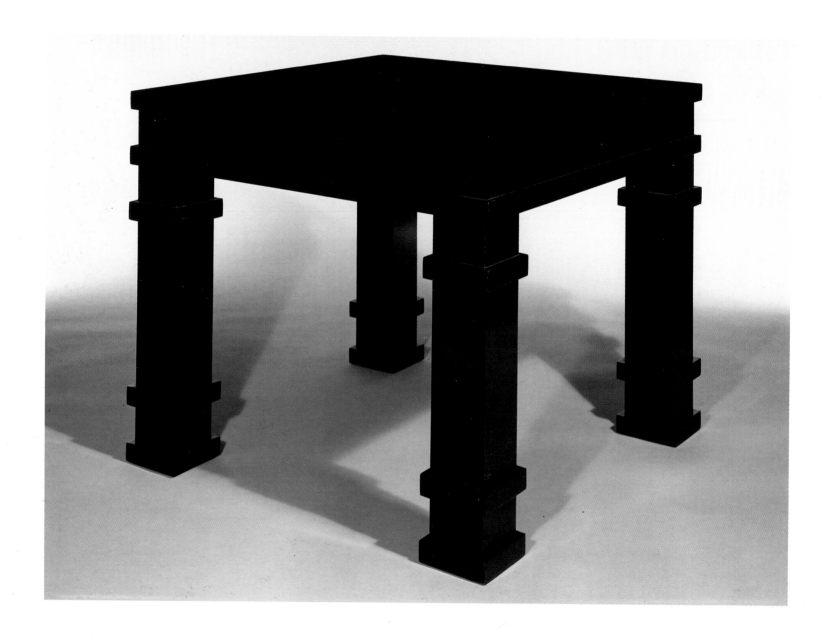

SCOTT BURTON

12
Child's Table and Chair
1978
Lacquered wood, fabric, foam rubber, steel and
brass
Chair: 27×12×12 (68·6×30·5×30·5)
Table: 21×22×17 (53·3×55·9×43·2)

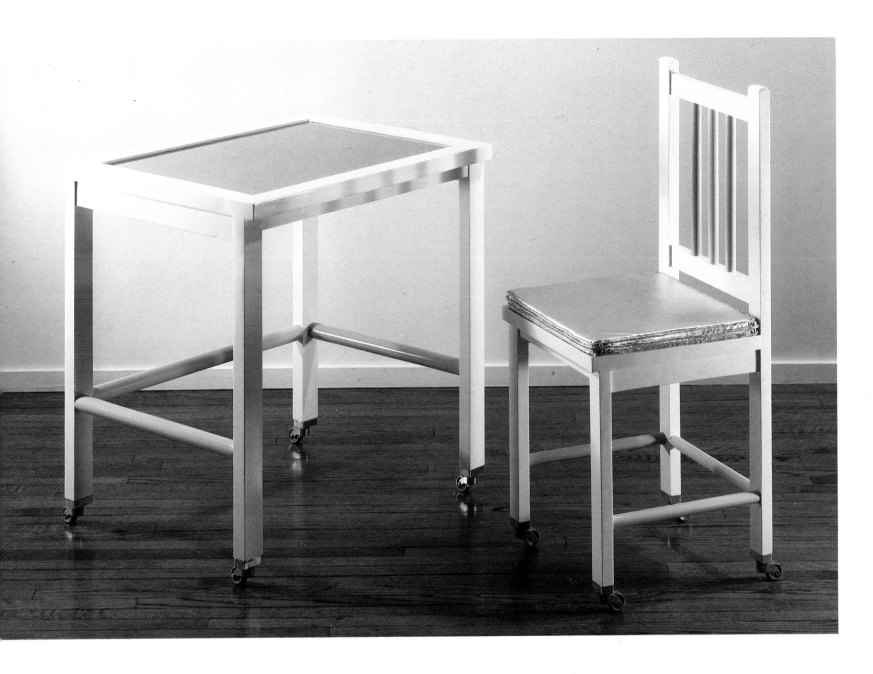

SCOTT BURTON

13
Rock Chair
1982
Orange-red lava stone
42×45×54 (107×114·3×137·2)

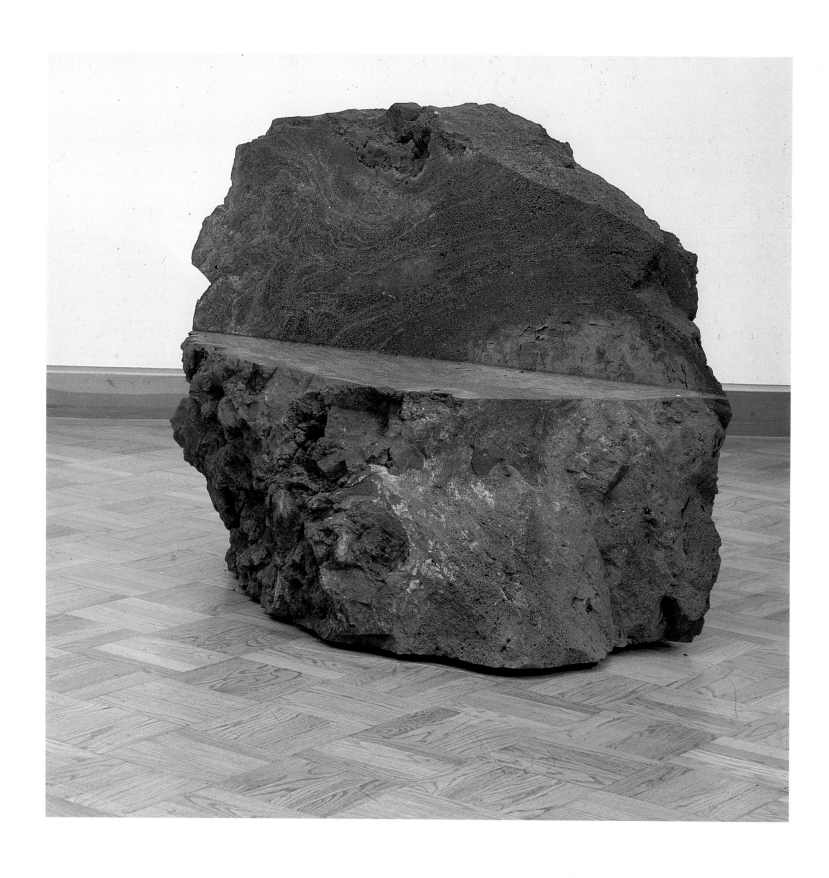

SCOTT BURTON

14
Rock Chair
1982
White lava stone
48×40×36 (122×101·6×91·4)

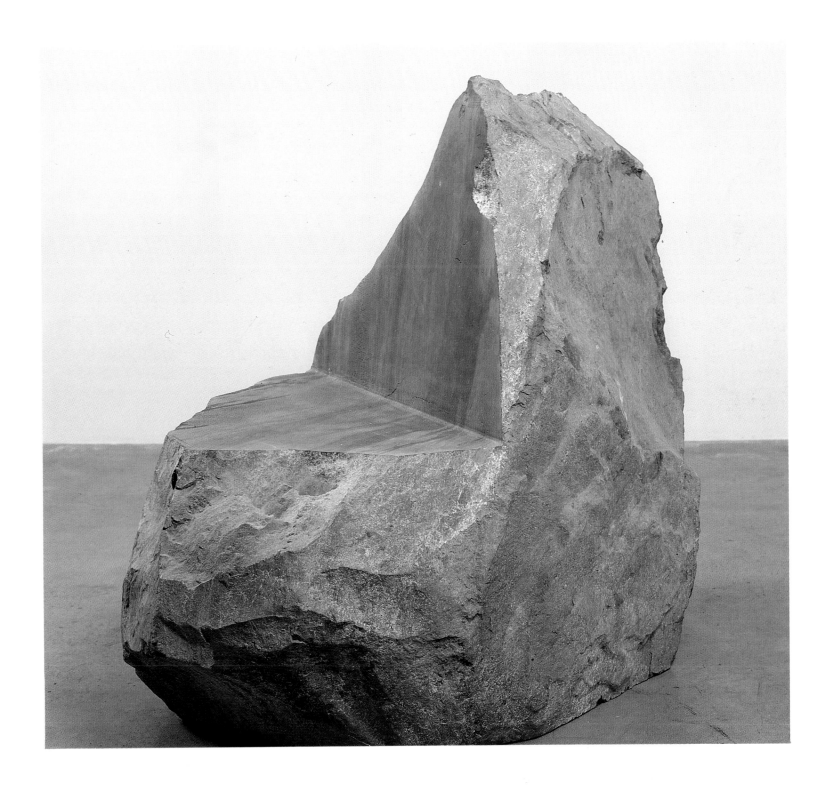

SCOTT BURTON

15
Onyx Table
1978/81
Onyx, steel armature, fluorescent light
29×60×60 (73·6×152·4×152·4)

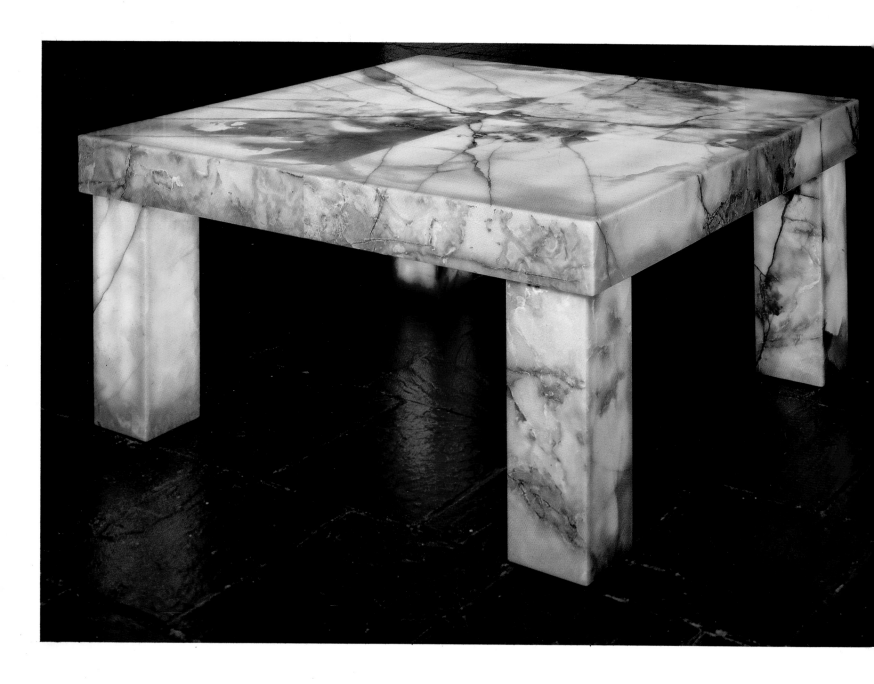

SCOTT BURTON

16
Chaise Longue
1983/84
Rosa Baveno granite
3 parts, Overall: 41½×24×67 (105·4×61×170·2)

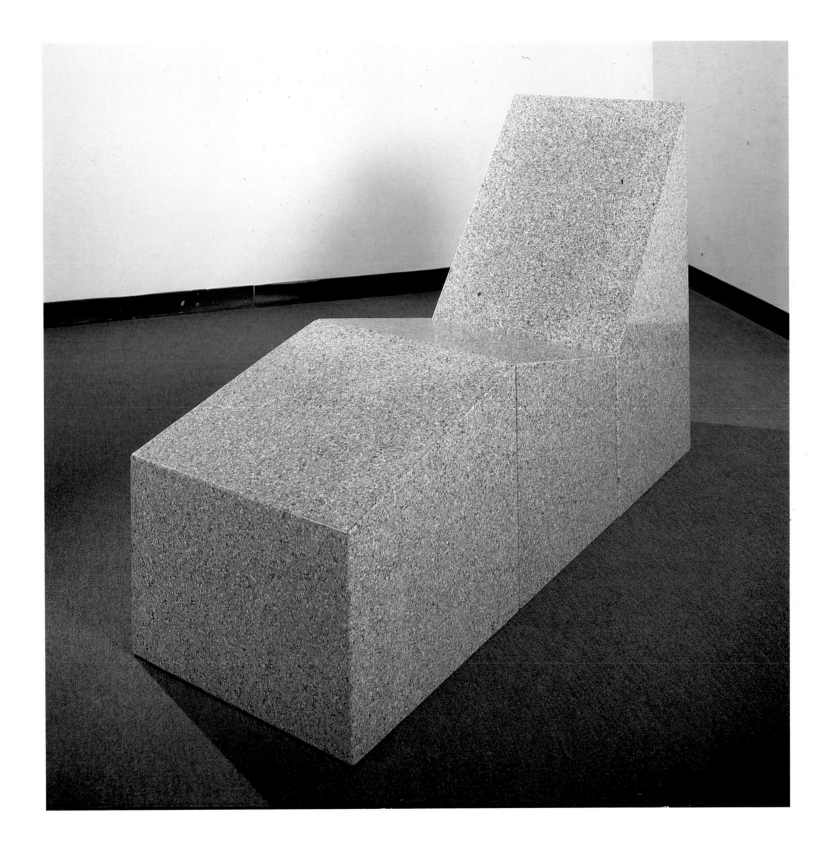

CHUCK CLOSE

17
Joe
1969
Acrylic on canvas
108×84 (274×213)

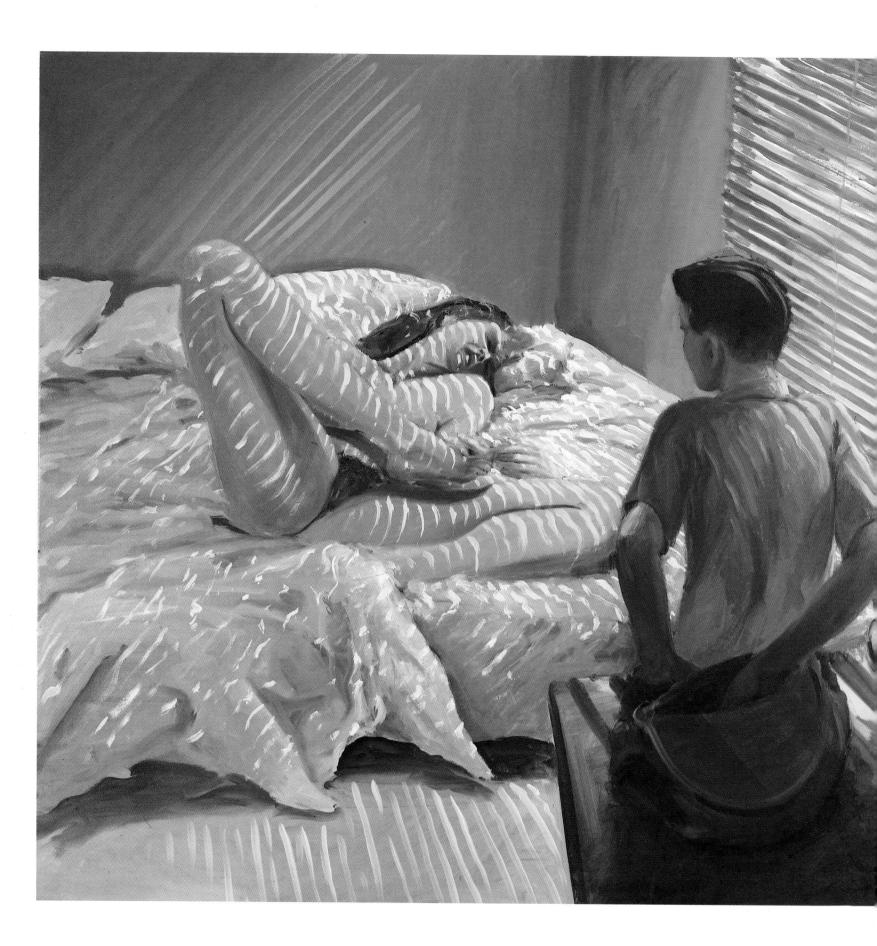

ERIC FISCHL

18
Bad Boy
1981
Oil on canvas
66×96 (168×244)

ERIC FISCHL

19
The Old Man's Boat and the Old Man's Dog
1982
Oil on canvas
84×84 (213·4×213·4)

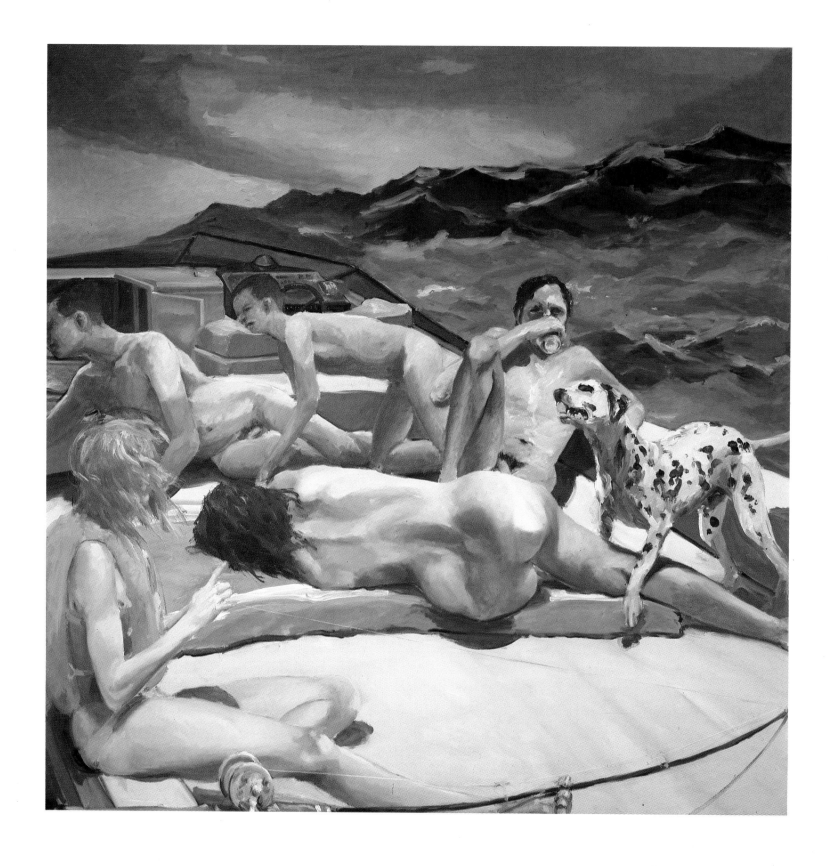

The Old Man's Boat and the Old Man's Dog

LEON GOLUB

21 (following page)
Mercenaries IV
1980
Acrylic on canvas
120×230 (305×584)

LEON GOLUB

20
Francisco Franco (1975)
1976
Acrylic on unprimed linen
20×17 (51×43)

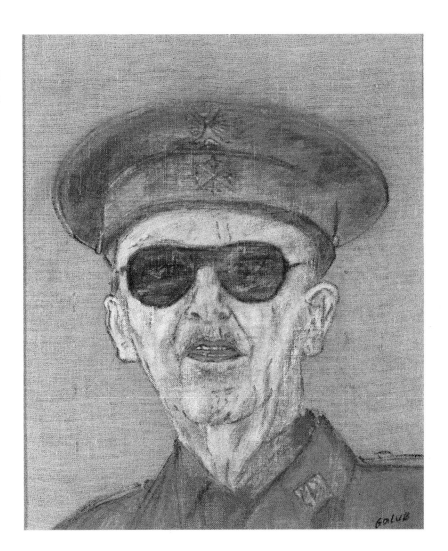

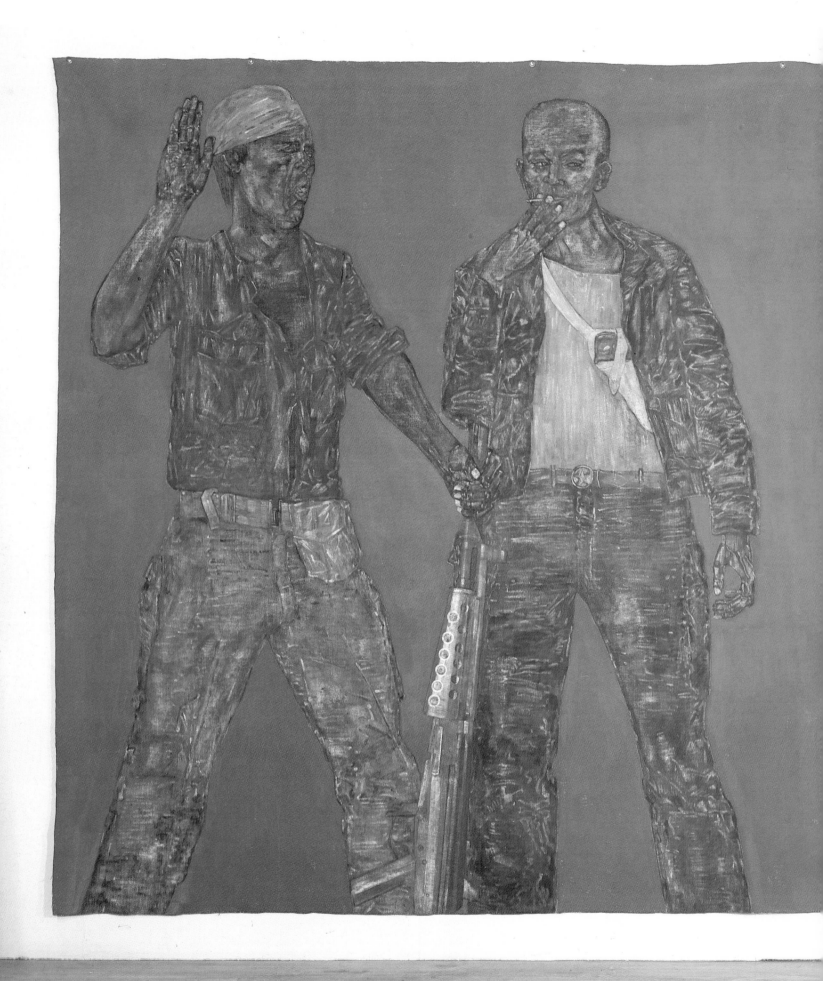

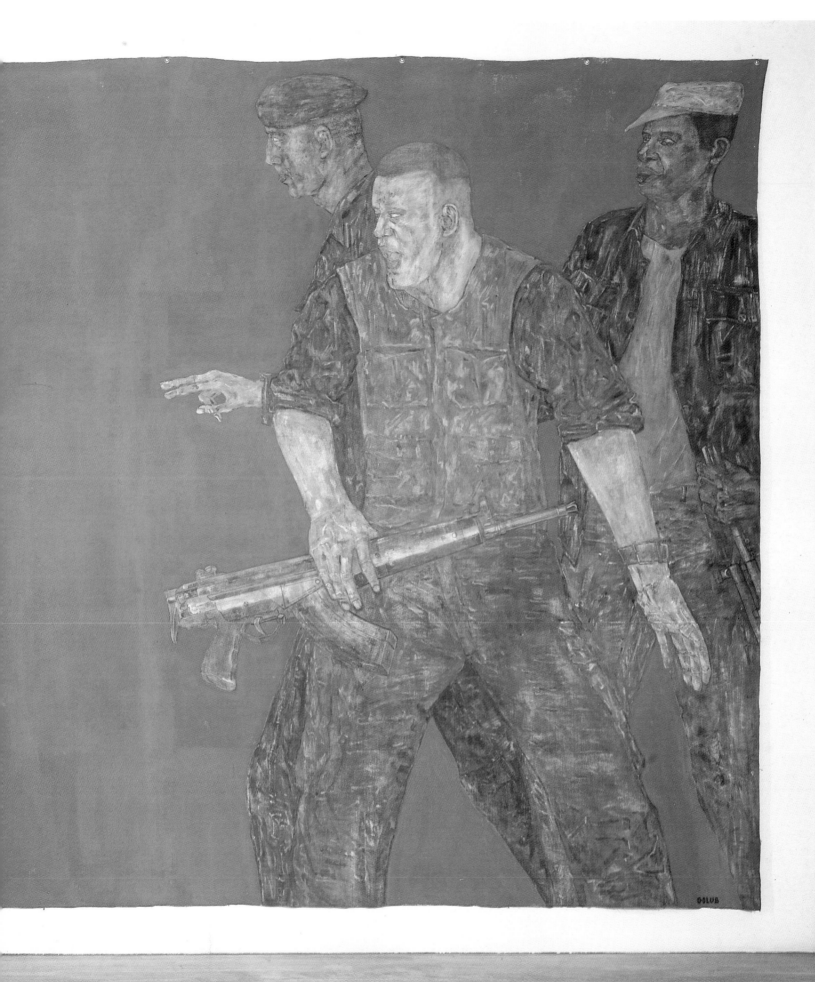

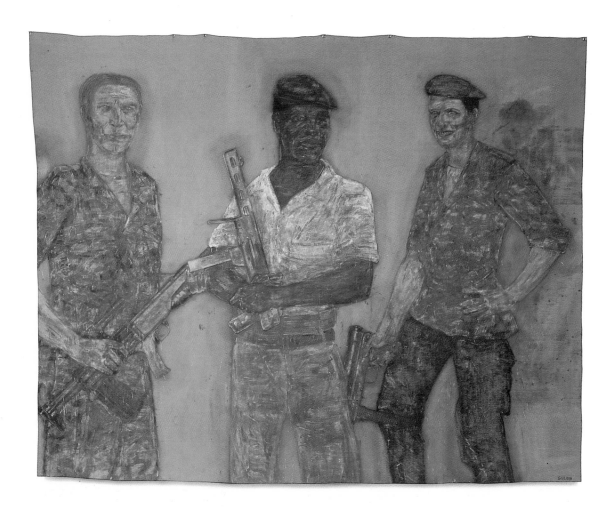

LEON GOLUB

22
Mercenaries I
1979
Acrylic on canvas
120×164 (305×416·6)

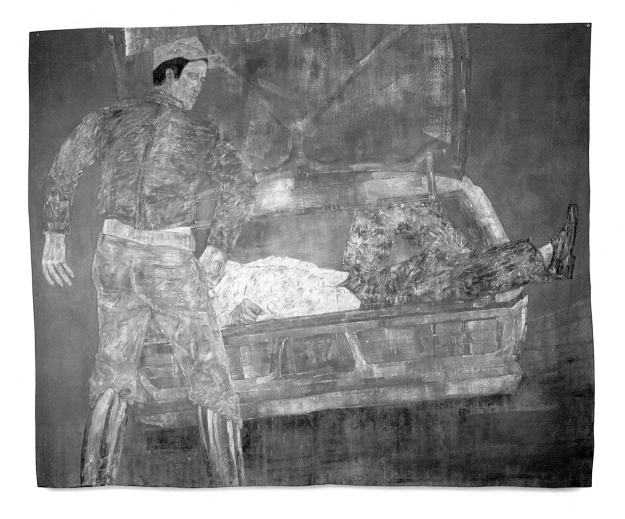

LEON GOLUB

23
White Squad (El Salvador) IV
1983
Acrylic on canvas
120×152 (305×386)

LEON GOLUB

24
Mercenaries V
1984
Acrylic on linen
120×172 (305×437)

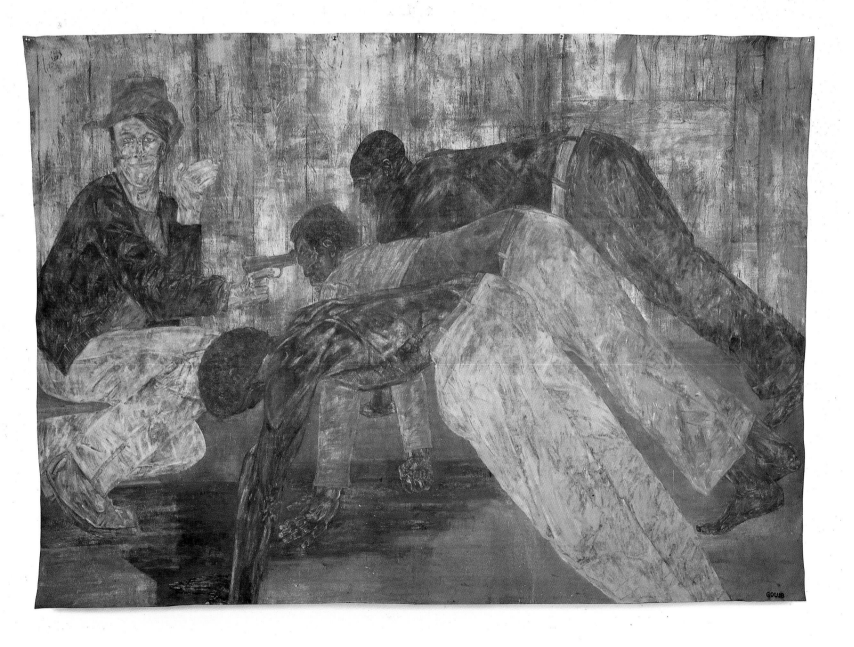

NEIL JENNEY

25
Forest and Lumber
1969
Acrylic on canvas
58¼×70¼ (148×178·4)

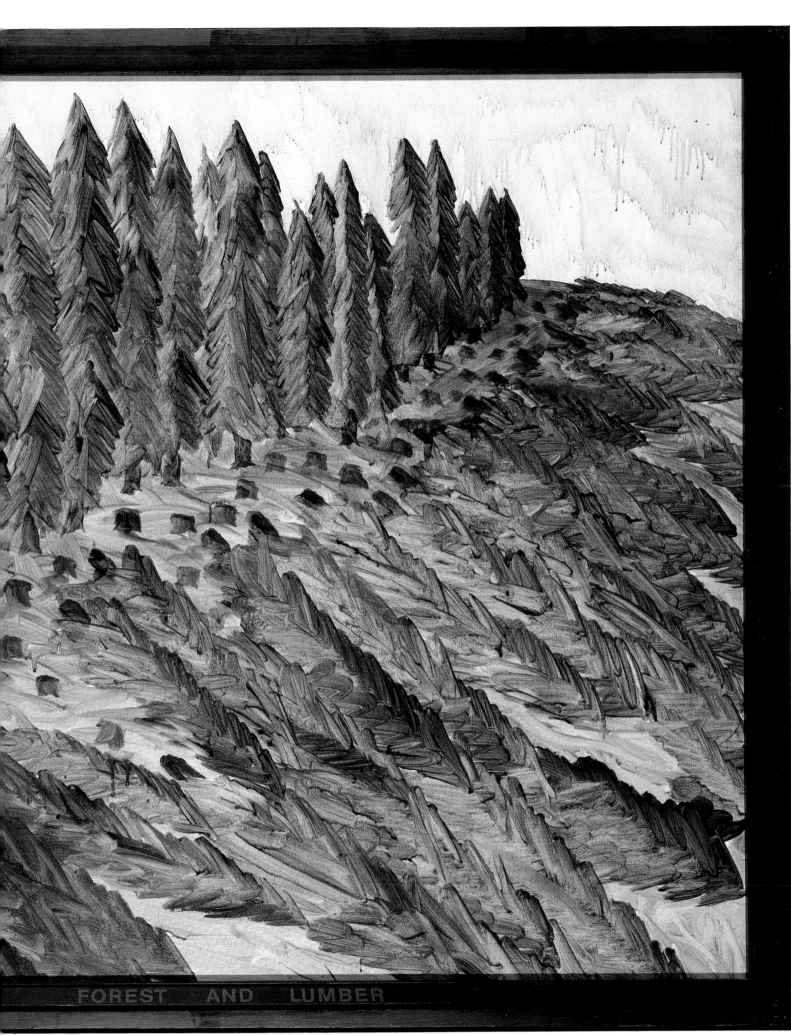

FOREST AND LUMBER

NEIL JENNEY

26
Loaded and Unloaded
1969
Acrylic on canvas
58¼×70¼ (148×178·4)

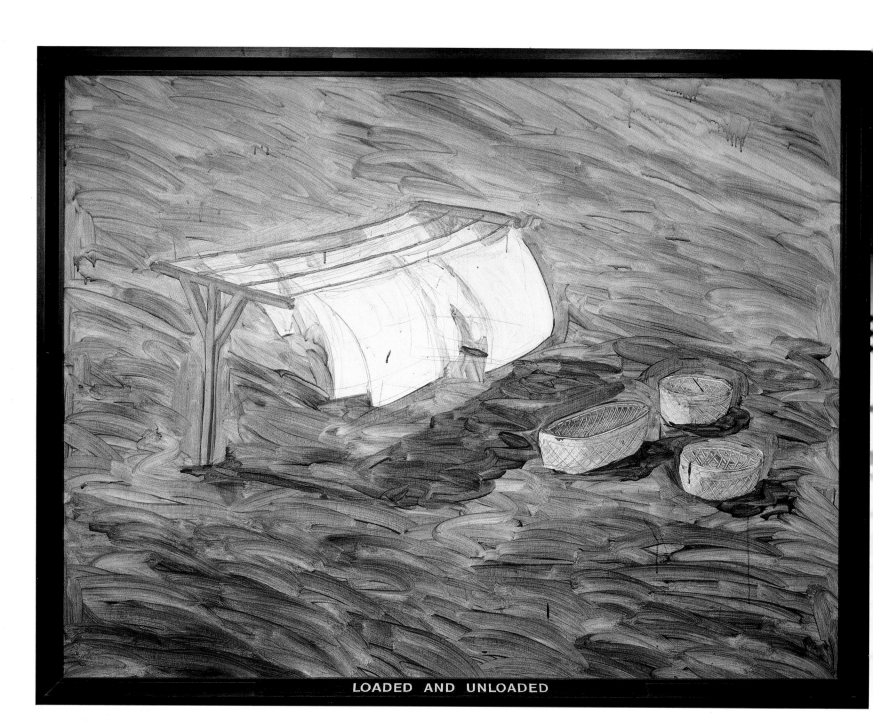

NEIL JENNEY

27
Man and Machine
1969
Acrylic on canvas
58×70 (147×178)

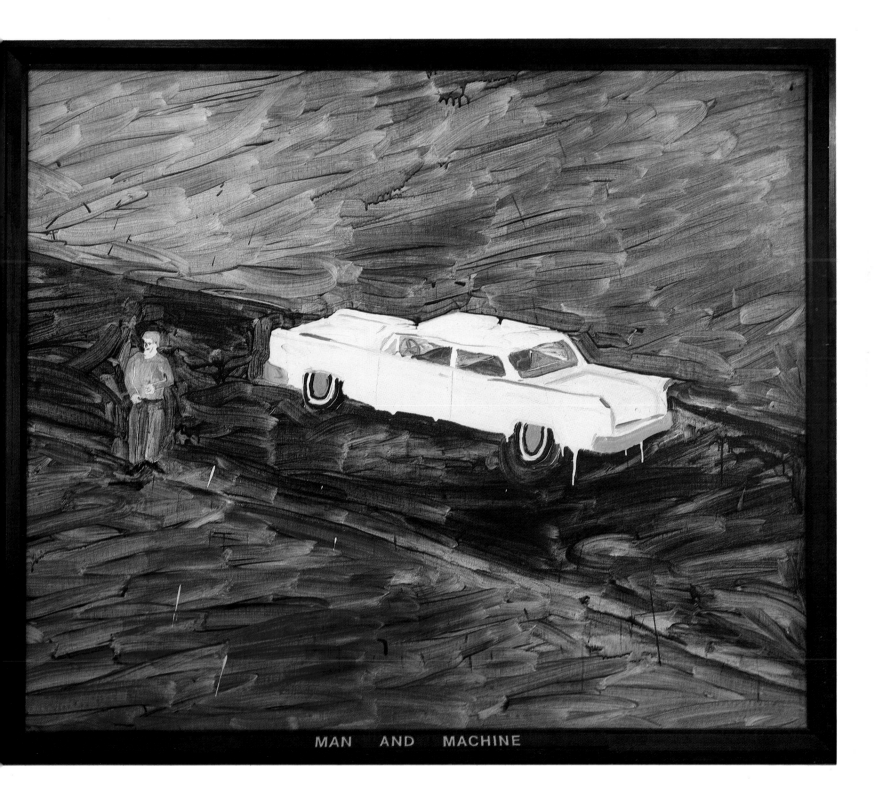

NEIL JENNEY

28
Window No. 6
1971/76
Oil on panel
39³⁄₄ × 57¹⁄₂ (101 × 146)

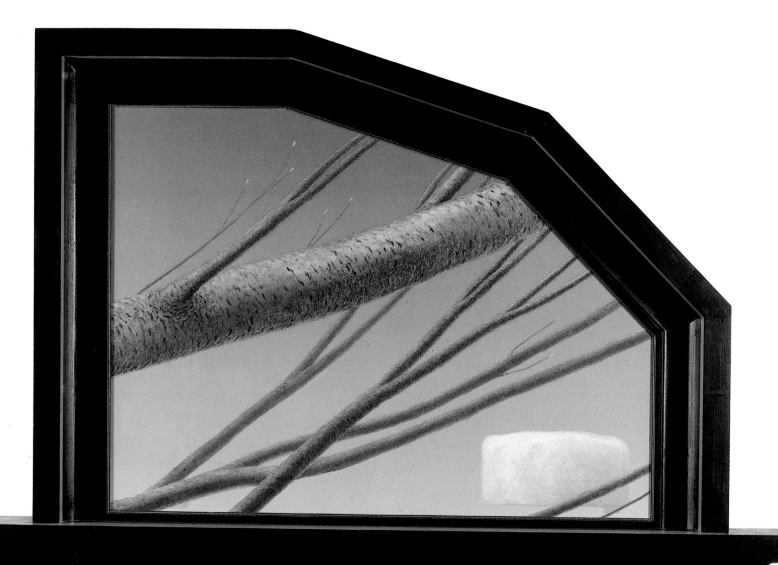

NEIL JENNEY

29
Atmosphere
1976
Oil on panel
36½×67 (92·7×170·2)

BILL JENSEN

30
Claude
1979
Oil on linen
23×16 (58×41)

BILL JENSEN

31
Guy in the Dunes
1979
Oil on linen
36×24 (92×61)

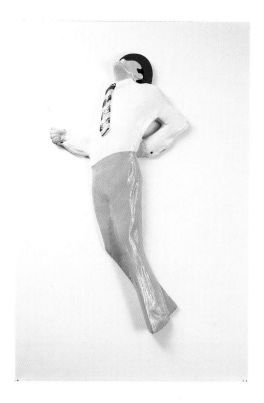

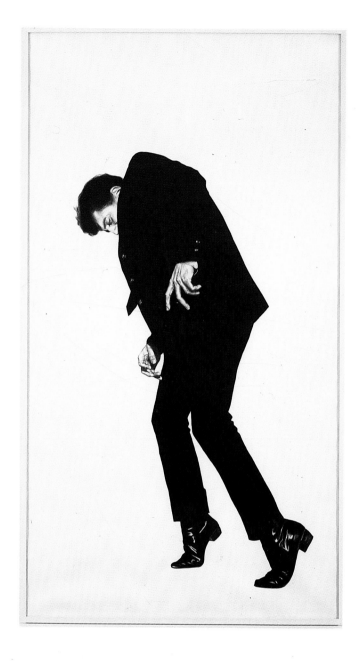

ROBERT LONGO

32 (above)
American Soldier and Quiet Schoolboy
1977
Enamel on cast aluminium
28×16×5 (71×40·6×13)

33 (right)
Men in the Cities
1981
Charcoal and graphite on paper
96×60 (244×152·4)

34 (below)
Men Trapped in Ice (triptych)
1979
Charcoal and graphite on board
Each panel: 60×40 (152·4×101·6)

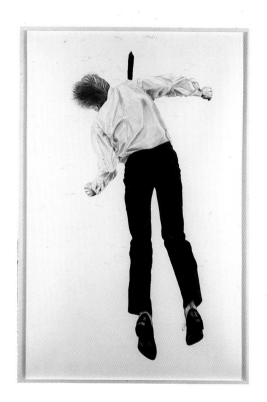

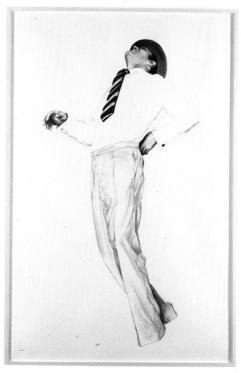

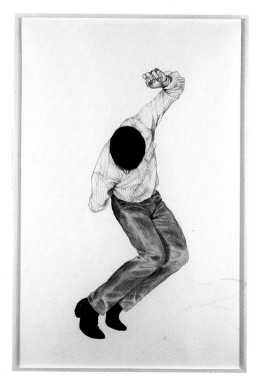

ROBERT LONGO

35
Corporate Wars: Walls of Influence
1982
Cast aluminium bonding, lacquer on wood
Each side panel: 108×60 (274×152·4)
Central panel: 108×84 (274×213·4)
Overall: 108×312×48 (274×792·5×122)

ROBERT LONGO

36
Tongue to the Heart
1984
Acrylic and oil on wood, cast plaster, hammered
lead on wood, durotran, acrylic on canvas
136×216×25 (345·4×548·6×63·5)

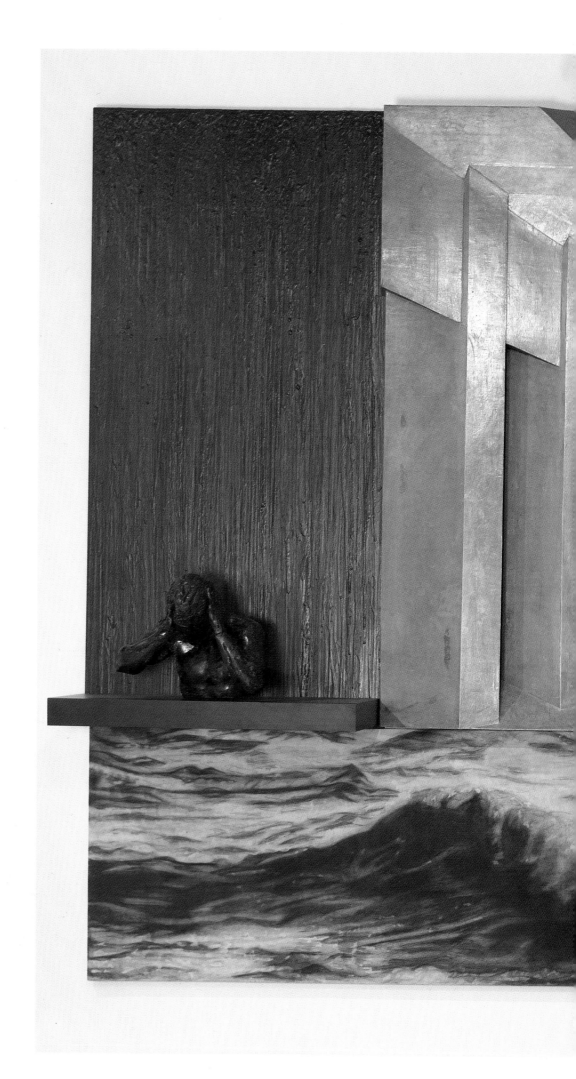

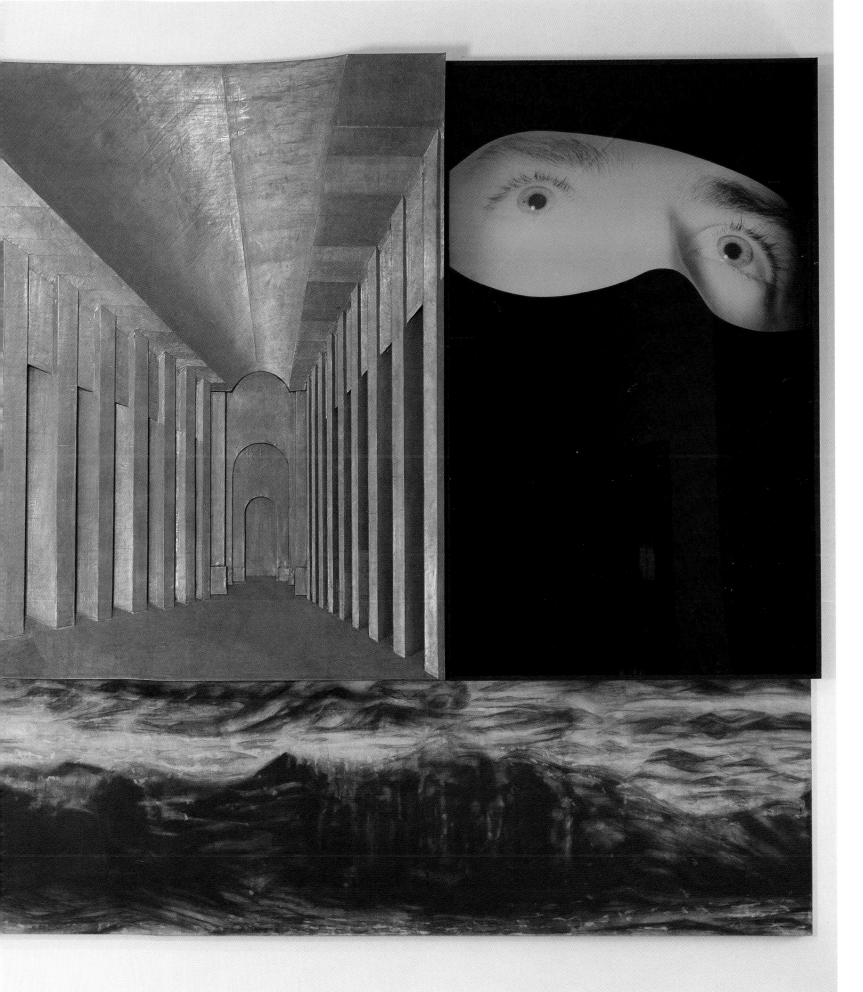

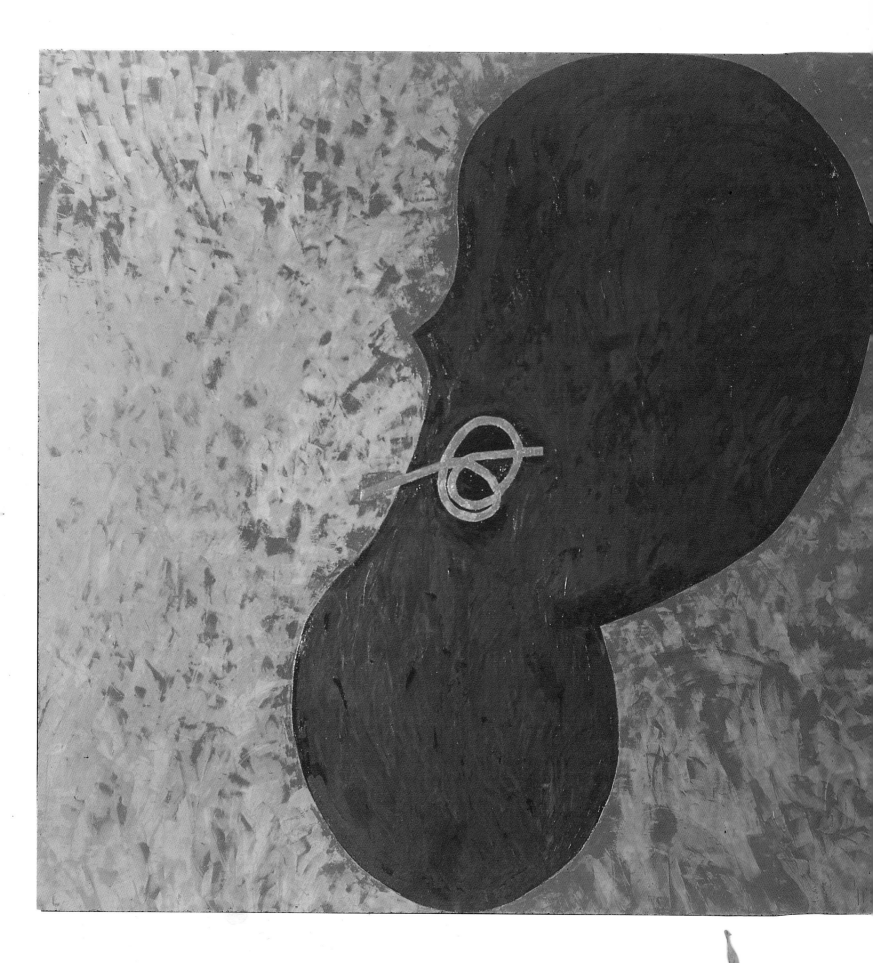

ELIZABETH MURRAY

37
Beginner
1976
Oil on canvas
113×114 (287×289·5)

ELIZABETH MURRAY

38
New York Dawn
1977
Oil on canvas
88½×65 (225×165)

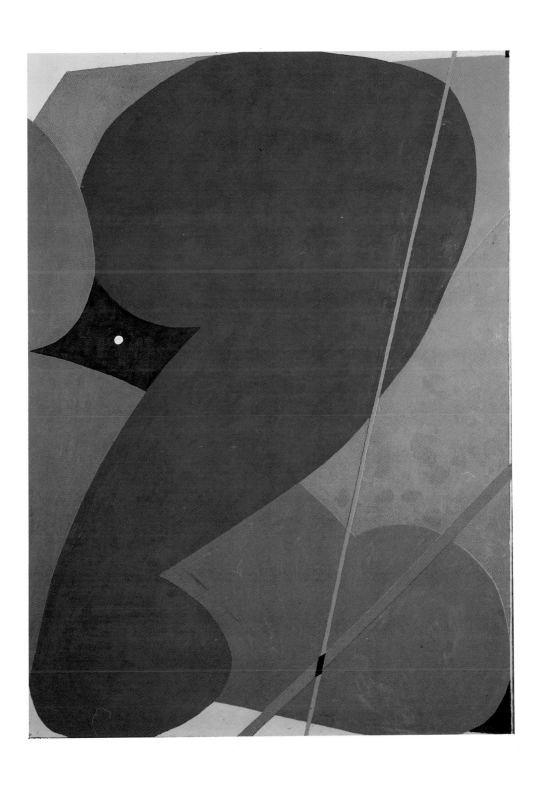

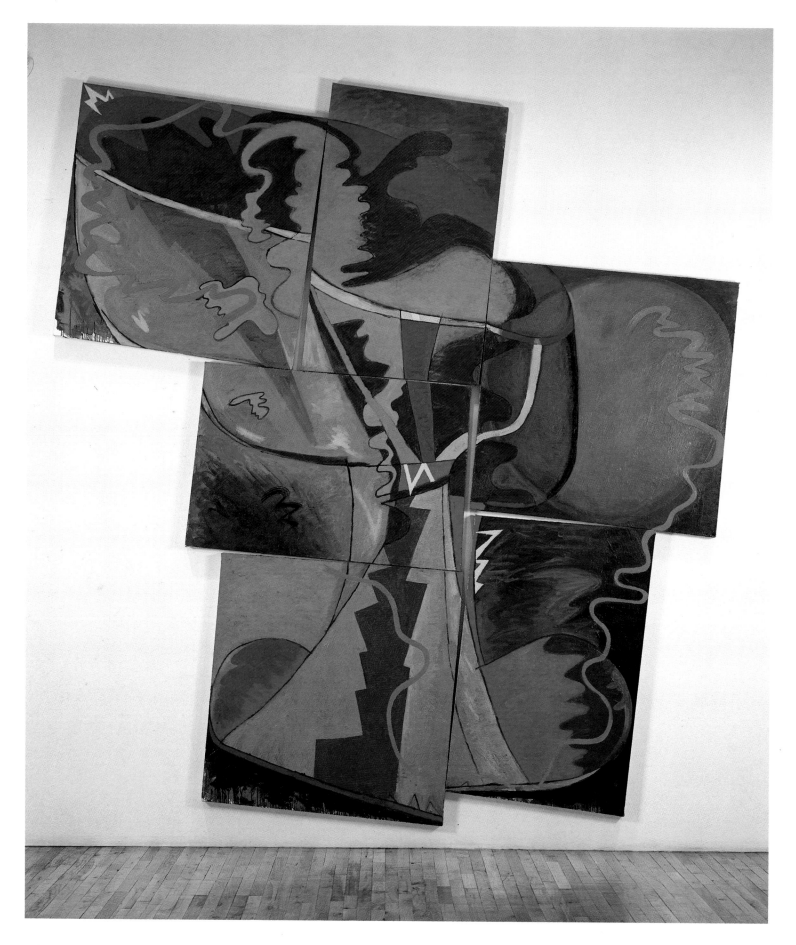

ELIZABETH MURRAY

39
Small Town
1980
Oil on canvas
6 parts, Overall: 132×130 (335×330)

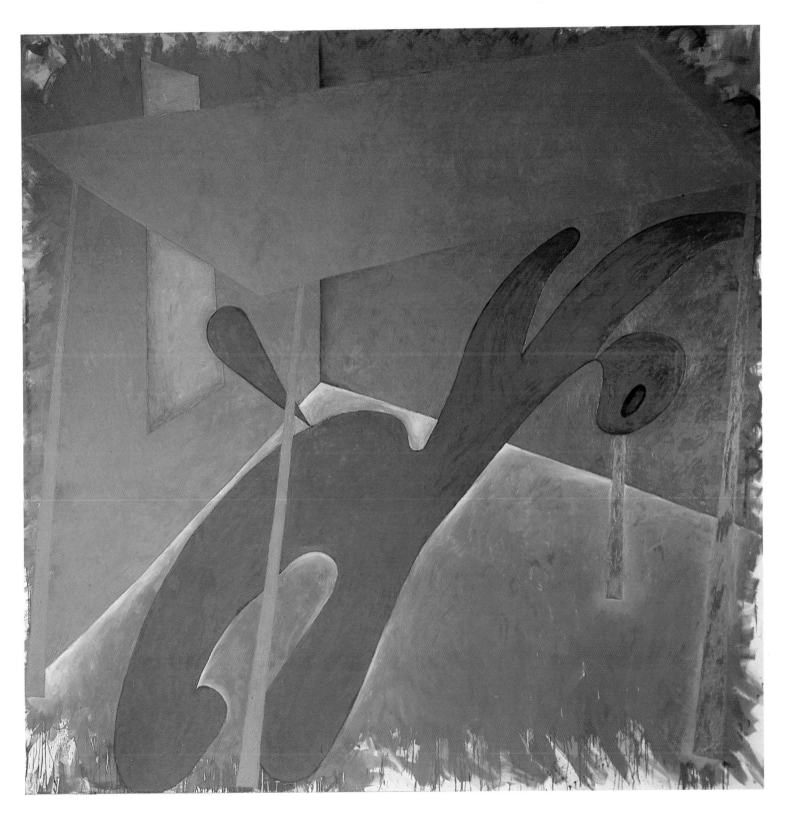

ELIZABETH MURRAY

40
Sleep
1983/84
Oil on canvas
129×129 (327·7×327·7)

JIM NUTT

41 (left)
Running Wild
1970
Acrylic on metal
46×43½ (117×110·5)

42 (below left)
Pink Encounter
1970/71
Acrylic on metal
23¾×18¼ (60·3×46·4)

43 (below right)
Tight Lips and Dreams
1972
Oil on board
16×16 (40·6×40·6)

44 (opposite)
You're Giving Me Trouble
1974
Acrylic on canvas
86½×73½ (220×187)

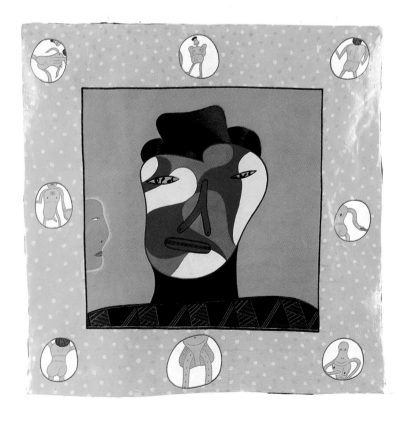

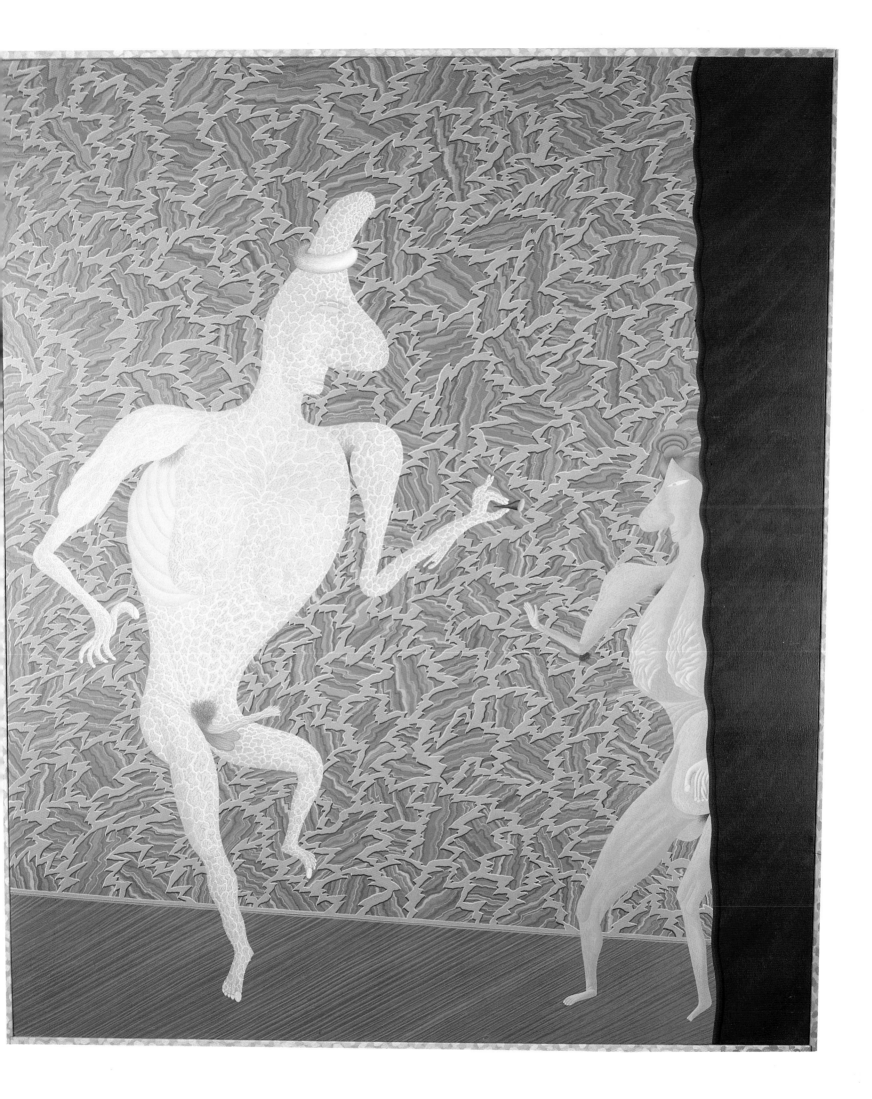

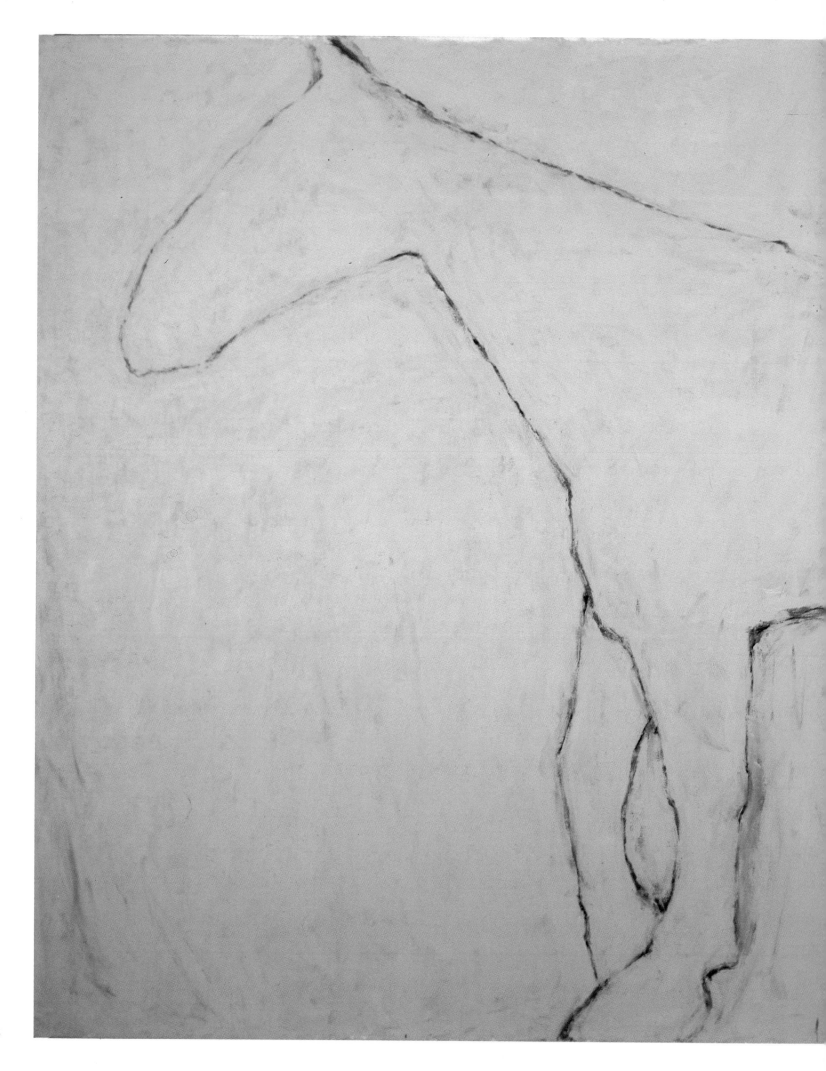

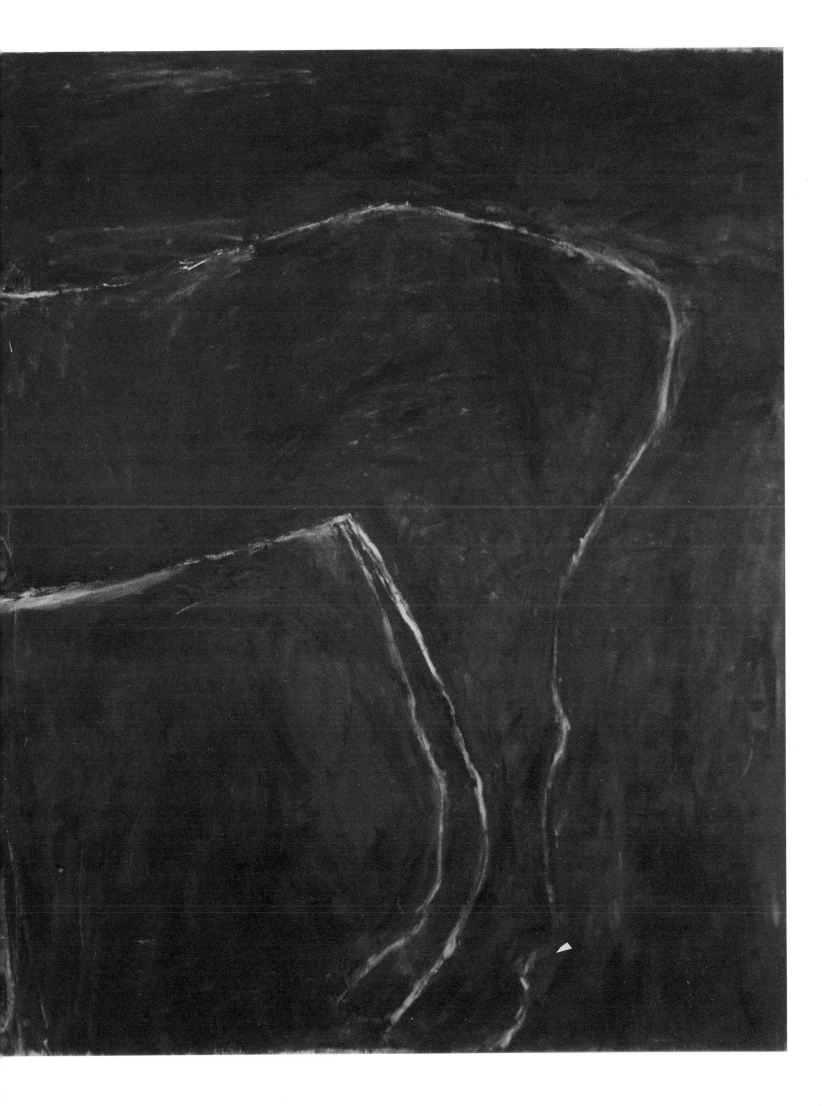

SUSAN ROTHENBERG

45 (previous page)
United States
1975
Acrylic and tempera on canvas
114×189 (289·6×480·1)

SUSAN ROTHENBERG

46
Cabin Fever
1976
Acrylic and tempera on canvas
66¾×84½ (170×214·6)

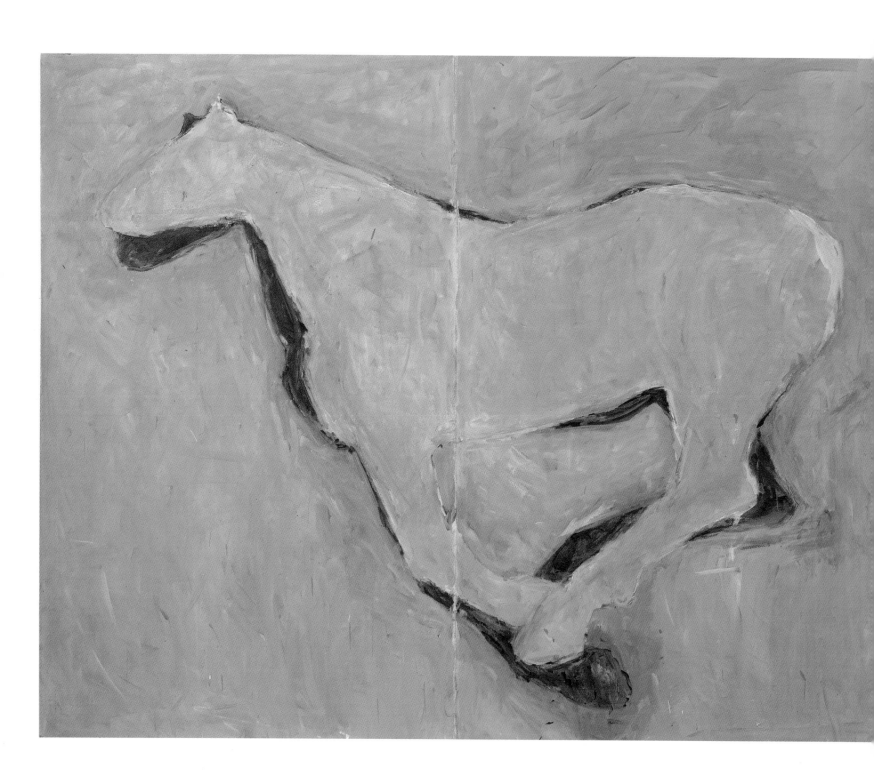

47
Untitled (Head)
1978
Acrylic on canvas
68×77½ (173×197)

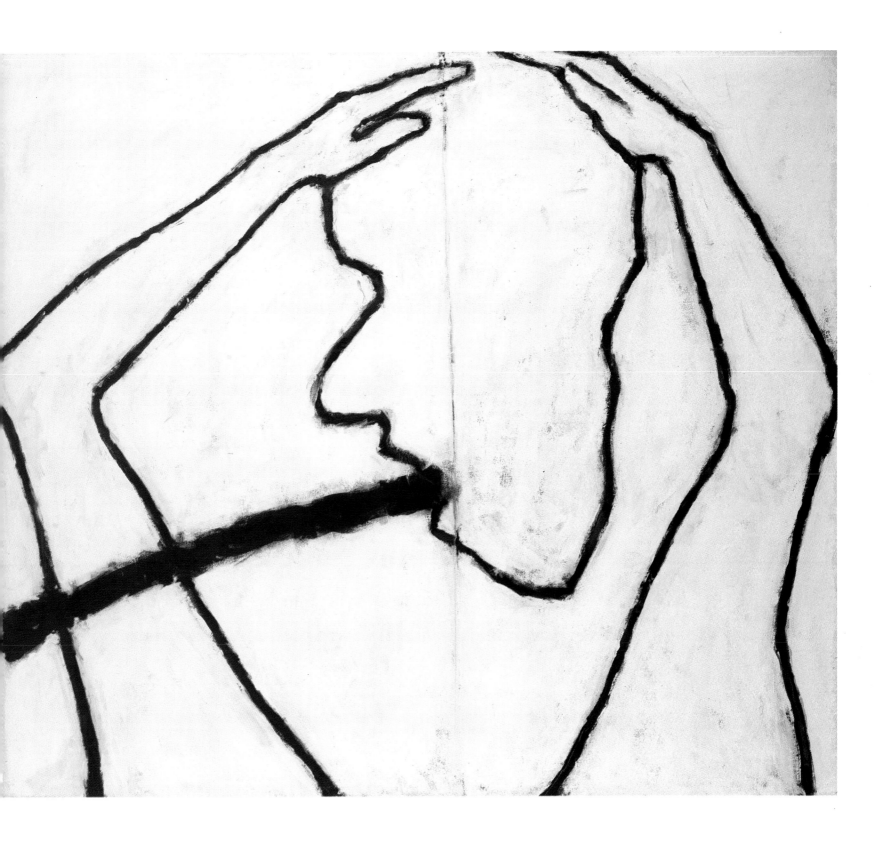

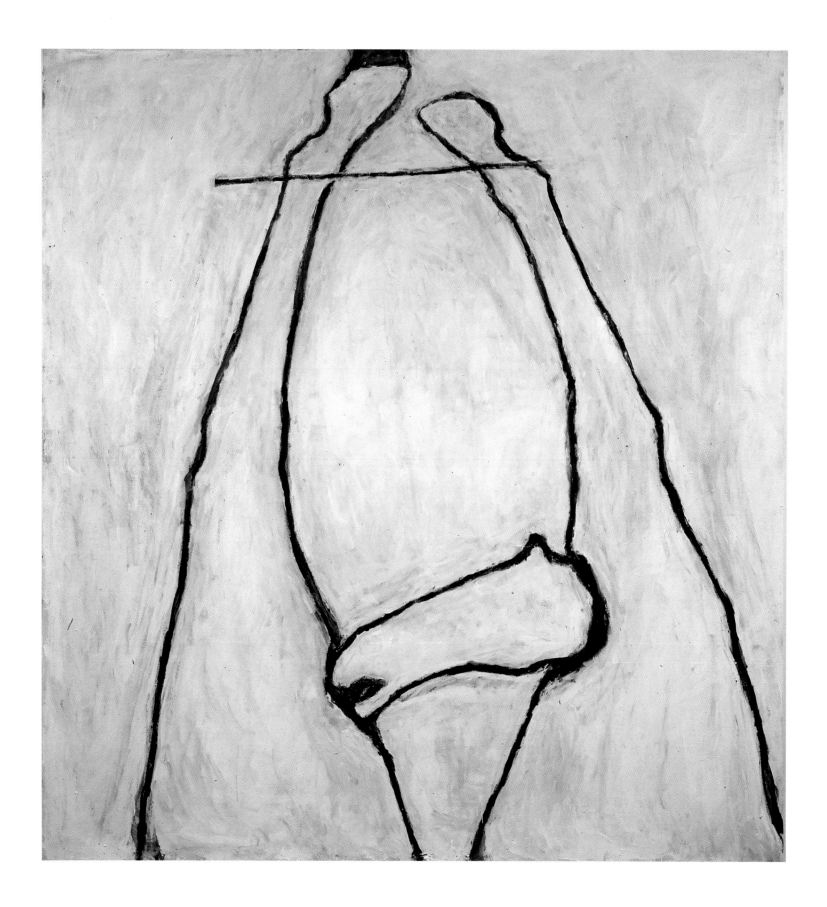

SUSAN ROTHENBERG

48
Squeeze
1978/79
Acrylic and flashe on canvas
92×87 (233·7×221)

SUSAN ROTHENBERG

49
Somebody Else's Hand
1979
Acrylic and flashe on canvas
21×36 (53×91)

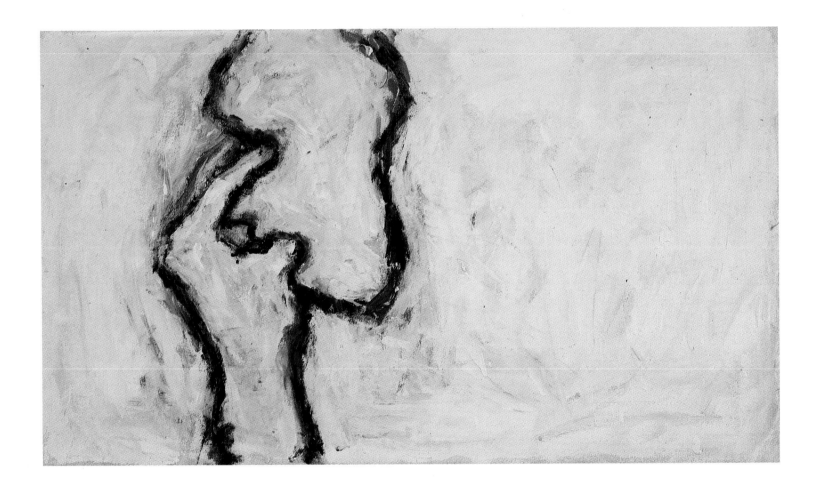

SUSAN ROTHENBERG

50
Patches
1982
Oil on canvas
87 × 117 (221 × 197)

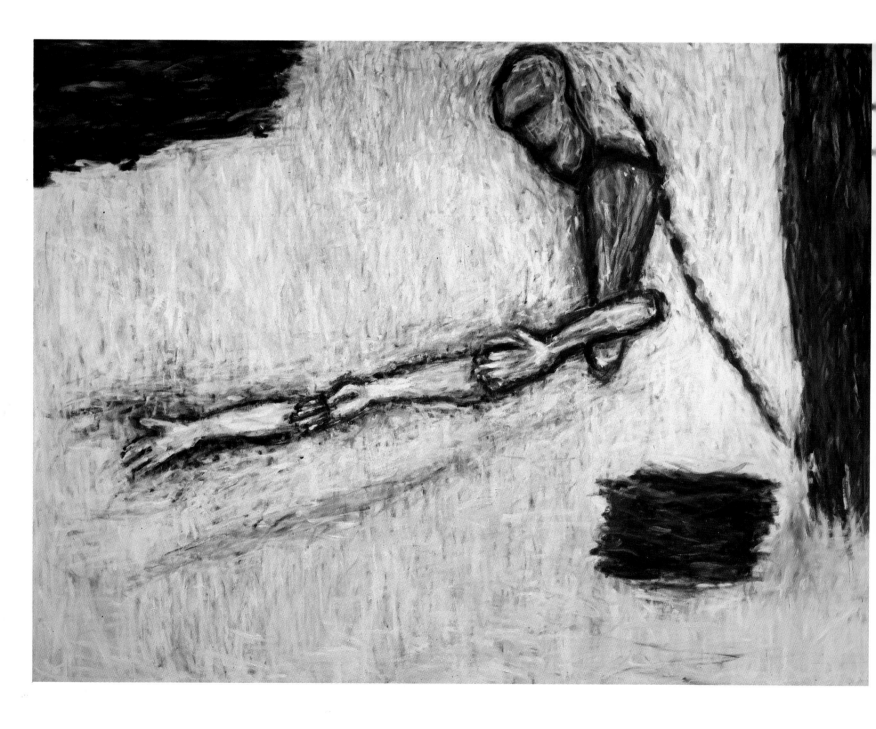

SUSAN ROTHENBERG

51
Skating an Eight
1983
Oil on canvas
63×41 (160×104)

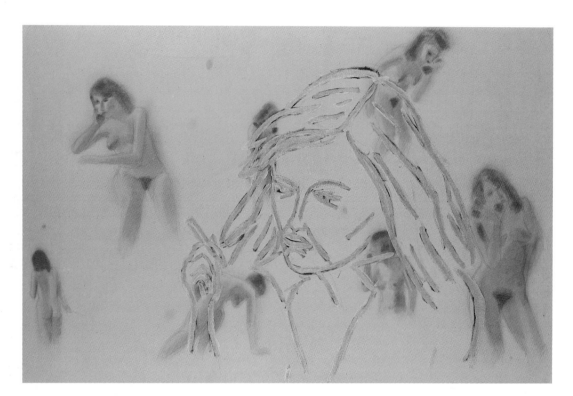

DAVID SALLE

52
He Aspires to the Conditions of the . . .
1979
Acrylic on canvas
48×70 (122×178)

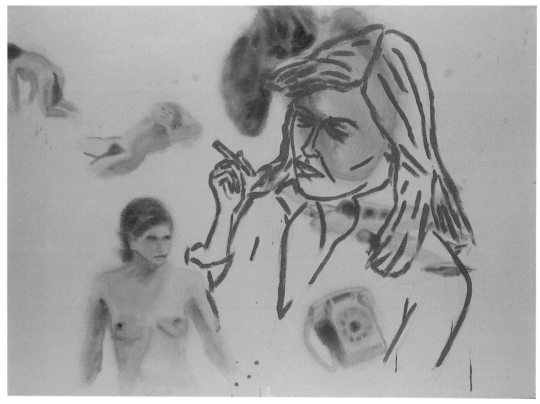

DAVID SALLE

53
Rob Him of Pleasure
1979
Acrylic on canvas
48×70 (122×178)

DAVID SALLE

54
Perhaps or Probably Really is Lost
1980
Acrylic on canvas
58×88 (147×223·5)

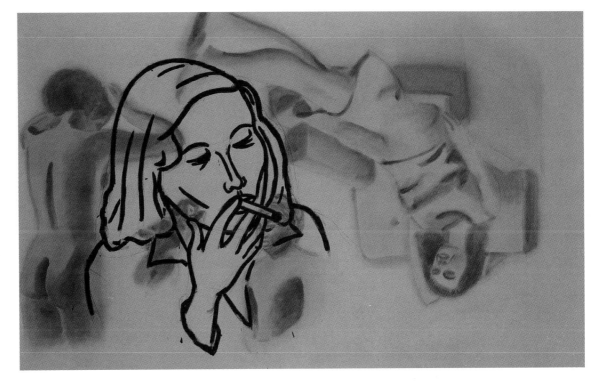

DAVID SALLE

55
The Fourth Since I Came Up
1980
Acrylic on canvas
2 panels: 48×72 (122×183)

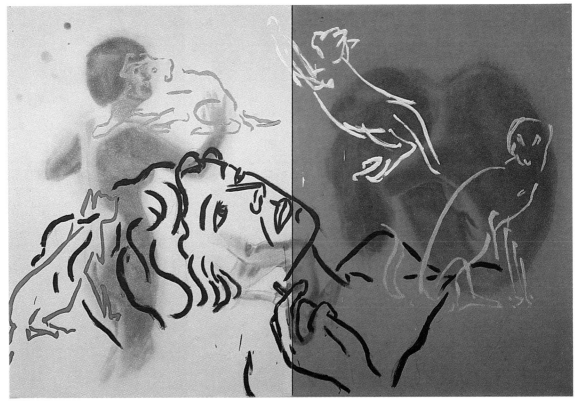

DAVID SALLE

56
The Power that Distributes and Divides
1981
Acrylic on canvas
2 panels: 86×100 (218·4×254)

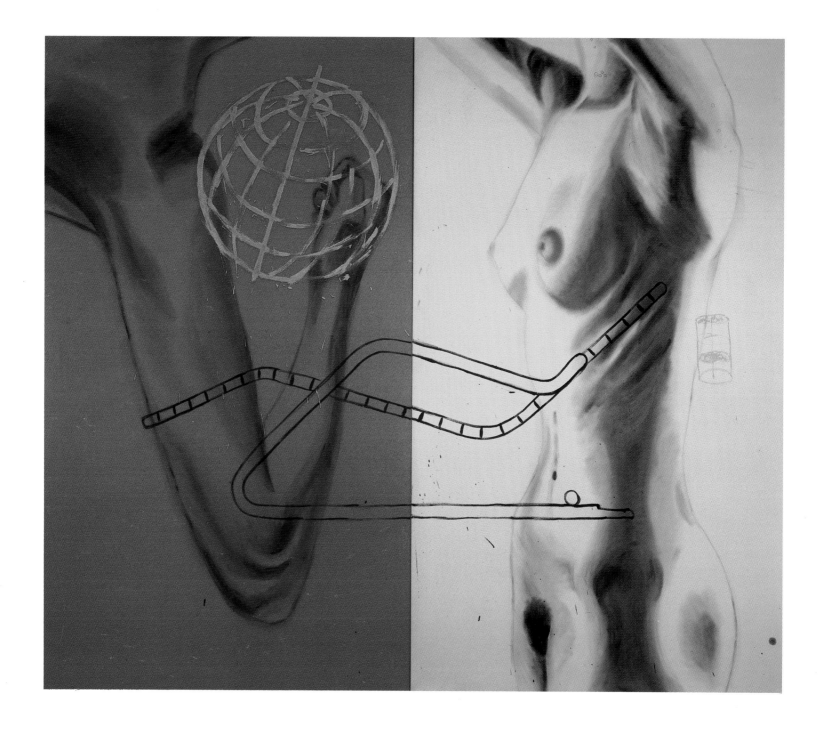

DAVID SALLE

57
From Planets to Favored Men
1981
Acrylic on canvas
2 panels: 84×120 (213·4×305)

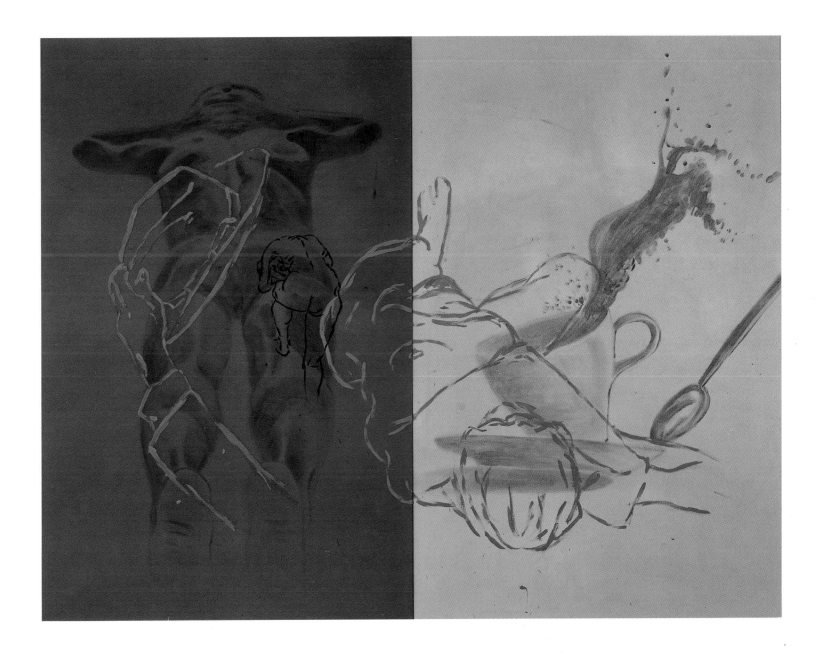

DAVID SALLE

58
A Couple of Centuries
1982
Acrylic and oil on canvas
2 panels: 110×160 (280×406·5)

DAVID SALLE

59
Zeitgeist Painting No. 4
1982
Acrylic and oil on canvas
2 panels: 156×117 (396×297)

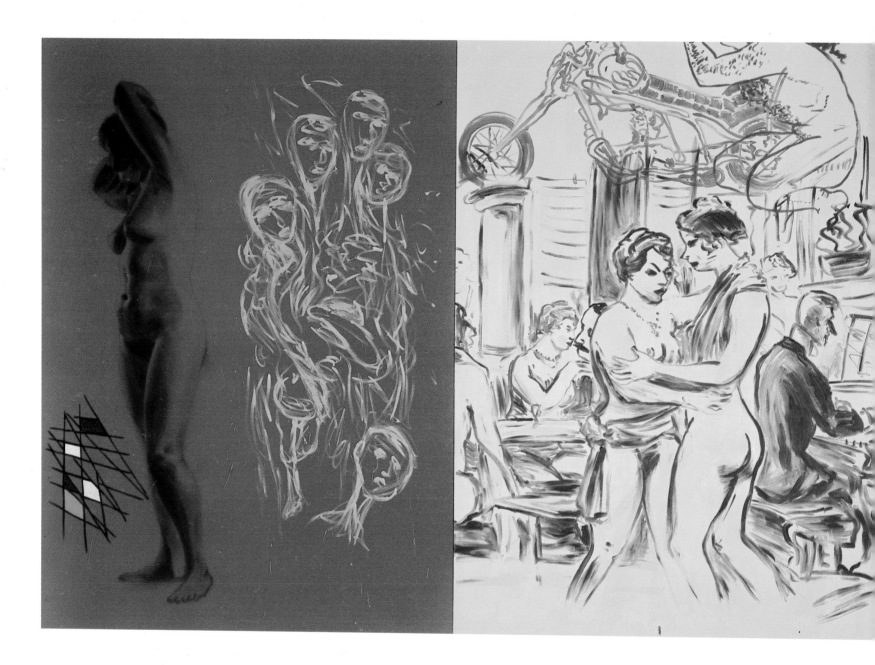

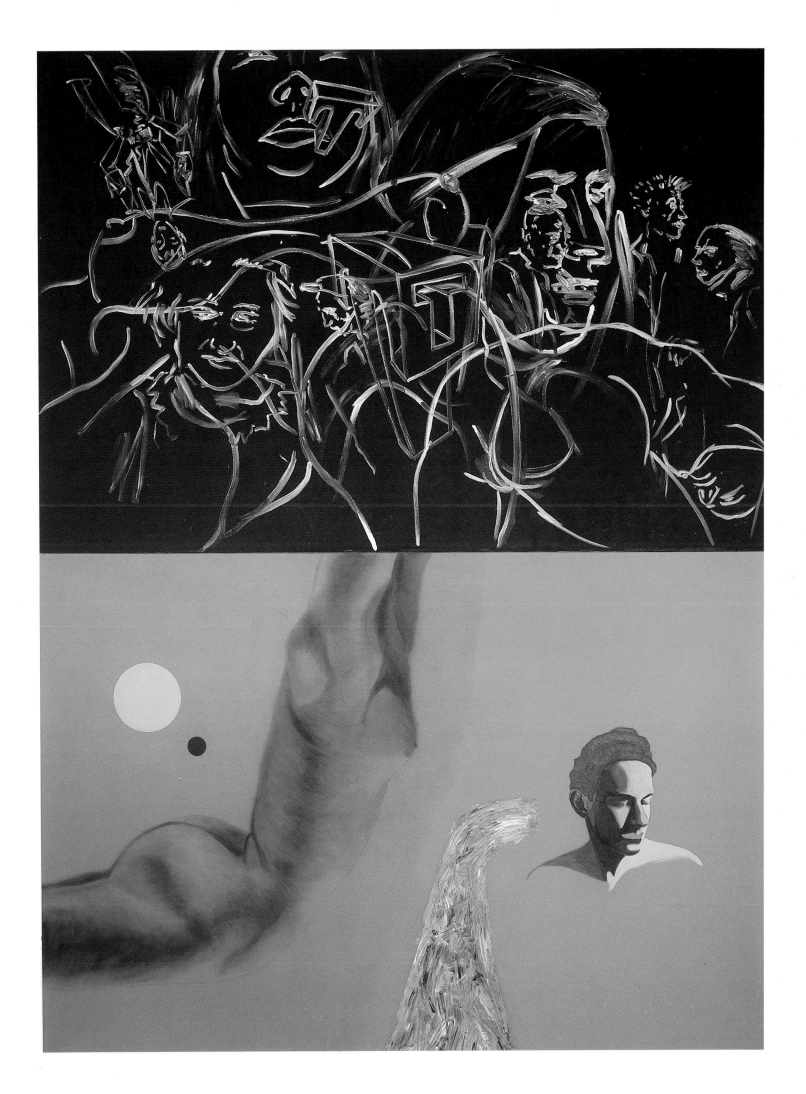

DAVID SALLE

60
Poverty is No Disgrace
1982
Acrylic and oil on canvas with chair attached
3 panels: 98×205 (249×520·7)

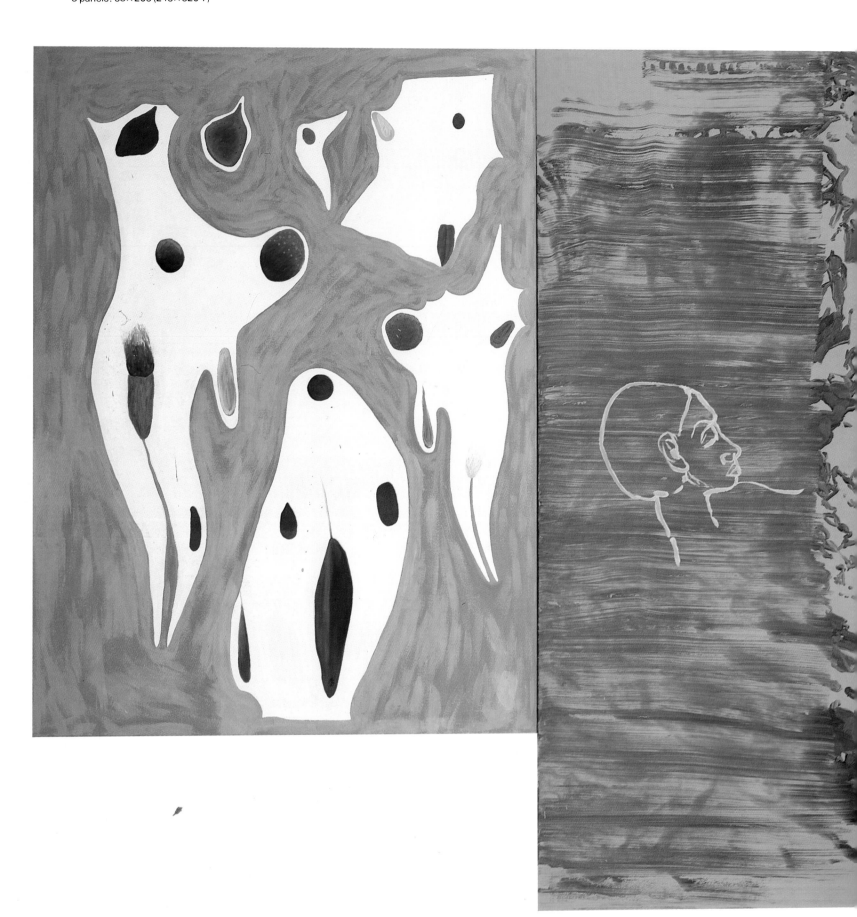

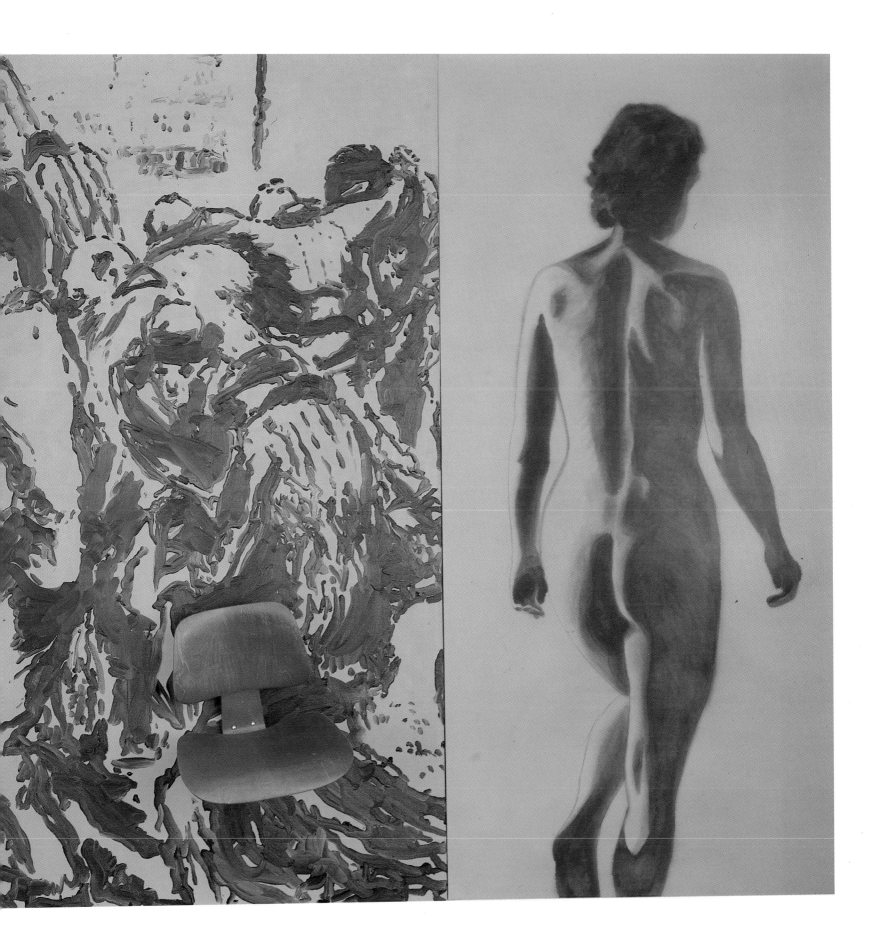

DAVID SALLE

61
Midday
1984
Acrylic and oil on canvas and wood
2 panels: 114×150 (289·6×381)

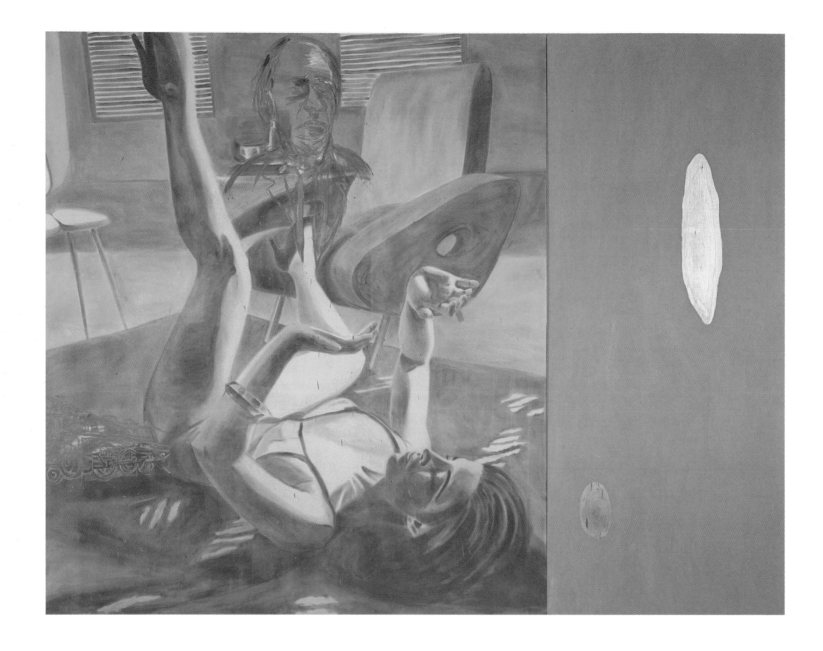

DAVID SALLE

62
The Trucks Bring Things
1984
Acrylic, oil and fabric on canvas with light fixture
2 panels: 102×173¼ (259×440)

DAVID SALLE

63 (following page)
My Head
1984
Acrylic and oil on canvas, wood
7 panels: 120×210½ (304·8×534·7)

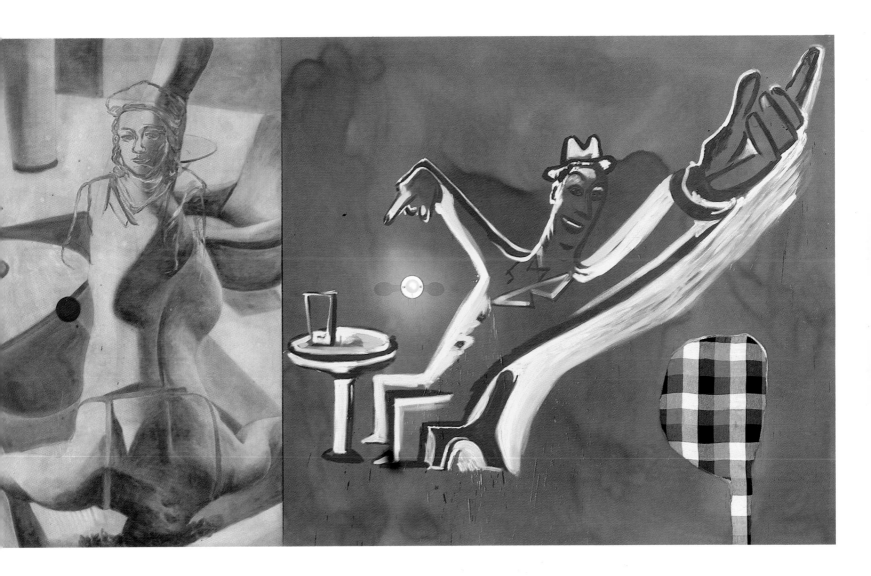

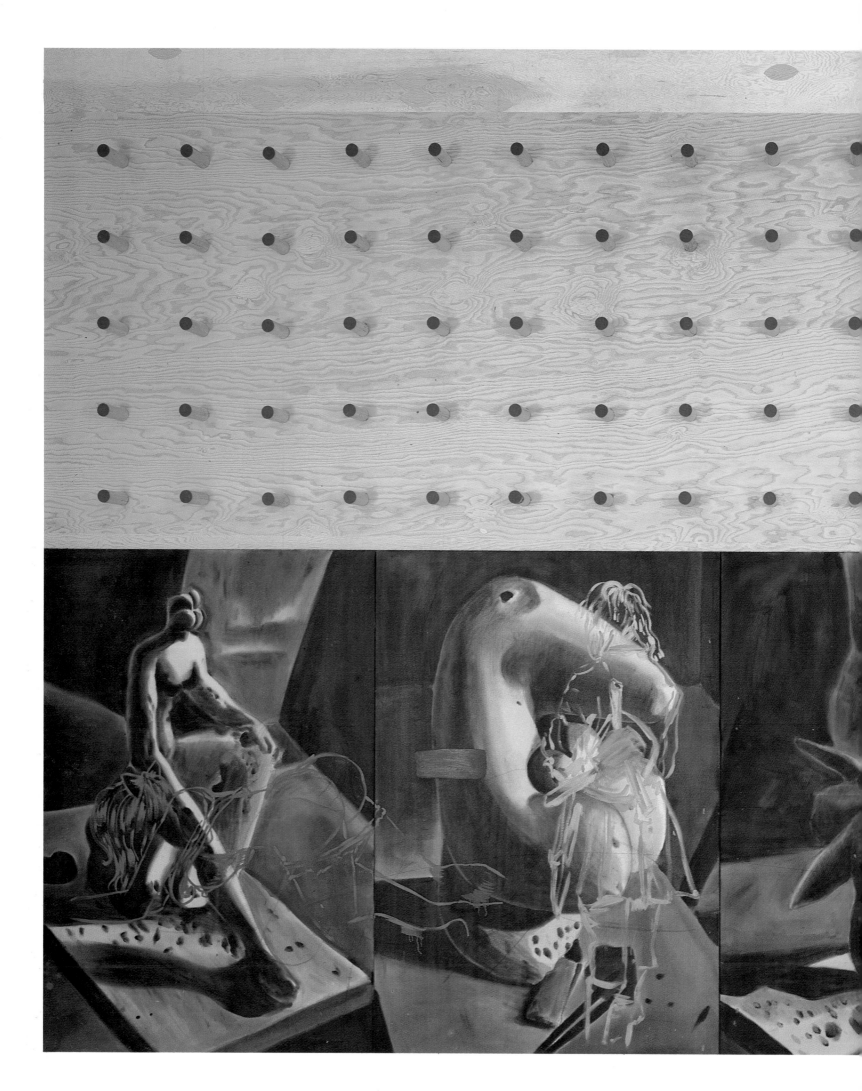

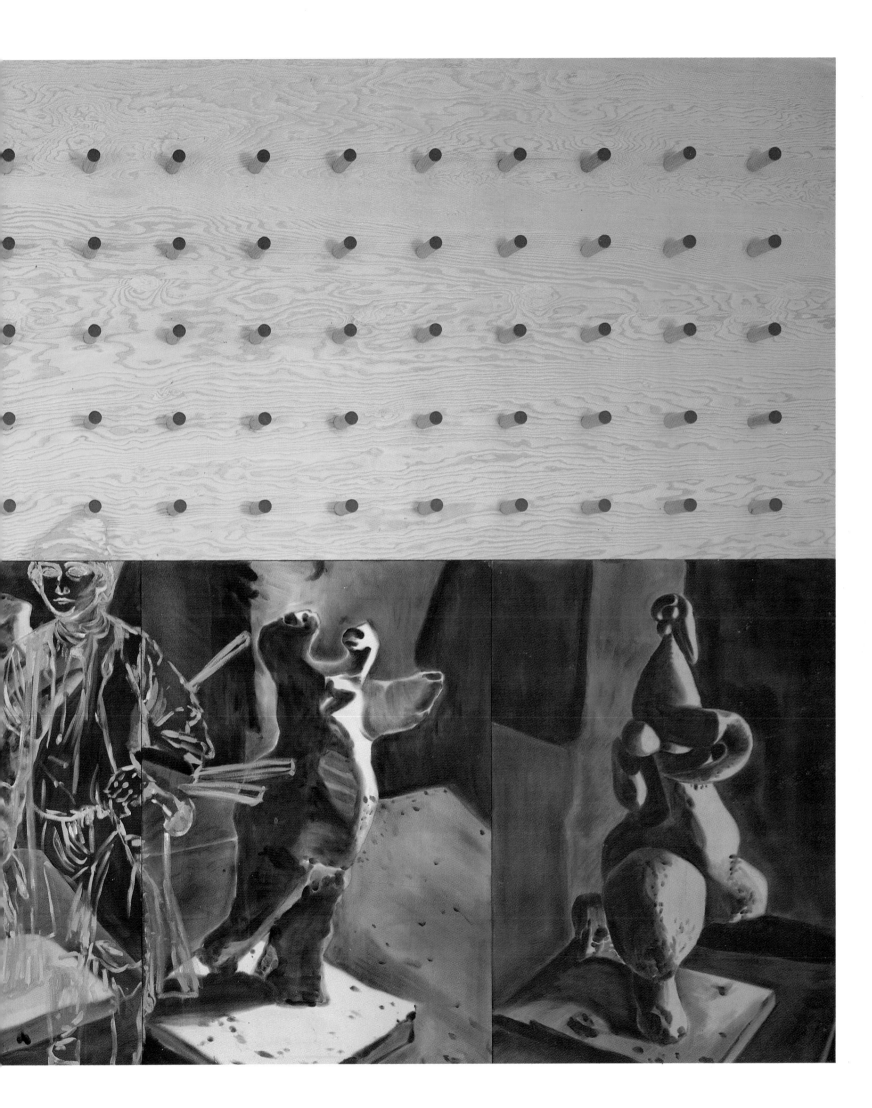

JOEL SHAPIRO

64
Untitled
1975
Cast iron
$3^1/_2 \times 7^1/_8 \times 7^3/_4$ ($9 \times 18 \times 19 \cdot 7$)

JOEL SHAPIRO

65
Untitled
1978
Cast bronze
2³/₄ × 23⁷/₁₆ × 17¹/₈ (7 × 59·7 × 43·3)

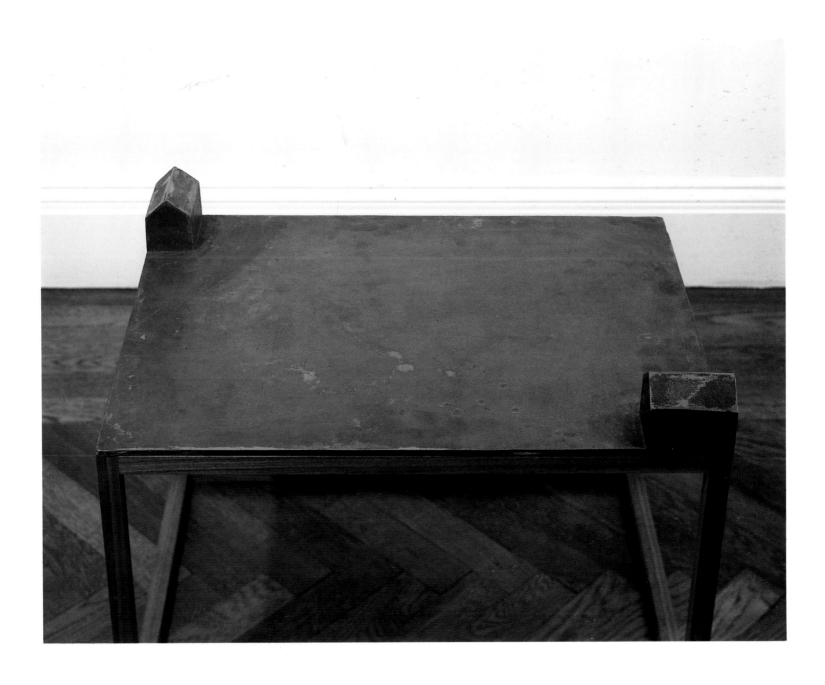

JOEL SHAPIRO

66
Untitled
1978
Cast bronze
2³/₄ × 7¹/₂ × 4¹/₂ (7 × 19 × 11·4)

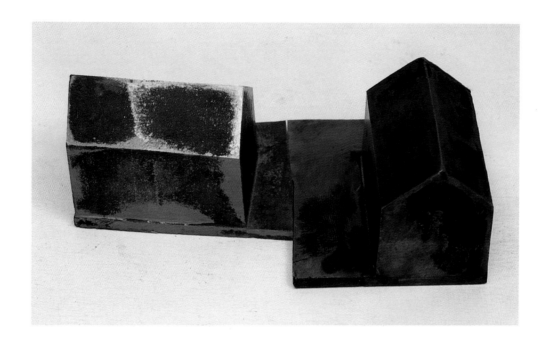

JOEL SHAPIRO

67
Untitled
1980
Cast bronze
6×7¾×16 (15·2×19·7×40·6)

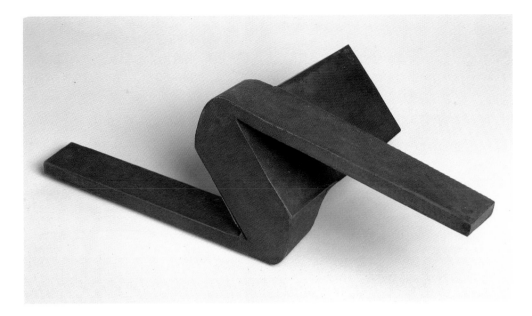

JOEL SHAPIRO

68
Untitled
1980/82
Cast bronze
23¾×13×8⅛ (60·3×33×20·6)

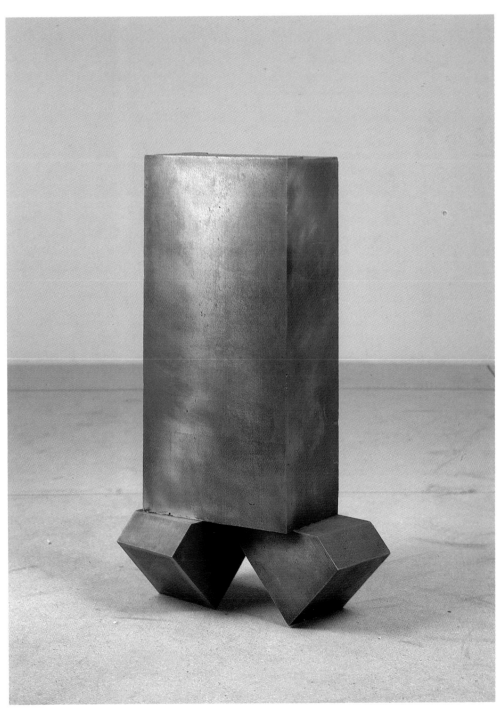

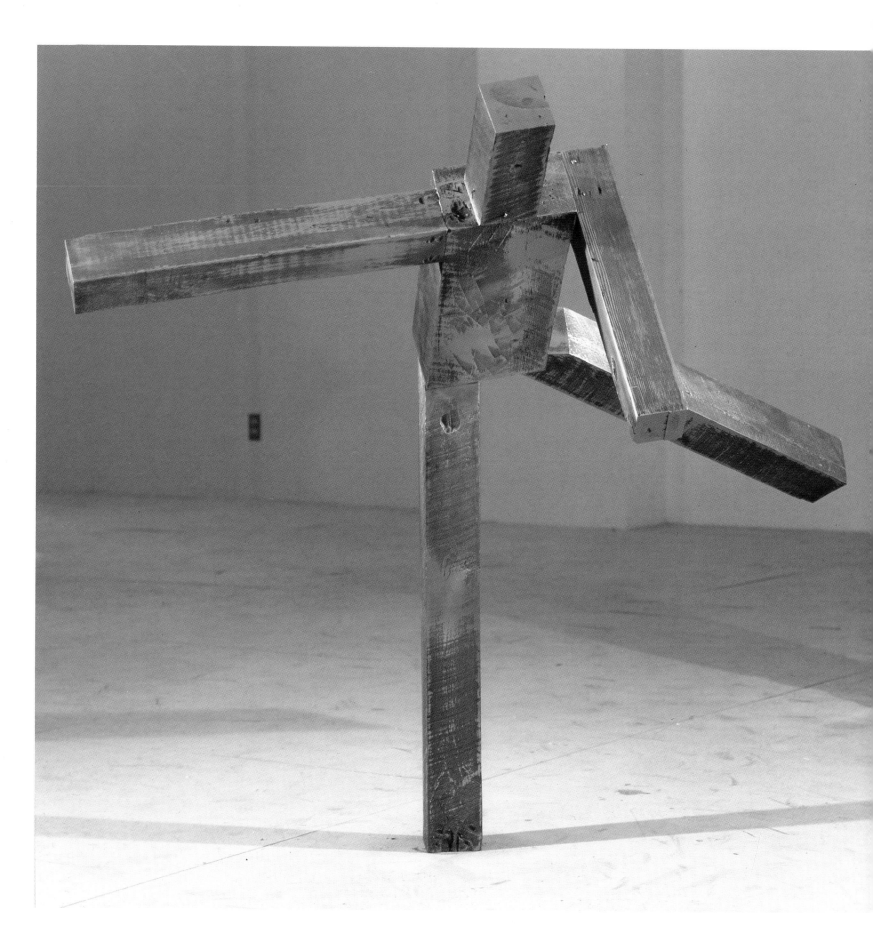

JOEL SHAPIRO

69
Untitled
1980/81
Cast bronze
52⁷/₈×64×45¹/₂ (134·3×162·6×115·6)

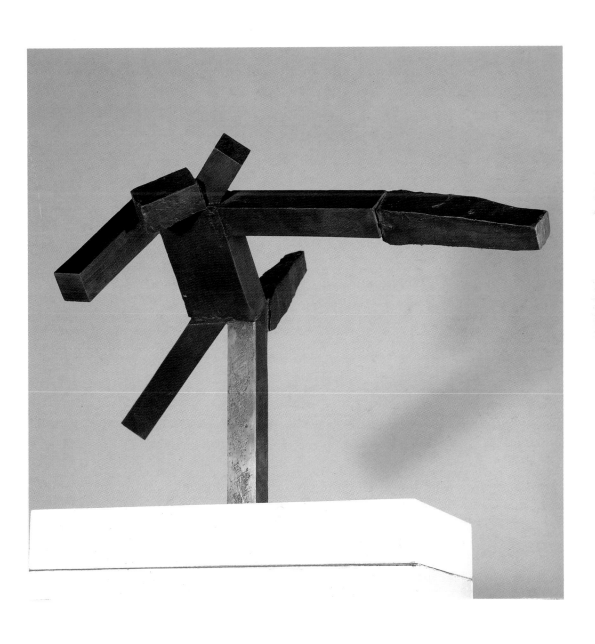

JOEL SHAPIRO

70
Untitled
1980/82
Cast bronze
11 1/8 × 17 × 10 3/4 (28·3 × 43 × 27·3)

CINDY SHERMAN

71
Untitled Film Still No. 3
1977
Black and white photograph
16×20 (40·6×50·8)

CINDY SHERMAN

72
Untitled Film Still No. 5
1978
Black and white photograph
16×20 (40·6×50·8)

CINDY SHERMAN

73
Untitled Film Still No. 18
1978
Black and white photograph
16×20 (40·6×50·8)

CINDY SHERMAN

74
Untitled Film Still No. 21
1978
Black and white photograph
16×20 (40·6×50·8)

CINDY SHERMAN

75
Untitled Film Still No. 25
1978
Black and white photograph
16×20 (40·6×50·8)

CINDY SHERMAN

76
Untitled Film Still No. 32
1979
Black and white photograph
16×20 (40·6×50·8)

CINDY SHERMAN

77
Untitled Film Still No. 45
1979
Black and white photograph
16×20 (40·6×50·8)

CINDY SHERMAN

78
Untitled Film Still No. 48
1979
Black and white photograph
16×20 (40·6×50·8)

CINDY SHERMAN

79
Untitled No. 66
1980
Colour photograph
20×24 (50·8×61)

CINDY SHERMAN

80
Untitled No. 70
1980
Colour photograph
20×24 (50·8×61)

CINDY SHERMAN

81
Untitled No. 74
1980
Colour photograph
20×24 (50·8×61)

CINDY SHERMAN

82
Untitled No. 87
1981
Colour photograph
24 × 48 (61 × 122)

CINDY SHERMAN

83
Untitled No. 88
1981
Colour photograph
24 × 48 (61 × 122)

CINDY SHERMAN

84
Untitled No. 92
1981
Colour photograph
24 × 48 (61 × 122)

CINDY SHERMAN

85
Untitled No. 97
1982
Colour photograph
45×30 (114·3×76)

CINDY SHERMAN

86
Untitled No. 98
1982
Colour photograph
45×30 (114·3×76)

CINDY SHERMAN

87
Untitled No. 99
1982
Colour photograph
45×30 (114·3×76)

CINDY SHERMAN

88
Untitled No. 100
1982
Colour photograph
45×30 (114·3×76)

CINDY SHERMAN

89
Untitled No. 96
1981
Colour photograph
24×48 (61×122)

CINDY SHERMAN

90 (opposite)
Untitled No. 122
1983
Colour photograph
Frame: 86³/₄× 57³/₄ (220× 146·7)

TERRY WINTERS

91
Fungus
1982
Oil on linen
60×78 (152·4×198)

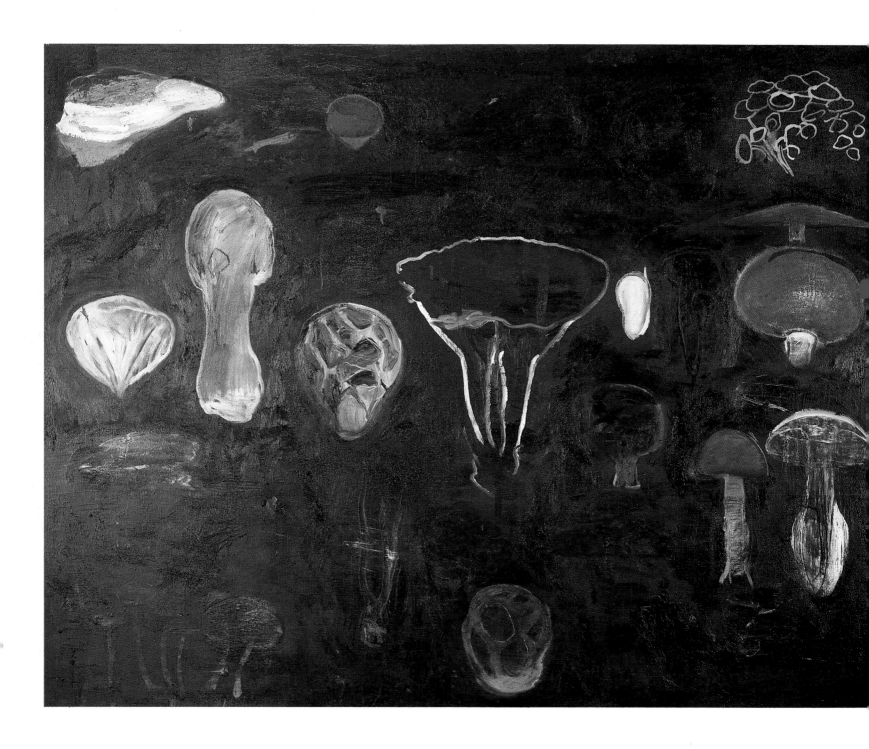

TERRY WINTERS

92
Caps, Stems, Gills
1982
Oil on linen
60×84 (152·4×213·4)

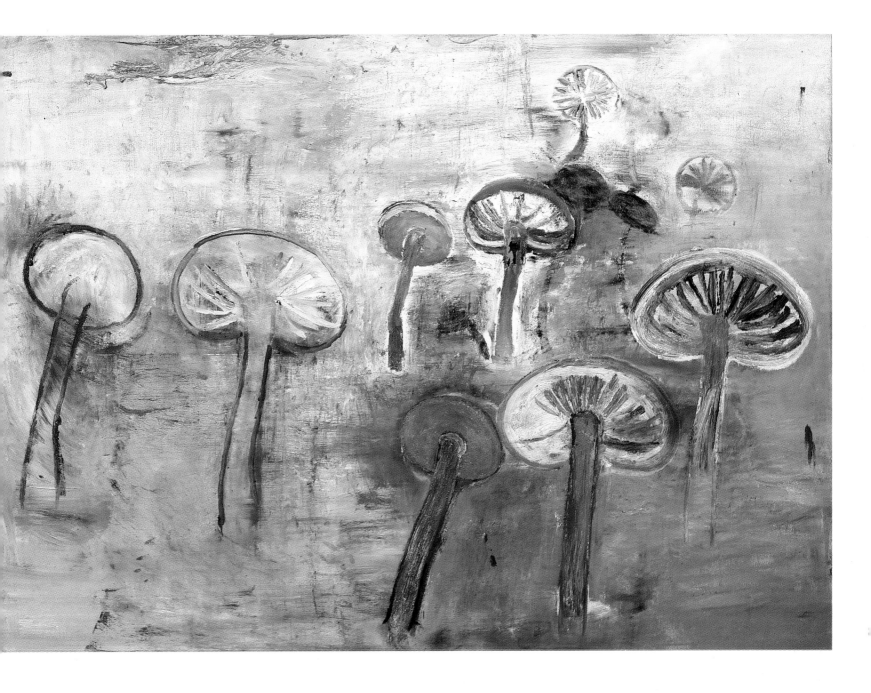

TERRY WINTERS

93
Botanical Subject 2
1982
Oil on linen
48×36 (122×91·4)

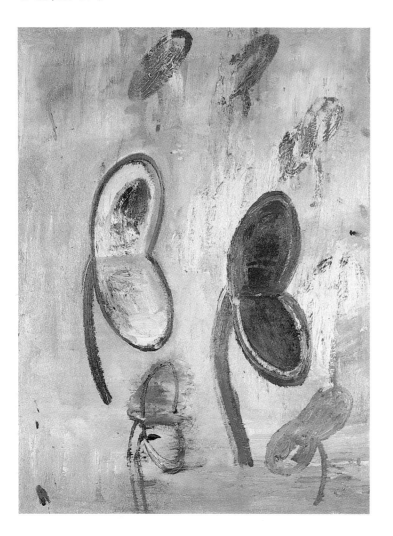

TERRY WINTERS

94
Botanical Subject 4
1982
Oil on linen
48×36 (122×91·4)

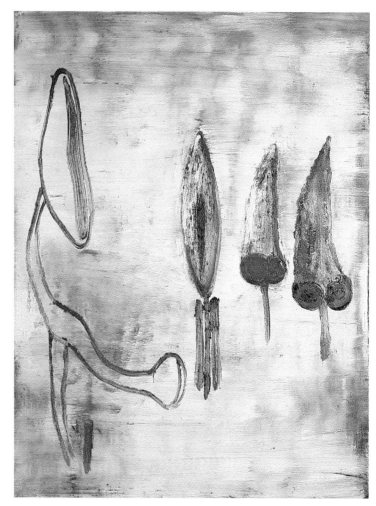

TERRY WINTERS

95
Botanical Subject 5
1982
Oil on linen
48×36 (122×91·4)

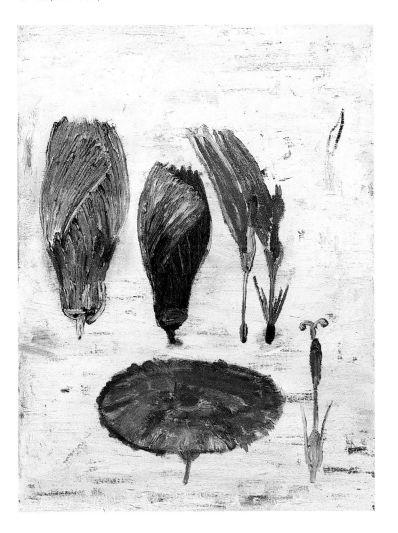

TERRY WINTERS

96
Botanical Subject 6
1982
Oil on linen
48×36 (122×91·4)

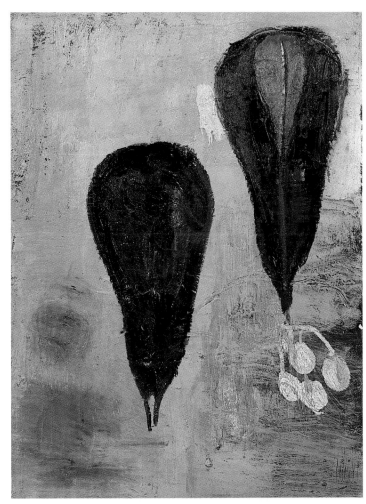

TERRY WINTERS

97
Stamina 1
1982
Oil on linen
60×84 (152·4×213·4)

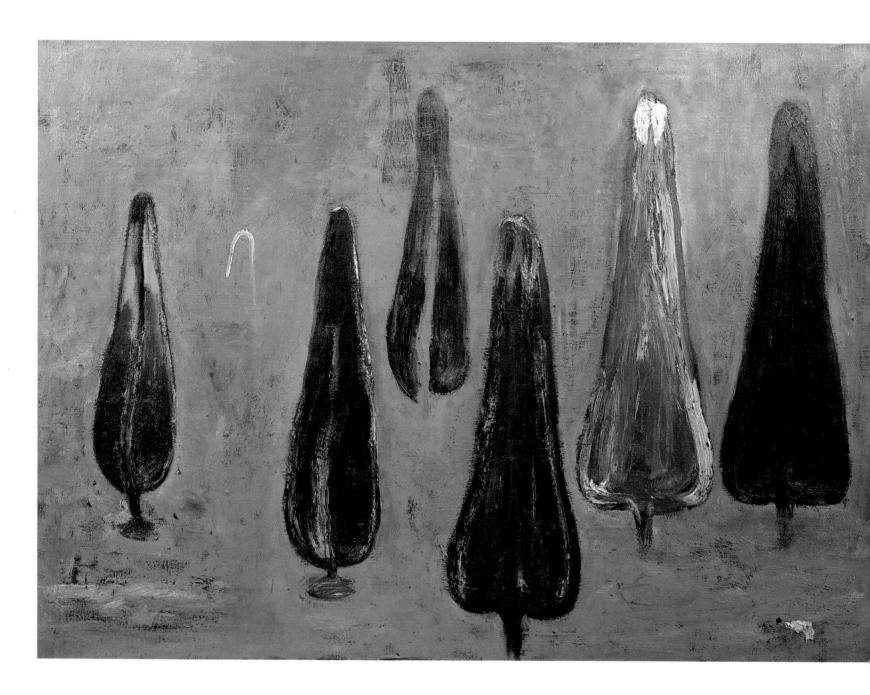

TERRY WINTERS

98
Stamina 2
1982
Oil on linen
60×84 (152·4×213·4)

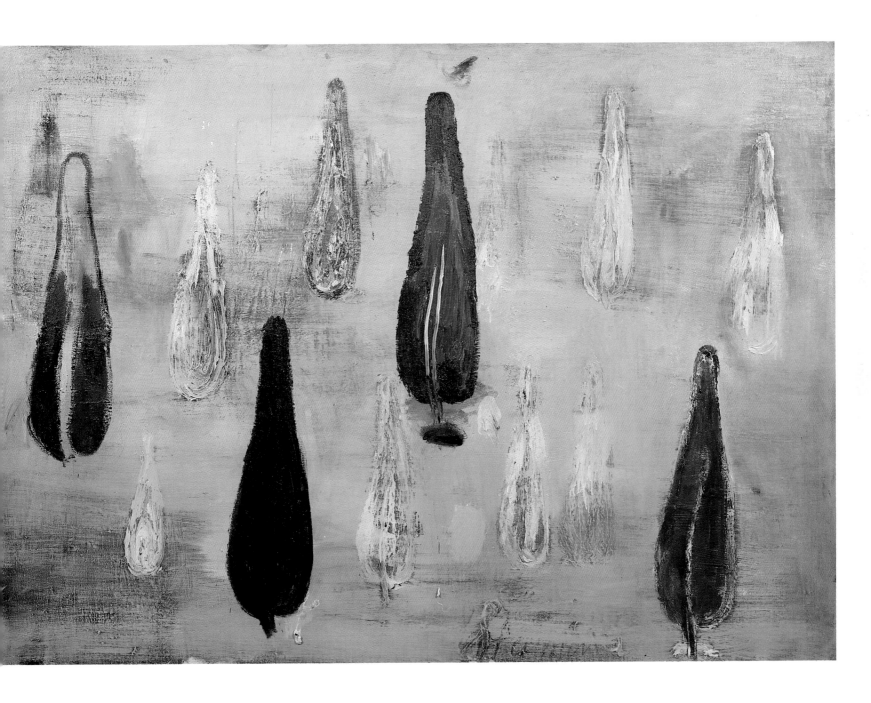

TERRY WINTERS

99
Theophrastus' Garden I
1982
Oil on linen
87×70 (221×178)

TERRY WINTERS

100
Theophrastus' Garden II
1982
Oil on linen
87×70 (221×178)

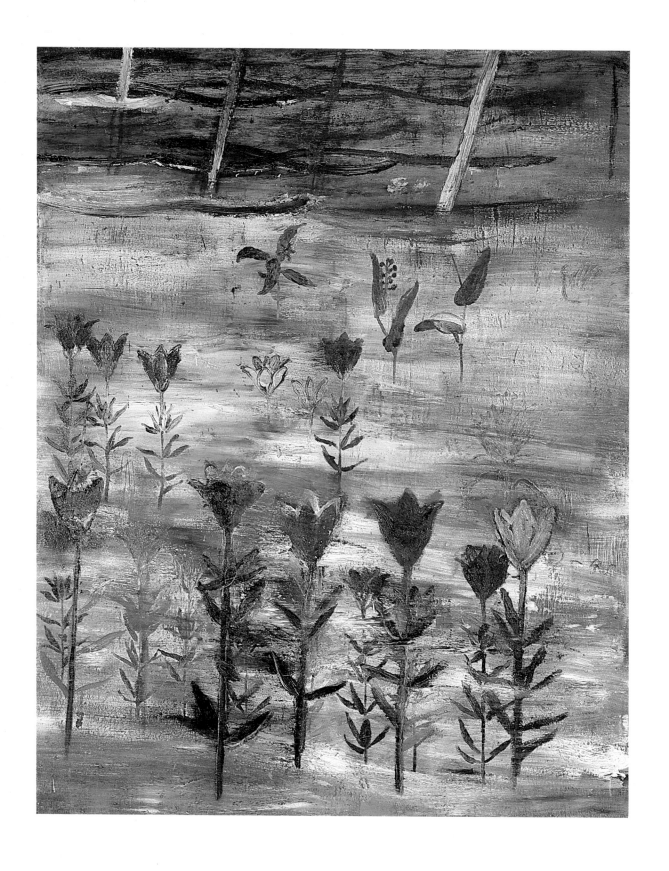

Theophrastus' Garden I
1982
Oil on linen
87×70 (221×178)

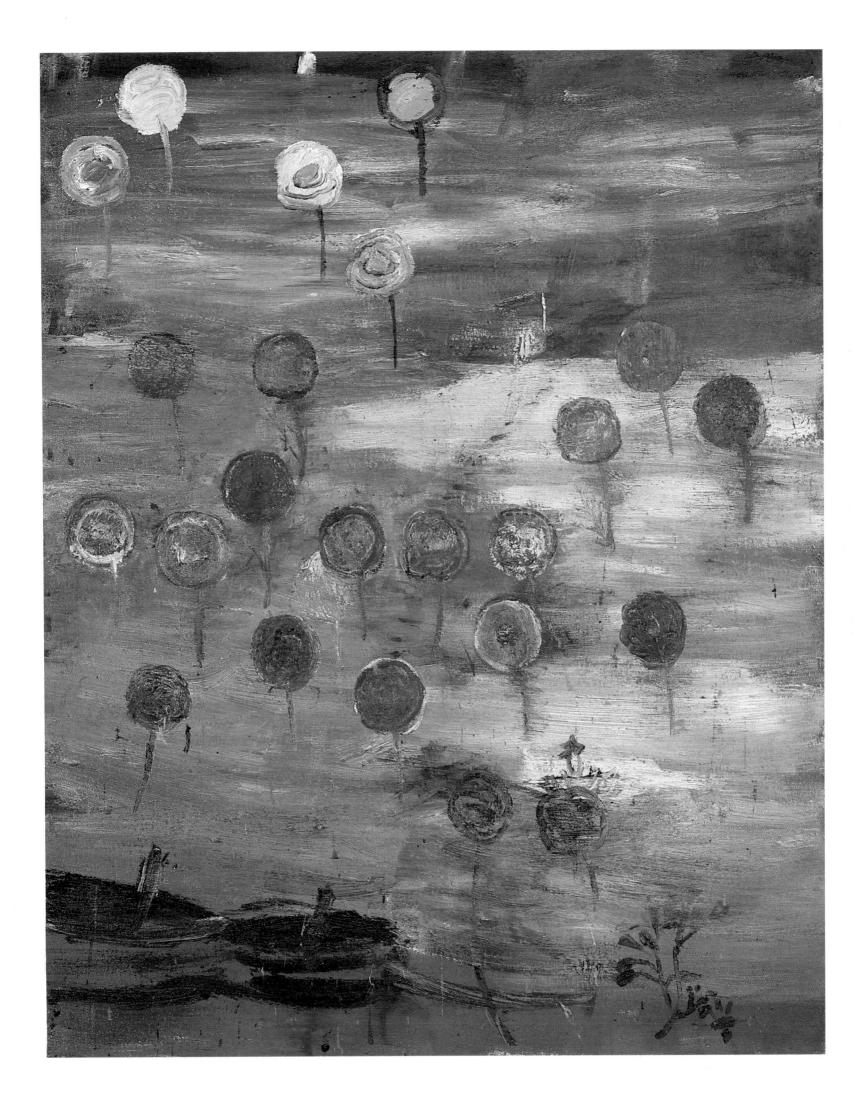

TERRY WINTERS

101
Colony
1983
Oil on linen
78½ × 103½ (199·4 × 263)

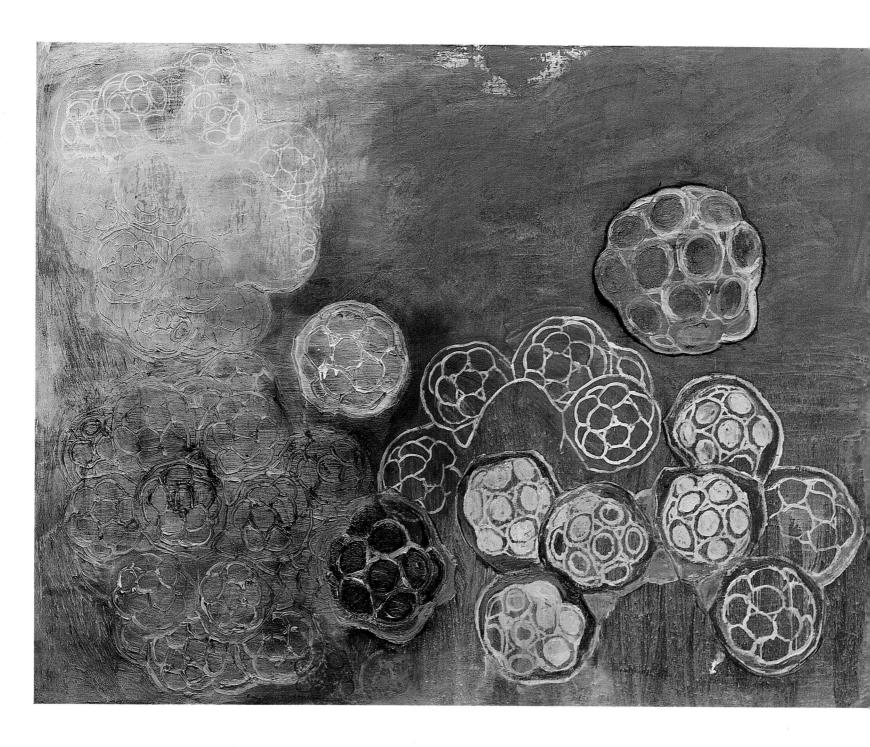

TERRY WINTERS

102
Untitled
1983
Oil on linen
42×26 (106·7×66)

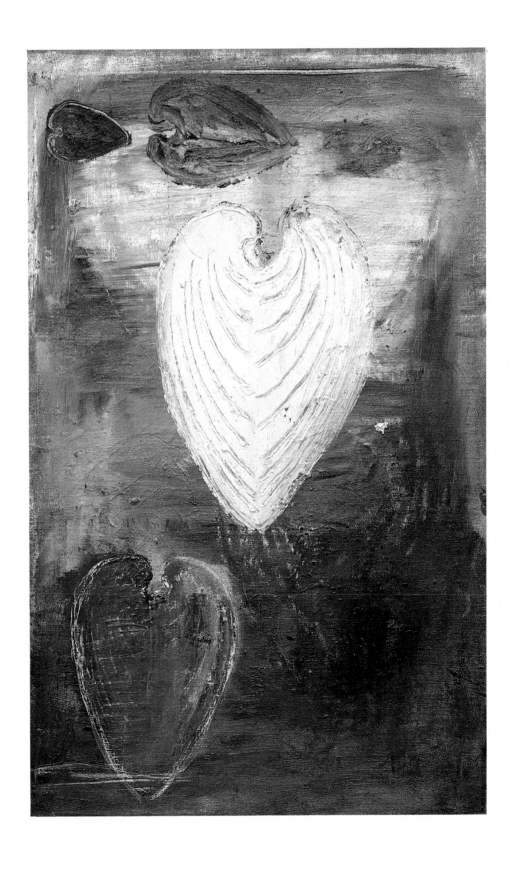

FRANCESCO CLEMENTE

103
Autoritratto
1980
Oil on canvas
12×8 (30·5×20·5)

FRANCESCO CLEMENTE

104 (above left)
I Quattro Punti Cardinali: Nord
1981
Pastel on paper
Sheet: 24×18 (61×45·5)

105 (above right)
I Quattro Punti Cardinali: Est
1981
Pastel on paper
Sheet: 24×18 (61×45·5)

106 (below right)
I Quattro Punti Cardinali: Sud
1981
Pastel on paper
Sheet: 24×18 (61×45·5)

107 (below left)
I Quattro Punti Cardinali: Ouest
1981
Pastel on paper
Sheet: 24×18 (61×45·5)

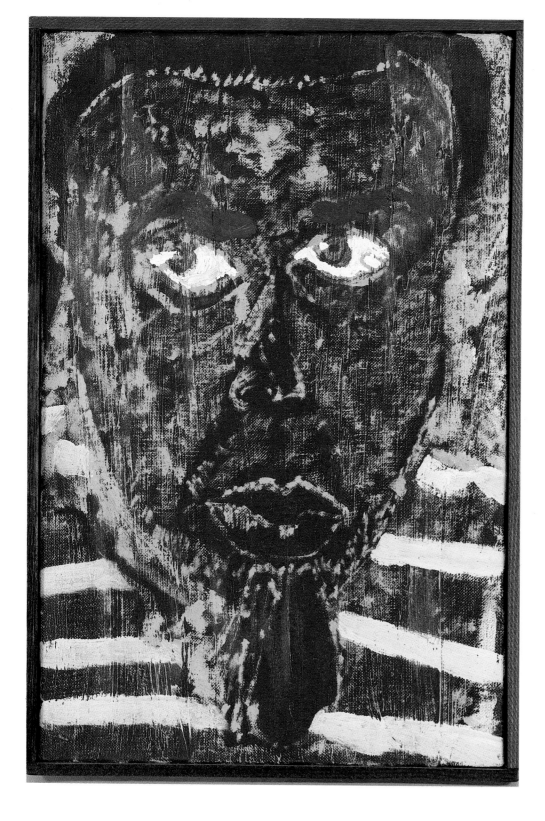

Autoritratto

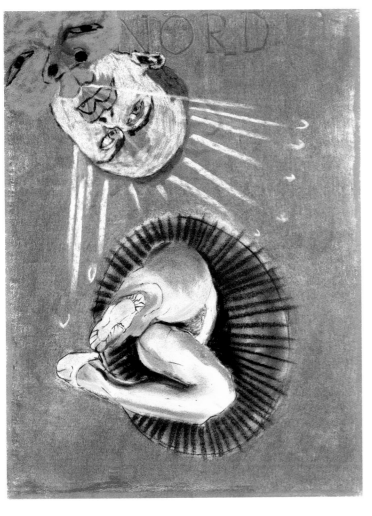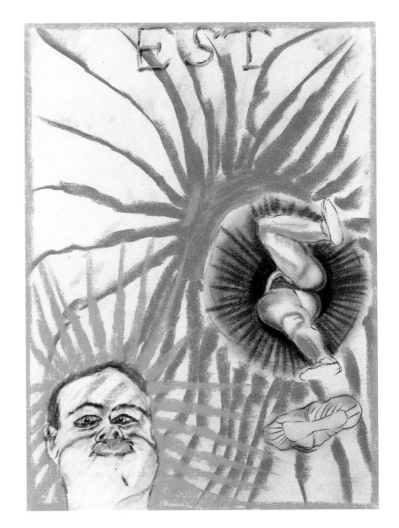
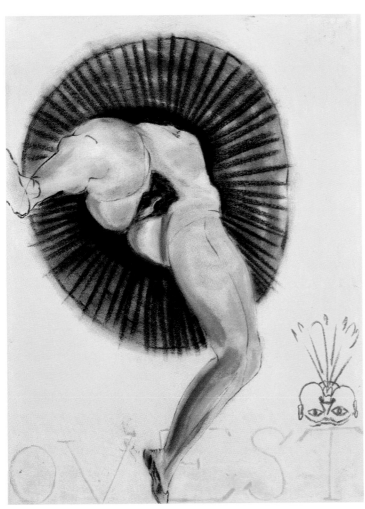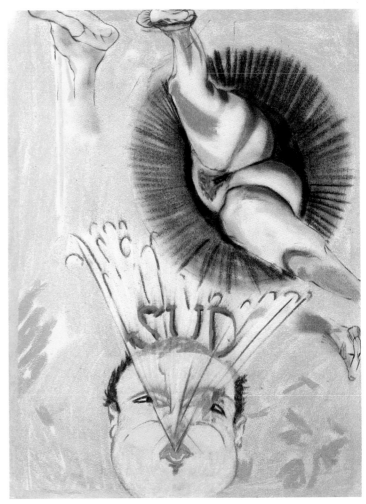

FRANCESCO CLEMENTE

108
Non Morte di Eraclito
1980
Charcoal and pastel on paper mounted on canvas
79×335 (201×850)

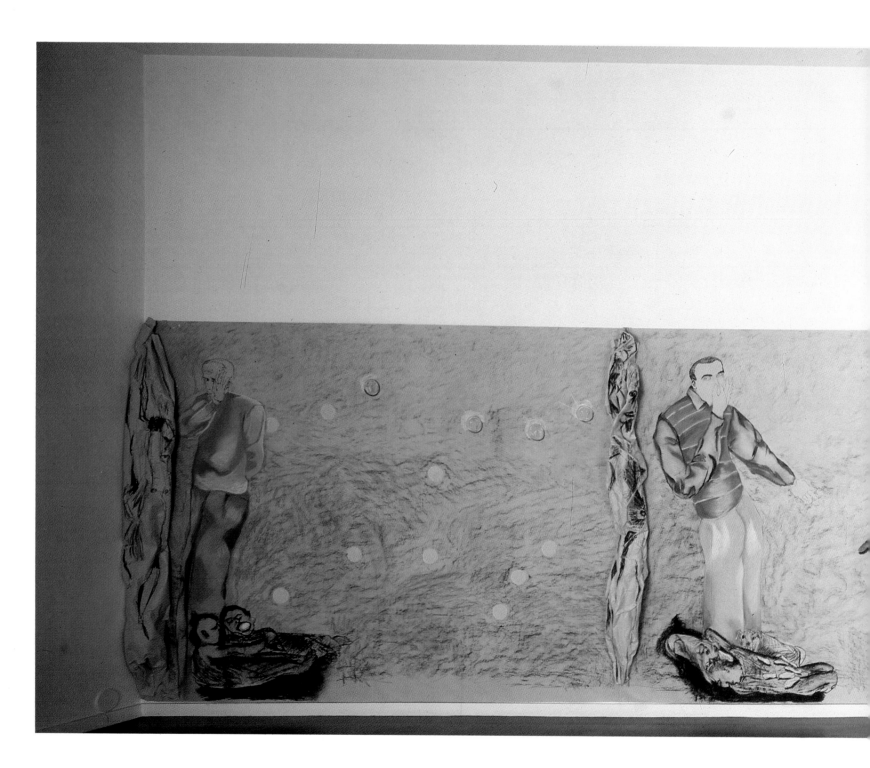

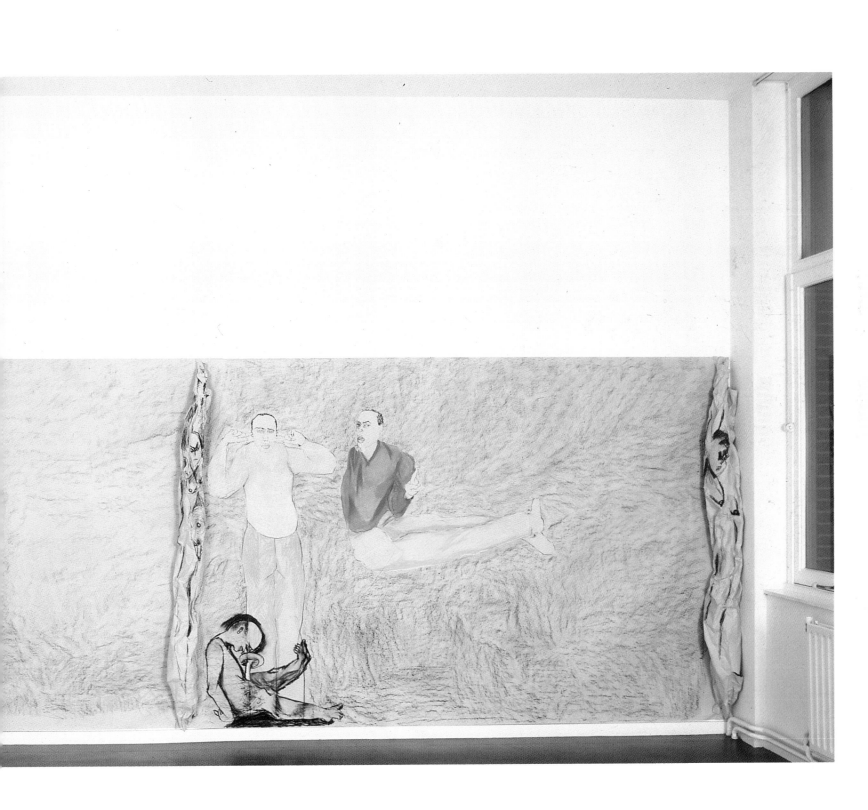

FRANCESCO CLEMENTE

109
Weight
1980
Pastel on paper
Sheet: 24×18 (61×45·5)

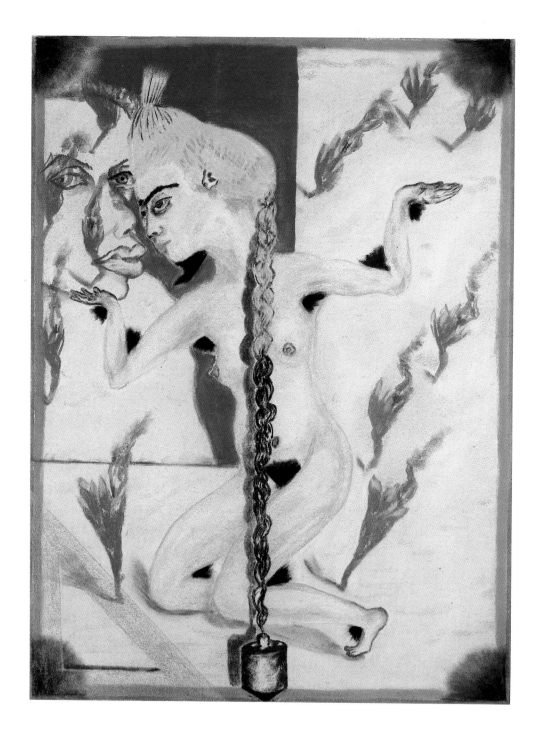

FRANCESCO CLEMENTE

110
Interior Landscape
1980
Pastel on paper
Sheet: 24×18 (61×45·5)

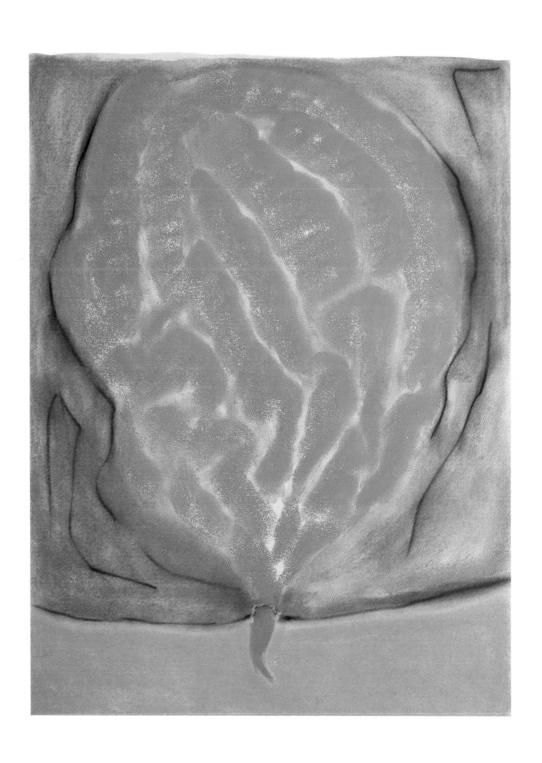

FRANCESCO CLEMENTE

111
Untitled
1981
Oil on canvas
Tondo: 20×16 (51×41)

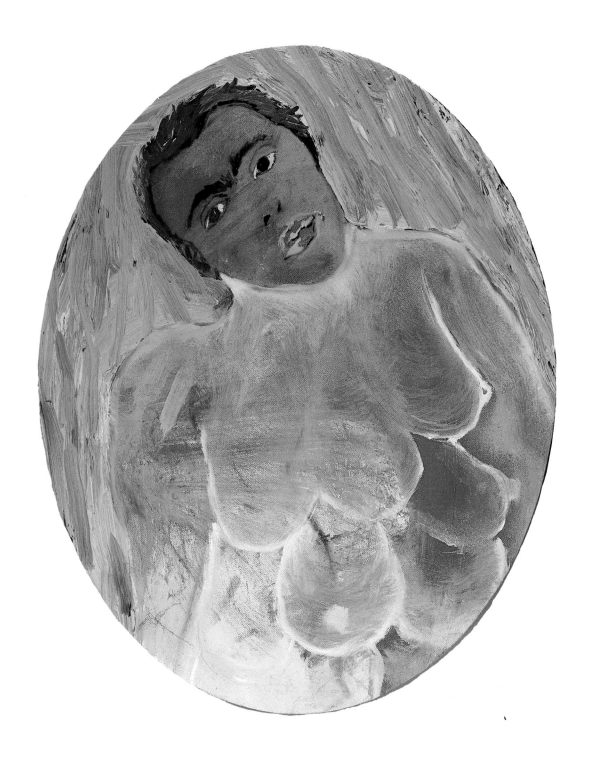

FRANCESCO CLEMENTE

112
One, Two, Three
1981
Oil on canvas and fabric
96×288 (244×732)

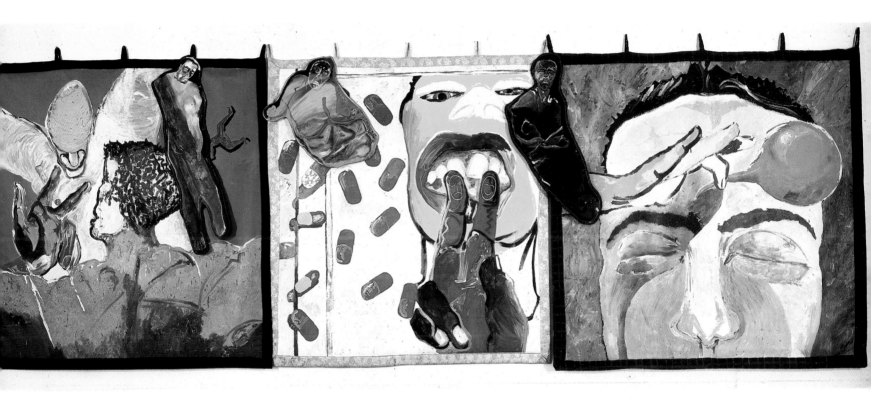

FRANCESCO CLEMENTE

113
The Magi
1981
Fresco
78¾×118 (200×300)

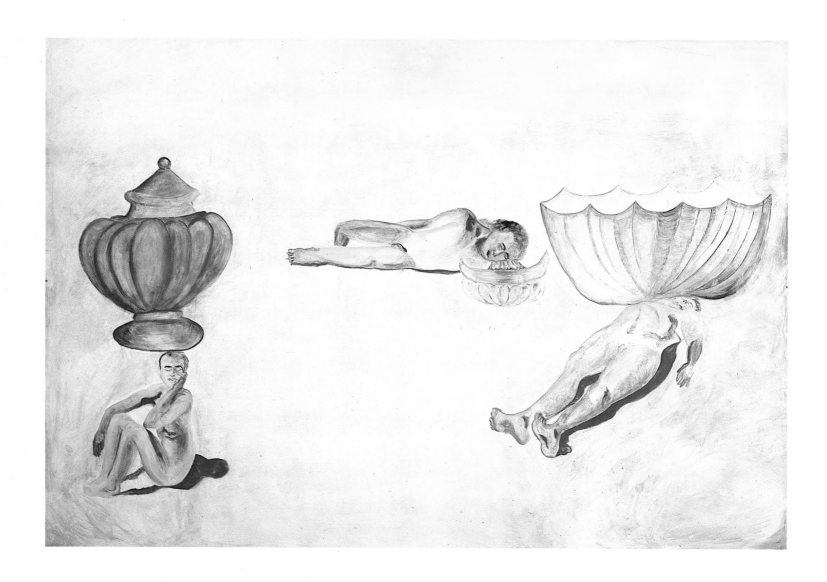

114
Smoke in the Room
1981
Fresco
78¾×118 (200×300)

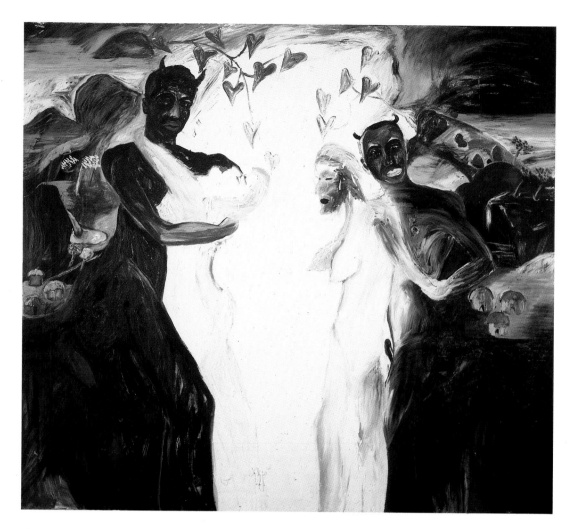

FRANCESCO CLEMENTE

115
The Fourteen Stations, No. I
1981/82
Oil and encaustic on canvas
78×88 (198×223·5)

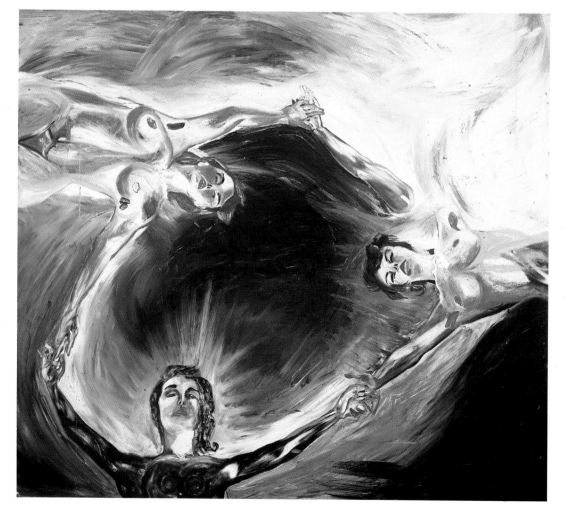

FRANCESCO CLEMENTE

116
The Fourteen Stations, No. II
1981/82
Oil on canvas
78×88 (198×223·5)

FRANCESCO CLEMENTE

117
The Fourteen Stations, No. III
1981/82
Encaustic on canvas
78 × 93 (198 × 236)

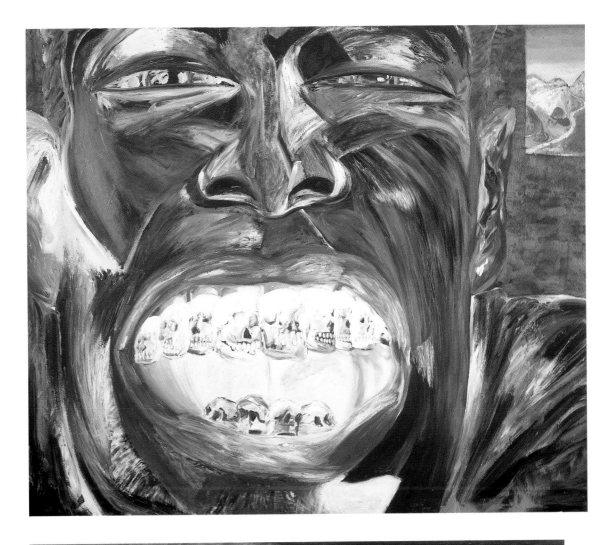

FRANCESCO CLEMENTE

118
The Fourteen Stations, No. IV
1981/82
Oil and encaustic on canvas
78 × 88½ (198 × 225)

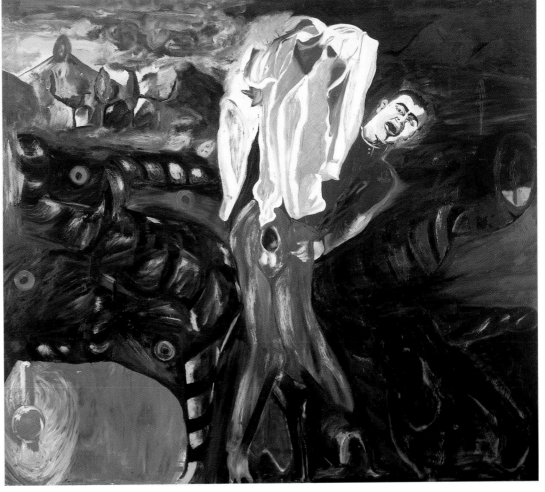

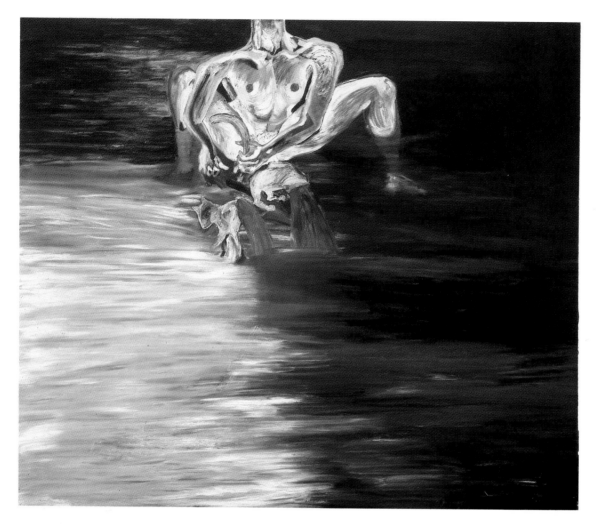

FRANCESCO CLEMENTE

119
The Fourteen Stations, No. V
1981/82
Oil on canvas
78×92 (198×233·5)

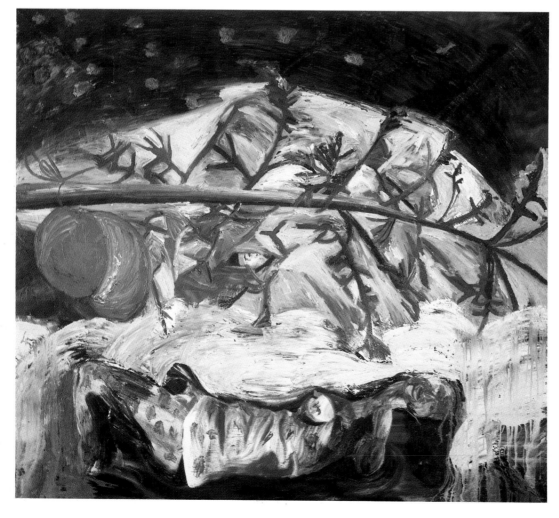

FRANCESCO CLEMENTE

120
The Fourteen Stations, No. VI
1981/82
Encaustic on canvas
78×88 (198×223·5)

FRANCESCO CLEMENTE

121
The Fourteen Stations, No. VII
1981/82
Oil on canvas
78×90 (198×228·5)

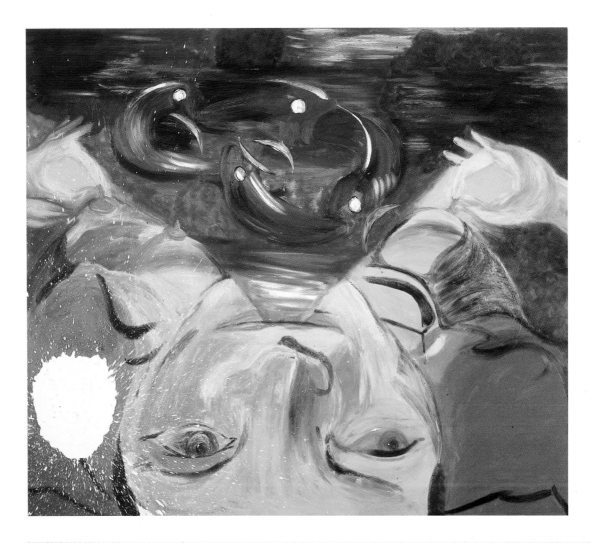

FRANCESCO CLEMENTE

122
The Fourteen Stations, No. VIII
1981/82
Oil and encaustic on canvas
78×93 (198×236)

FRANCESCO CLEMENTE

123
The Fourteen Stations, No. IX
1981/82
Encaustic on canvas
78×93 (198×236)

FRANCESCO CLEMENTE

124
The Fourteen Stations, No. X
1981/82
Oil and encaustic on canvas
78×93 (198×236)

FRANCESCO CLEMENTE

125
The Fourteen Stations, No. XI
1981/82
Oil on canvas
78×93 (198×236)

FRANCESCO CLEMENTE

126
The Fourteen Stations, No. XII
1981/82
Oil and encaustic on canvas
78×93 (198×236)

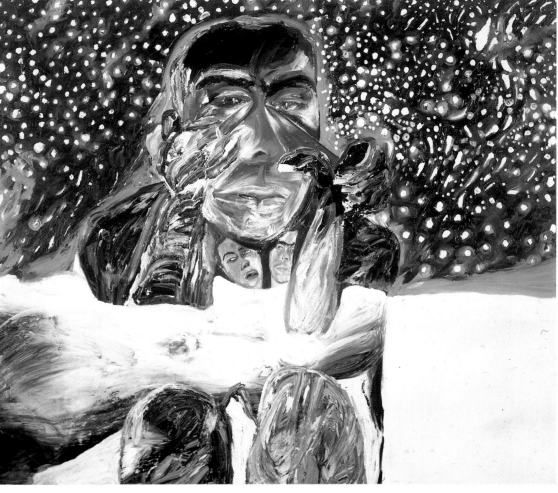

RICHARD DEACON

127
Untitled
1980
Laminated wood with rivets
118×114×114 (300×290×290)

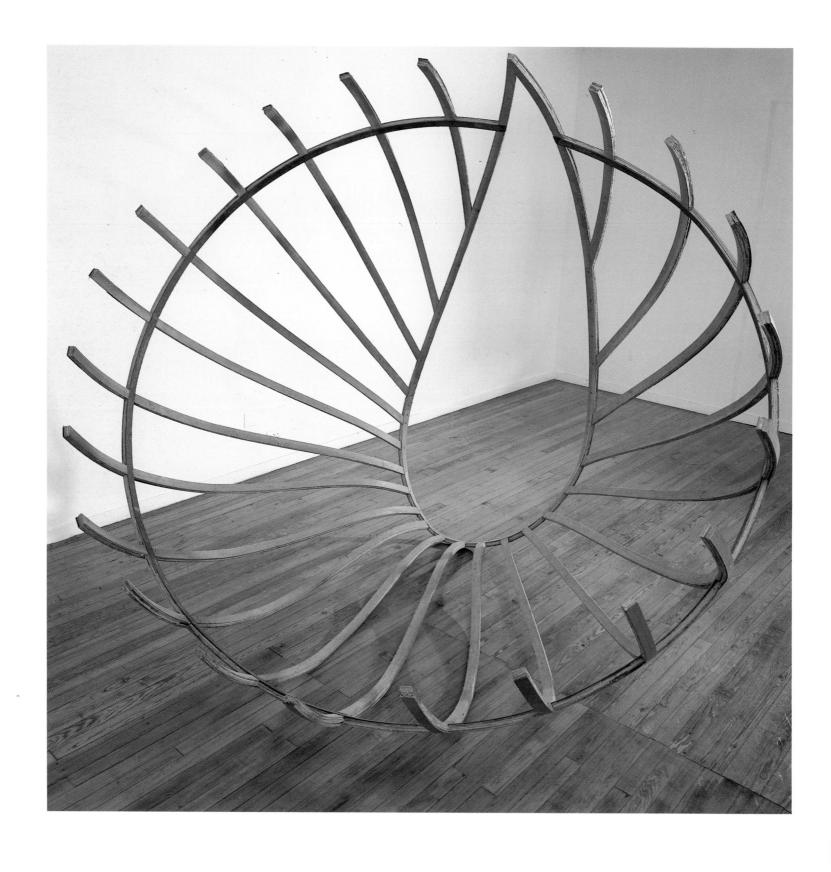

RICHARD DEACON

128
Untitled
1981
Laminated wood
84⅝×120×55 (215×305×140)

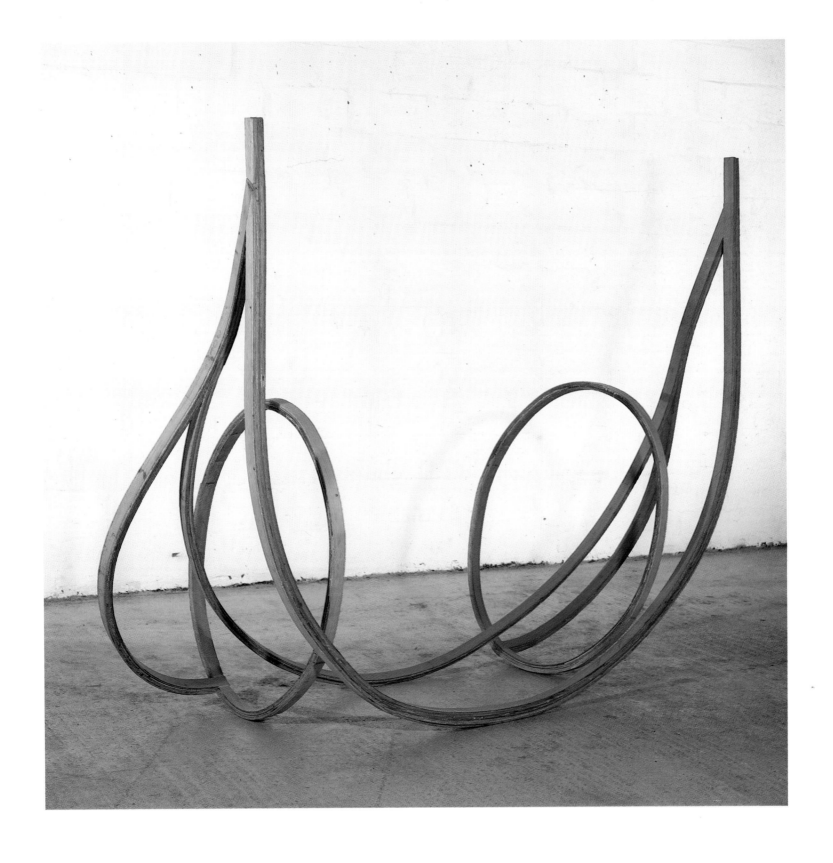

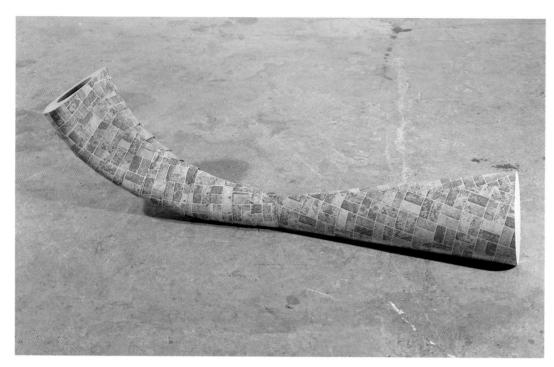

RICHARD DEACON

129 (left)
Art for Other People No. 2
1982
Marble, wood, vinyl plastic with rivets
17×62¼×13 (43×158×33)

130 (below)
If the Shoe Fits
1981
Galvanised and corrugated sheet steel with rivets
60×130⅜×60 (152·5×331×152·5)

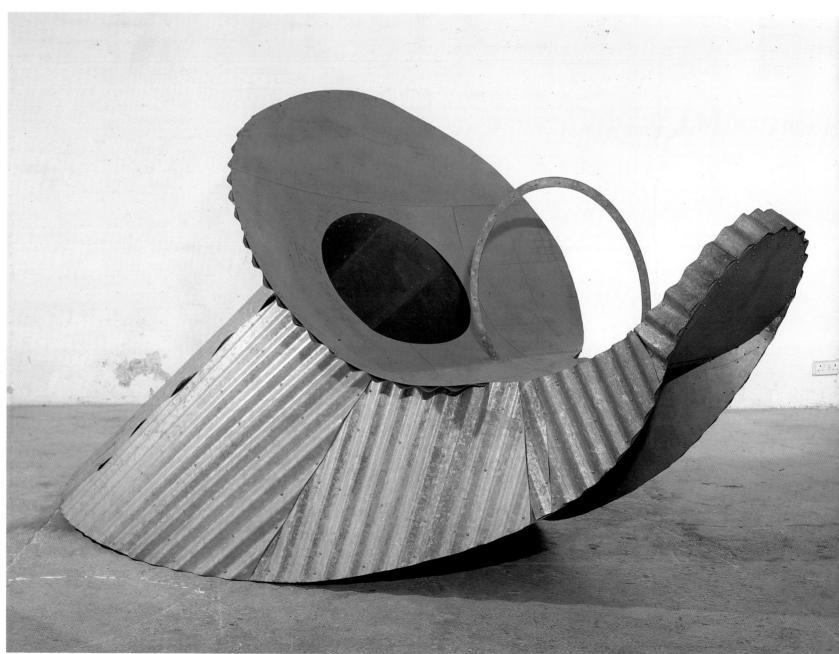

RICHARD DEACON

131 (right)
Art for Other People No. 5
1982
Laminated wood
42×42×72 (106·7×106·7×183)

132 (below)
For Those Who Have Ears No. 1
1982/83
Laminated wood and galvanised steel with rivets
84×144×60 (213·4×365·8×152·5)

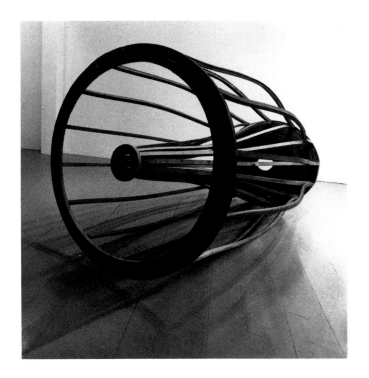

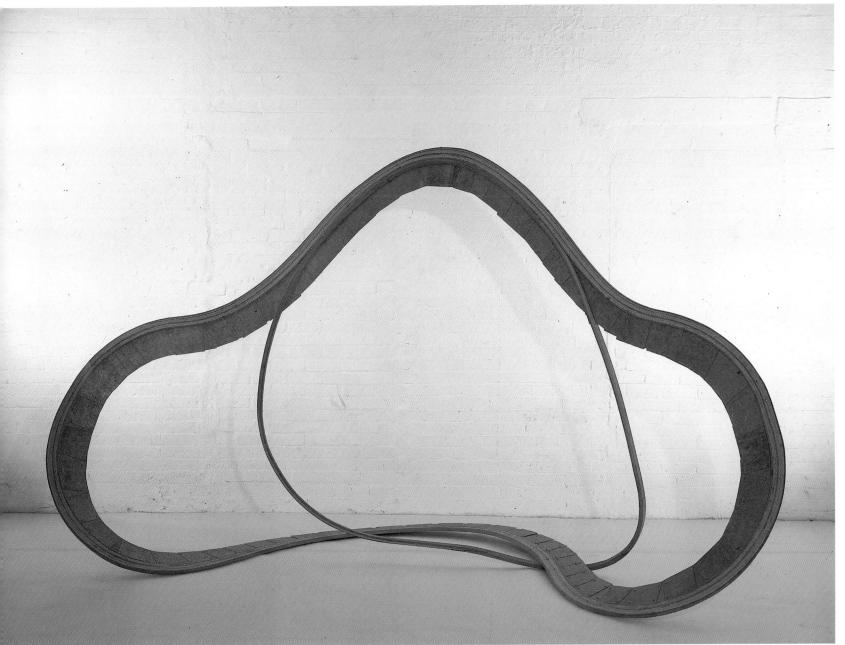

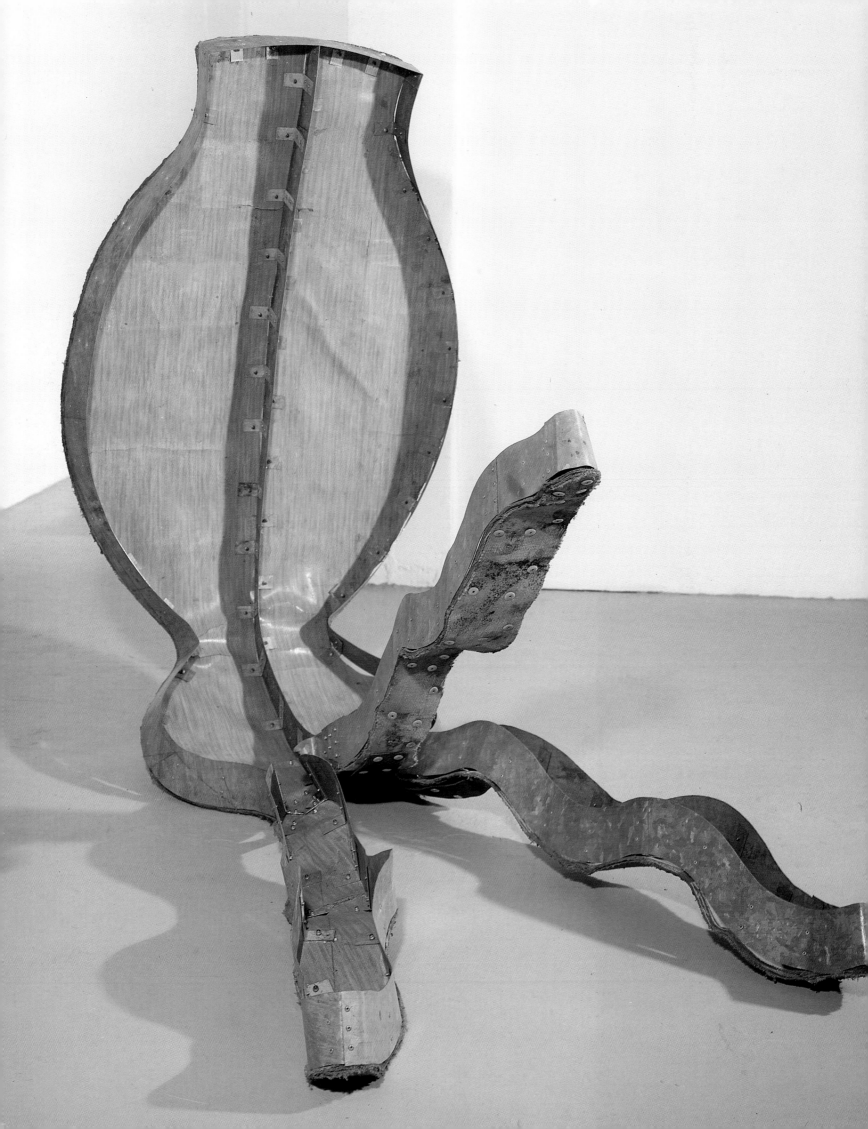

RICHARD DEACON

133 (opposite)
Out of the House
1983
Galvanised steel and linoleum with rivets
48×24×60 (122×61×152·5)

RICHARD DEACON

134 (below)
The Heart's in the Right Place
1983
Galvanised steel with rivets
79×130×92 (200·7×330·2×233·7)

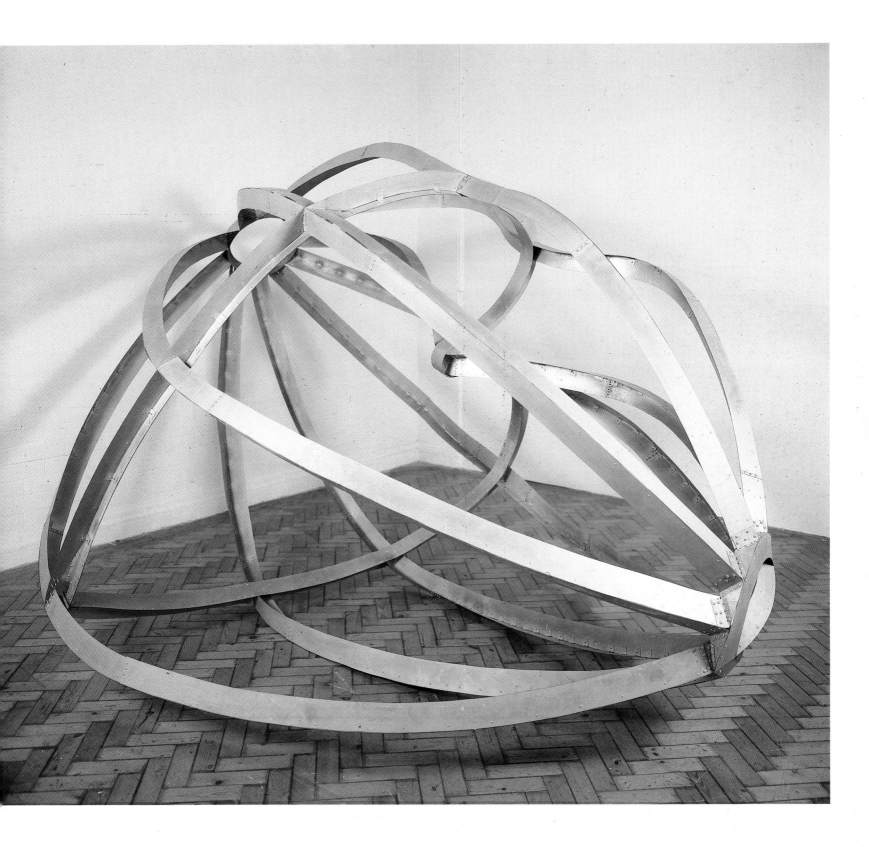

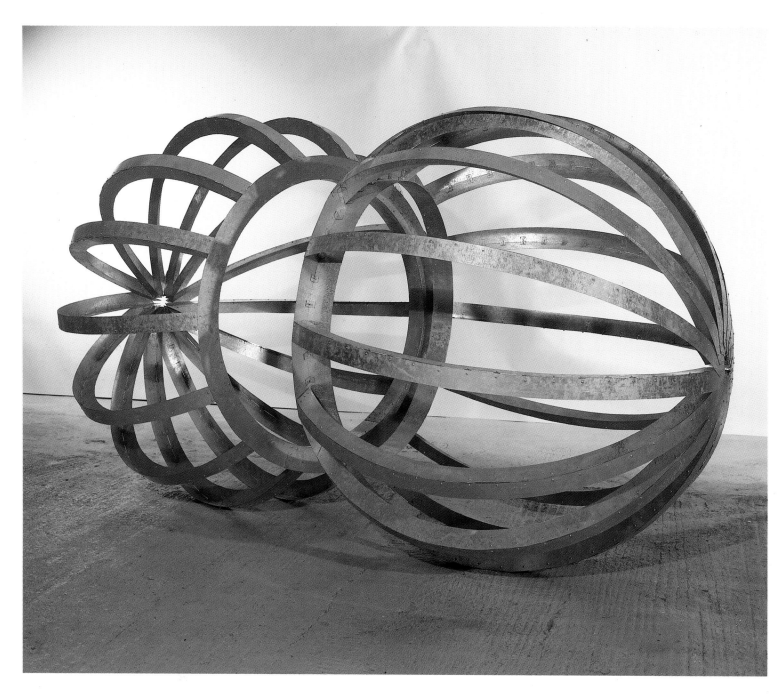

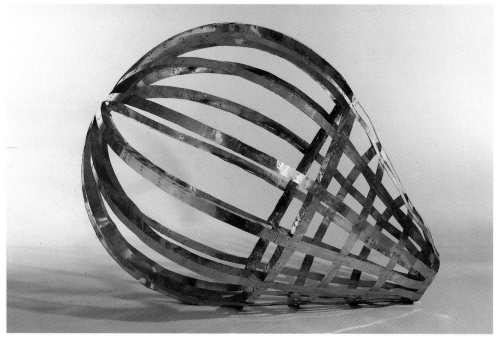

RICHARD DEACON

135 (above)
Two Can Play
1983
Galvanised steel
72×144×72 (183×365·8×183)

RICHARD DEACON

136 (left)
For those Who Have Eyes
1983
Stainless steel with rivets
60×60×90 (152·4×152·4×228·6)

RICHARD DEACON

137 (above)
Art for Other People No. 9
1983
Galvanised steel with rivets
21 × 13³/₈ × 4¹/₃ (53 × 34 × 11)

138 (right)
Tall Tree in the Ear
1983/84
Galvanised steel, laminated wood and blue canvas
147⁵/₈ × 98¹/₂ × 59 (375 × 250 × 150)

HOWARD HODGKIN

139
Family Group
1973/78
Oil on panel
36×42 (91·4×106·7)

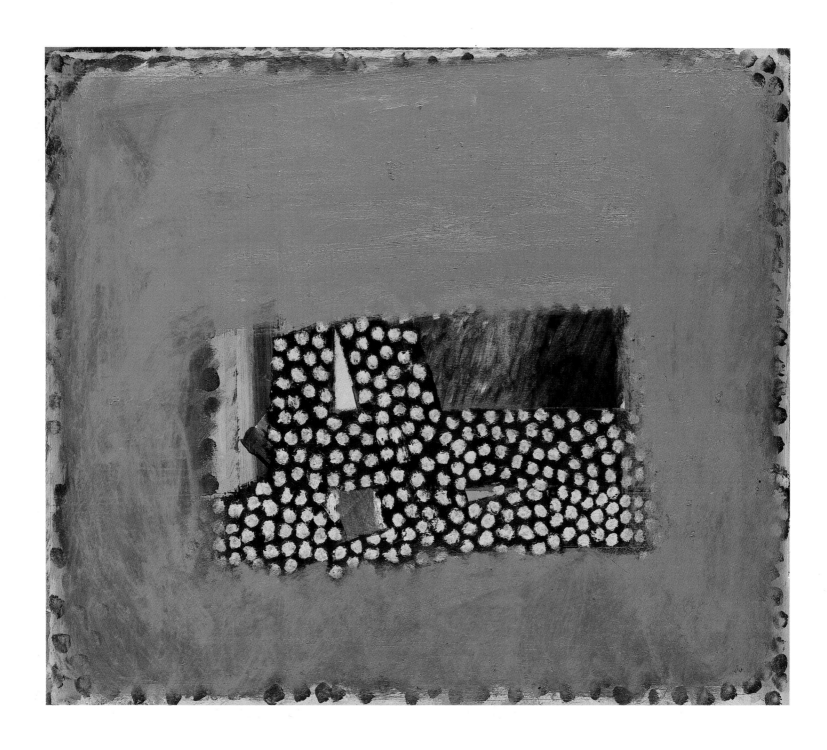

HOWARD HODGKIN

140
Paul Levy
1976/80
Oil on panel
20⁷/₈×24 (53×61)

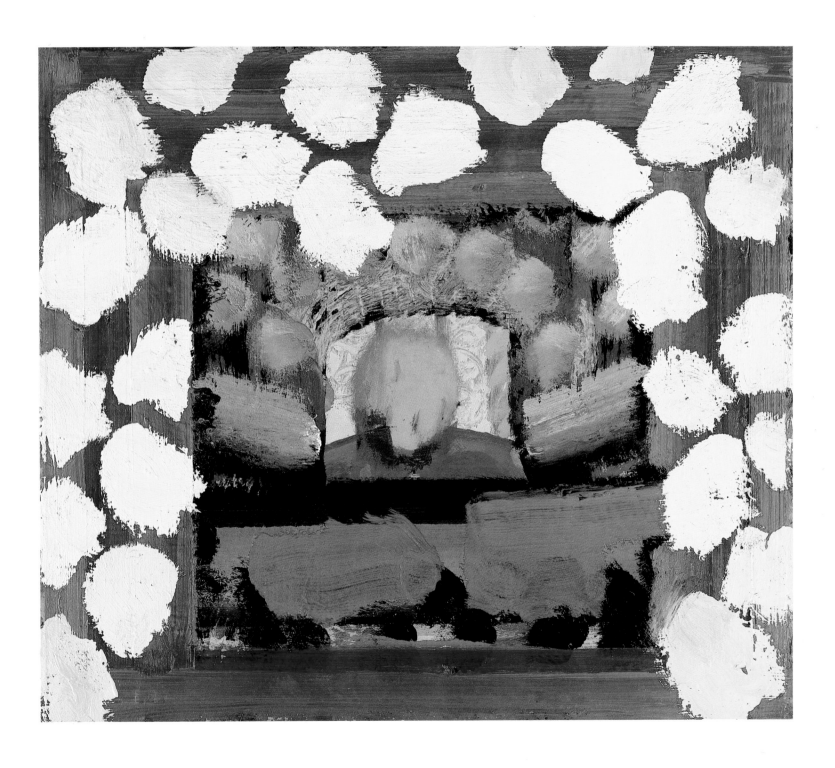

LEON KOSSOFF

141
**Children's Swimming Pool, 11 o'clock Saturday
morning, August 1969**
1969
Oil on board
60×81 (152×205)

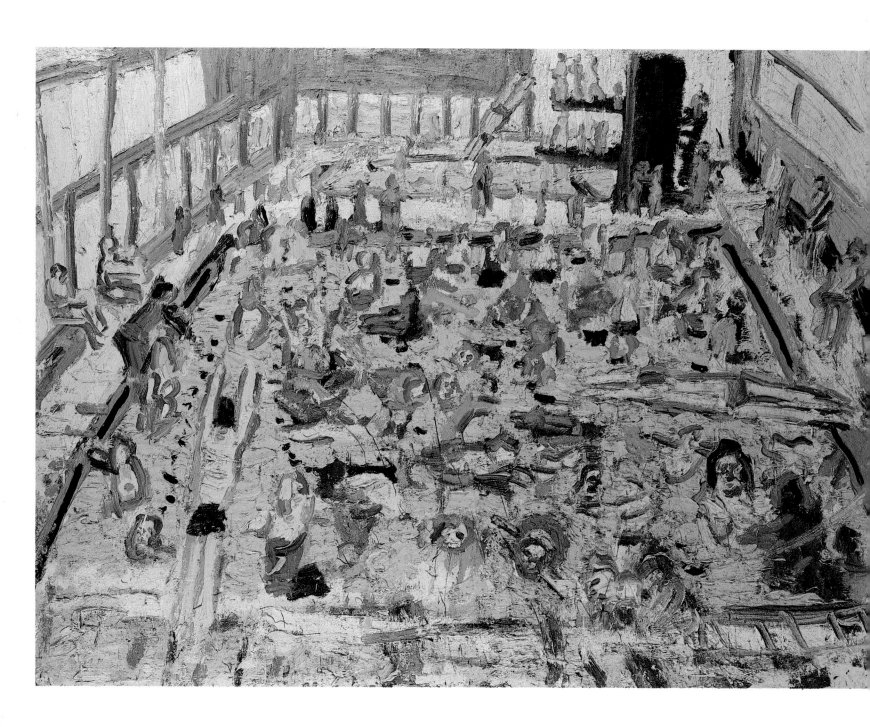

LEON KOSSOFF

142
School Building, Willesden, Spring 1981
1981
Oil on board
53½×65½ (136×166·4)

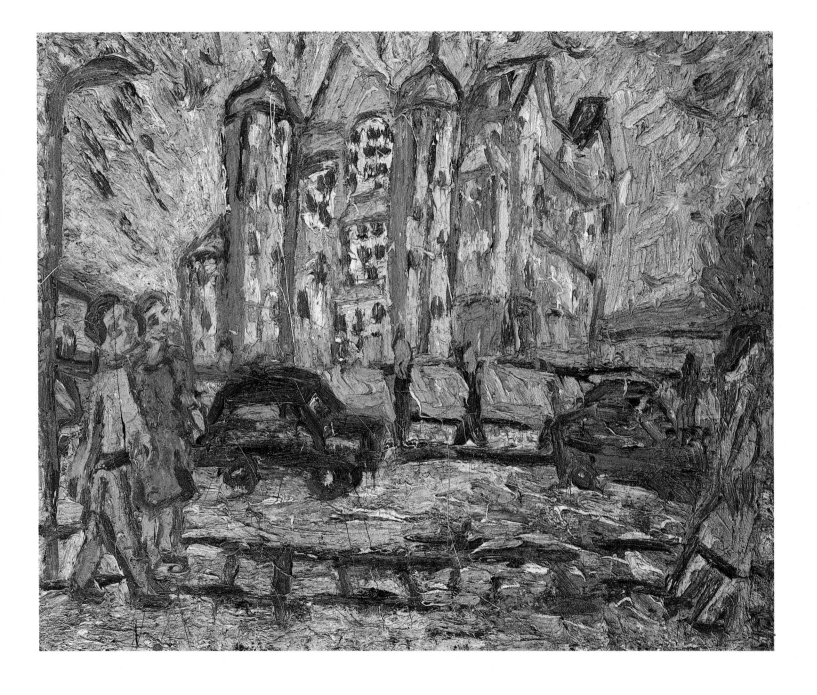

LEON KOSSOFF

143
Family Party, January 1983
1983
Oil on board
66×98¼ (167·6×249·5)

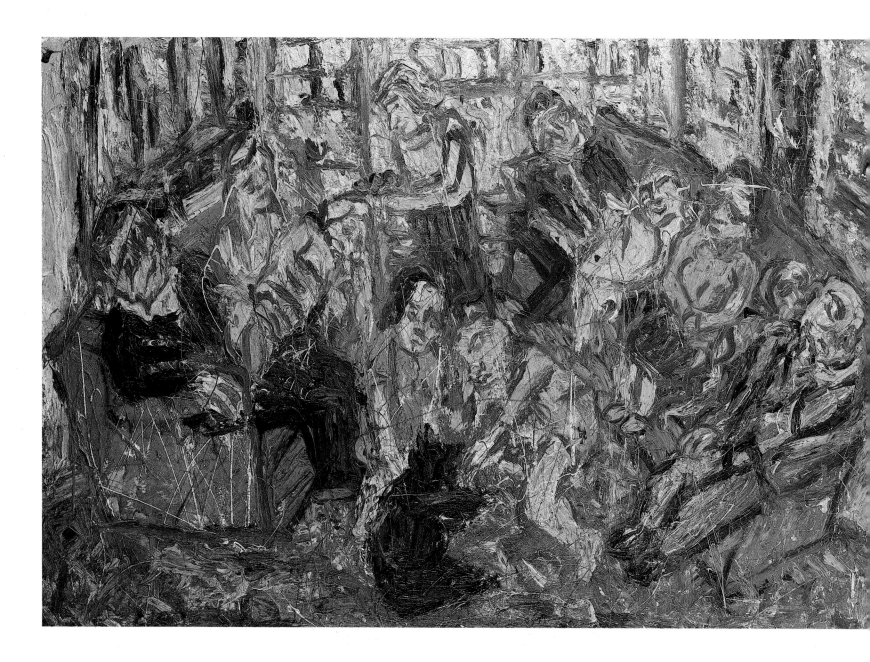

LEON KOSSOFF

144
Inside Kilburn Underground, Summer 1983
1983
Oil on board
54¼×66¼ (137·8×168·3)

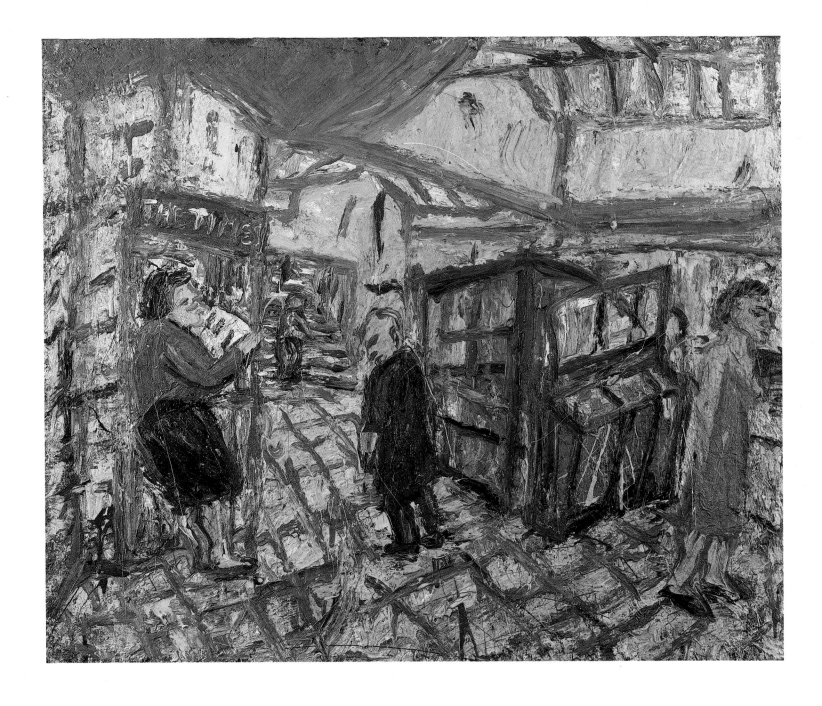

SEAN SCULLY

145
The Bather
1983
Oil on canvas
96 × 120 (243·8 × 304·8)

SEAN SCULLY

146
By Day and By Night
1983
Oil on canvas
97½ × 142 (247·7 × 360·7)

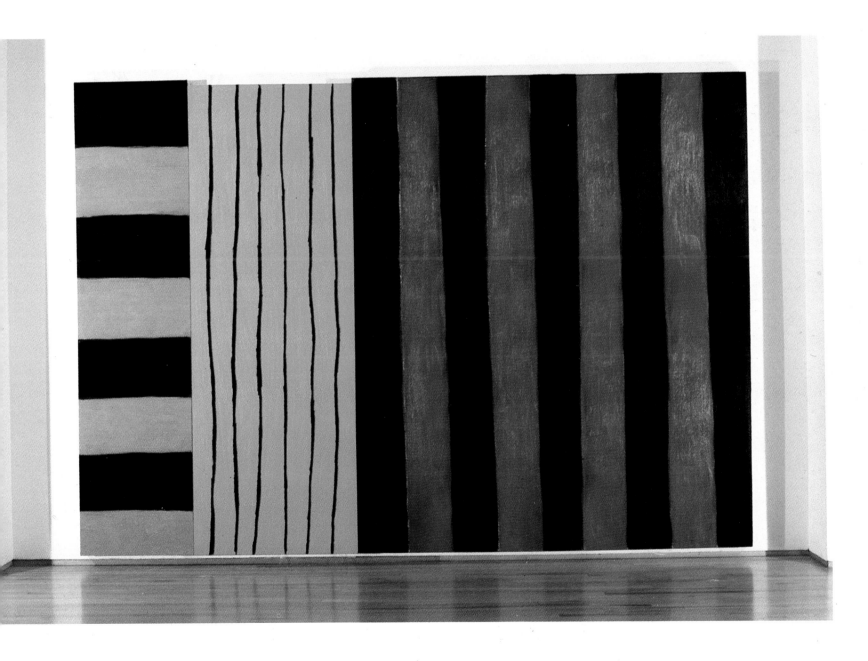

VICTOR WILLING

147
Navigation
1977
Oil on canvas
78¾×94½ (200×240)

VICTOR WILLING

148
Griffin
1982
Oil on canvas
98½×78¾ (250×200)

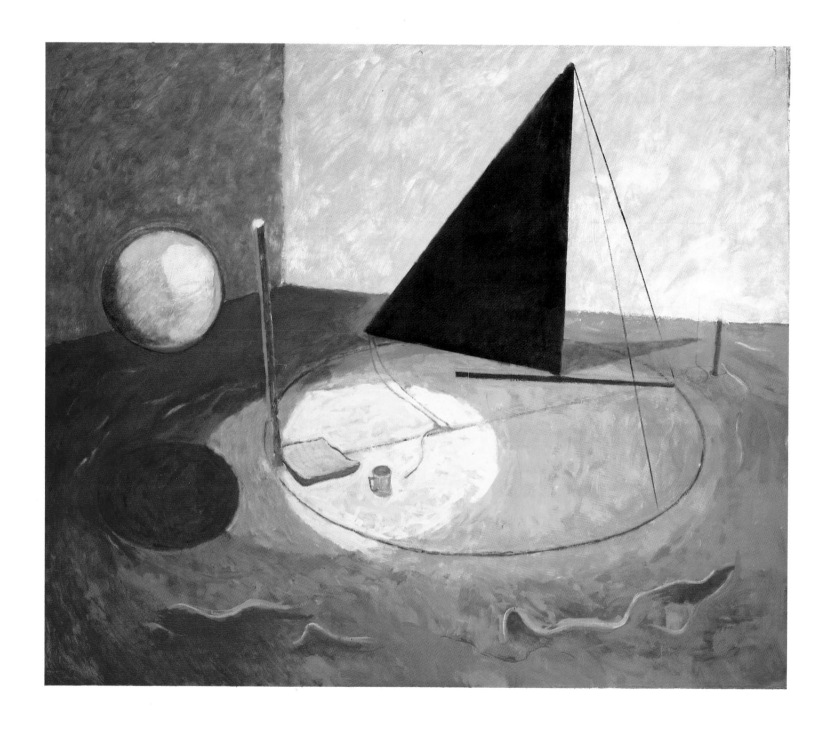

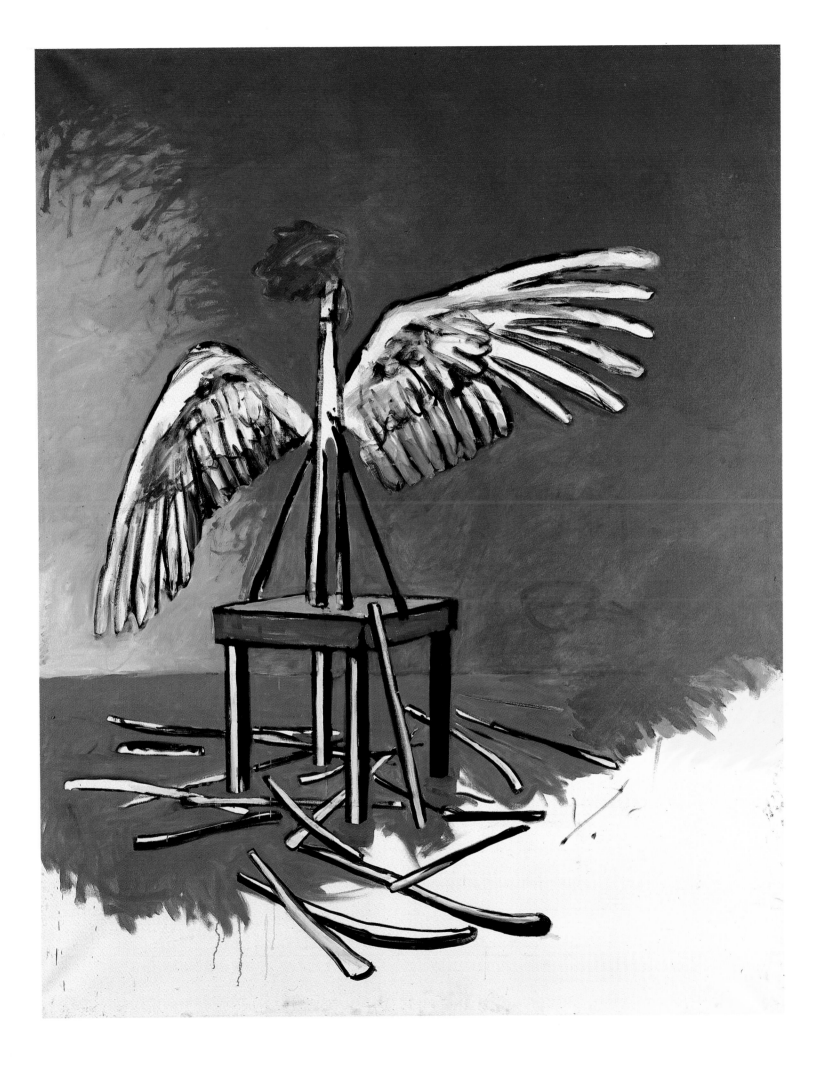

VICTOR WILLING

149
Knot
1984
Oil on canvas
78¾×86½ (200×220)

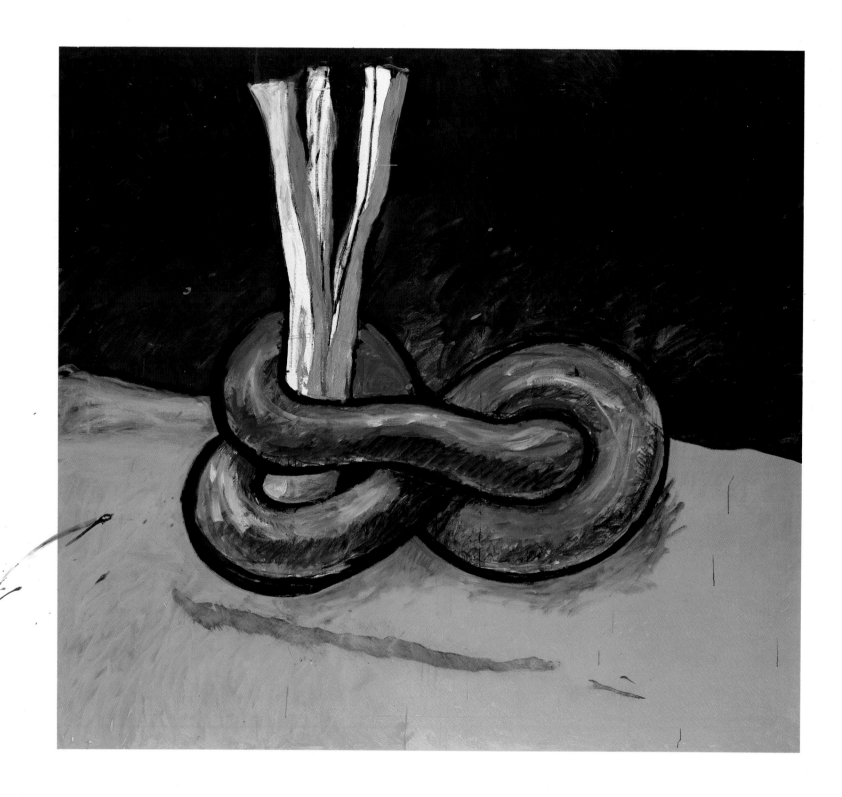

VICTOR WILLING

150
Callot Harridan
1984
Oil on canvas
78³/₄×86¹/₂ (200×220)